MUSEUMS AND RESTITUTION

Museums and Restitution
New Practices, New Approaches

Edited by

LOUISE TYTHACOTT
School of Oriental and African Studies, University of London, UK

KOSTAS ARVANITIS
University of Manchester, UK

ASHGATE

Published by
Ashgate Publishing Limited
Wey Court East
Union Road
Farnham
Surrey, GU9 7PT
England

Ashgate Publishing Company
110 Cherry Street
Suite 3-1
Burlington, VT 05401-3818
USA

www.ashgate.com

British Library Cataloguing in Publication Data
A catalogue record for this book is available from the British Library

The Library of Congress has cataloged the printed edition as follows:
Museums and restitution : new practices, new approaches / [edited] by Louise Tythacott and Kostas Arvanitis.
 pages cm.—(Information and cultural management)
 Includes bibliographical references and index.
 ISBN 978-1-4094-3563-1 (hardback)—ISBN 978-1-4094-3564-8 (ebook)—ISBN 978-1-4724-0026-0 (epub) 1. Museums—Collection management. 2. Restitution. 3. Material culture—Conservation and restoration. 4. Art—Provenance. 5. Art thefts. 6. Cultural property—Protection. 7. Museums—Acquisitions. I. Tythacott, Louise. II. Arvanitis, Kostas.
 AM133.M8727 2014
 069'.5—dc23
 2014010738

ISBN: 9781409435631 (hbk)
ISBN: 9781409435648 (ebk – PDF)
ISBN: 9781472400260 (ebk – ePUB)

Printed in the United Kingdom by Henry Ling Limited, at the Dorset Press, Dorchester, DT1 1HD

Contents

List of Figures and Tables

Figures

Tables

Notes on Contributors

Kostas Arvanitis is a Senior Lecturer in Museology at the University of Manchester. He has a MA and PhD in Museum Studies from the University of Leicester and a first degree in History and Archaeology from the Aristotle University of Thessaloniki, Greece. His research crosses the fields of museology, archaeology and digital heritage. He has published on the theory and practice of digital, social and mobile media in museums and the interpretation of archaeological sites in urban environments.

Tristram Besterman works as a freelance adviser in the museums, cultural and higher education sectors. His career in UK museums spans forty years. The social purpose of museums as trusted places of cultural engagement is of particular interest to him, and his work on professional ethics, engagement with source communities, management and leadership has focused on issues of social interaction, cultural identity, accountability and sustainability. Tristram's interest in innovative, interdisciplinary approaches to public engagement with issues of local and global concern draws on his experience in both the scientific and artistic spheres. As Director of The Manchester Museum (1994-2005) he was able to work with communities of identity, museum colleagues and academics in testing such ideas and putting such principles into practice.

Piotr Bienkowski runs a cultural consultancy specializing in organizational change, community engagement and cultural planning. His practice focuses on community participation in arts, culture and heritage, the mechanisms of change in organizations, and the importance of intercultural dialogue and debate in fostering understanding and social cohesion. Previously he was Head of Antiquities at National Museums Liverpool, Deputy (and Acting) Director at Manchester Museum, Professor of Archaeology and Museology at the University of Manchester, and Chair of the North West Federation of Museums and Galleries.

Neil Curtis is Head of Museums and Honorary Senior Lecturer in Anthropology, both in the University of Aberdeen. He studied Archaeology (Glasgow, 1986), Museum Studies (Leicester, 1988) and Education (Aberdeen, 1995). His research has included young children's learning in museums, considerations of the social and cultural roles of museums today, including repatriation and the treatment of human remains, and studies of Scottish antiquarianism and museum history.

Kalliopi Fouseki is a Lecturer at the Centre for Sustainable Heritage of the University College London (UCL) where she coordinates the MSc course in Sustainable Heritage. Prior to this, she taught at the Open Universities in the UK, Greece and Cyprus and she worked as the New Audience Advocate at the Science Museum. After the completion of her MA and PhD thesis at UCL, she worked as a Post-doctoral Research Assistant at the University of York on the 1807 Commemorated project, an AHRC-funded project that explored public perceptions on the commemoration of the 'Abolition of the slave trade'.

Eeva-Kristiina Harlin was educated as an archaeologist in the University of Helsinki and osteoarchaeologist in the University of Stockholm. She has worked as a curator in the Norwegian Sámi museum, RiddoDuottarMuseat, and with repatriation issues in a project in the Finnish Sámi museum, Siida. She is currently undertaking research on repatriation politics in the Nordic countries.

Ines Katenhusen holds a degree in German Literature and Language and History (MA in 1992). She holds a PhD in Art and Politics, Hannover's forays into modernity during the Weimar Republic (Kunst und Politik. Hannovers Auseinandersetzungen mit der Moderne in der Weimarer Republik). Since 1999, she has been associate professor at the Faculty of Philosophy, Leibniz University Hannover. Currently, she is working on a book publication on the German-American curator and museum reformer Alexander Dorner (1893-1957). After having coordinated an international interdisciplinary Master's programme between 1999 and 2007, she is now working as research administrator and officer for public relations at her university.

Maureen Matthews is a recent graduate of the Institute of Social and Cultural Anthropology at the University of Oxford. She is also an award-winning Canadian radio documentary maker. She has worked in the Ojibwe speaking community of Pauingassi Manitoba since 1992 creating five documentaries about the religious understandings of a people last studied 65 years ago by American anthropologist, A. Irving Hallowell. The subject of her chapter, a botched repatriation of Ojibwe artefacts from Pauingassi, began as a radio documentary. Her recent thesis combines Hallowell's historic ethnography and her own fieldwork into a theoretically informed analysis of repatriation.

Conal McCarthy has strong links with museums, art galleries and heritage organizations around New Zealand and Australia, and worked as an educator, interpreter and curator before becoming director of the Museum & Heritage Studies programme at Victoria University in 2005. His research interests include museum history, theory and practice, Māori visual culture and contemporary heritage issues. His latest book, *Museums and Māori*, was published in 2011.

Anne May Olli is a Norwegian Sámi, educated as a conservator in the University of Oslo. She has worked as a conservator in the Norwegian Sámi museum, RiddoDuottarMuseat, where she worked with emphasis on documentation of traditional Sámi technology and its use in conservation. She completed a Master's degree in 2013, which focused on pesticide issues in Sámi museums.

Helen A. Robbins is the Repatriation Director at the Field Museum where she coordinates domestic and international repatriation activities. As part of her work, she evaluates and conducts empirical research on repatriation claims and is actively involved in consultation with, and outreach to, Native American groups. She collaborates on exhibitions and manages an internship programme. With General Counsel and curators, she is working to establish consistent standards of research and review and is actively involved in the ongoing development of Museum policy and procedures regarding international repatriation and other matters. She received an MA and PhD in anthropology from the University of Arizona.

Louise Tythacott is a Senior Lecturer in Curating and Museology of Asian Art at the School of Oriental and African Studies, University of London, and was previously a Lecturer in Museology at the University of Manchester. She has worked in the museum field for over a decade, latterly as Head of Asian, African, Oceanic and American collections at National Museums Liverpool. She has published widely on the relationship between museums and anthropology: her books include *Surrealism and the Exotic* (Routledge, 2003) and *The Lives of Chinese Objects: Buddhism, Imperialism and Display* (Berghahn, 2011). She is also a Managing Editor of the journal, *Museum and Society*.

Demelza van der Maas is a researcher and lecturer at VU University in Amsterdam. She has a MA and PhD in Museum and Heritage Studies, and has worked in several Dutch museums, such as the Jewish Historical Museum and the Tropenmuseum in Amsterdam. Her special research interest lies in the historical construction of identity and its resonance in museum and heritage practice. Her PhD thesis focused on identity construction and cultural heritage practice in the Dutch IJsselmeer polders.

Acknowledgements

First and foremost, our thanks go to the contributors of this volume. Their conference papers not only inspired but offered the content of this volume. Without their contributions, this would not have materialized. We also thank the other conference speakers and participants, for making 'Museums and Restitution' such a successful conference.

We are grateful to our volunteering team of MA Art Gallery and Museum Studies students (cohort 2009-10), Kayleigh Carr, Catherine Downey, Dan Feeney, Erika Kvam, Cordelia Mackay and Elizabeth Walley, who contributed enthusiastically to the running of the 'Museums and Restitution' conference in July 2010. Many thanks also to Hannah Mansell, conference administrator at the School of Arts, Languages and Cultures, who took care of the financial and booking aspects of the conference.

We also thank the Programme Panel of the Conference for their advice and suggestions at the early stages of planning the scope and aims of the conference: Sam Alberti (Museums & Archives, The Royal College of Surgeons); Malcolm Chapman (The Hunterian, University of Glasgow); Zachary Kingdon (National Museums Liverpool); Sharon Macdonald (Department of Sociology, University of York); and Helen Rees Leahy (Centre for Museology, University of Manchester).

The Manchester Museum was an excellent host of the conference; our thanks to Anna Davey, Ron McGregor, Nick Merriman at the Museum for all their help and support before and during the conference.

We are grateful to Ashgate for approaching us after the conference to explore the possibility of this publication and for guiding us throughout it, in particular Lianne Sherlock, Dymphna Evans and Sadie Copley-May. We are equally grateful to the peer reviewers of the book chapters, who gave their time and expert opinion to this volume.

Chapter 1

Museums and Restitution: An Introduction

Louise Tythacott and Kostas Arvanitis

Restitution is one of the most important, yet emotive and contentious issues facing Western museums in the twenty-first century. Its current high profile reflects changing global power relations and the increasingly vocal criticisms of the historical concentration of the world's heritage in the museums of the West. Indeed, the 'Declaration on the Importance and Value of Universal Museums', which was signed by the directors of eighteen of the world's most renowned museums in 2003, propelled the subject to the forefront of debate as never before.[1]

Over recent years the issue of restitution has taken on new complexions, with different processes emerging. There is an increasing emphasis on museums working with source communities, and on forms of repatriation other than the return of objects (Peers and Brown 2003). The language of discussion too has changed, with, for example, 'reunification' as well as 'repatriation' being applied in relation to the Parthenon Marbles (Fouseki, Chapter 11). The opening of a new Acropolis Museum in Athens in 2009 further added to the debates. Different issues are coming to the fore in the twenty-first century – for example, the response from the government of the People's Republic of China to the Yves Saint Laurent auction of Chinese looted bronzes at Christie's in Paris in 2009. The fact that a range of countries is teaming up to co-ordinate and strengthen their efforts towards repatriation,[2] demonstrates that this is a trend set to continue.

Despite the increasing importance of the subject for both policies and practices in museums, existing academic publications on the subject have focused largely

1 For more information on the declaration, see Merryman 2006, and also Cuno, in Merryman 2006. A transcript of the Declaration is printed on pp. 24-6. See also http://icom. museum/fileadmin/user_upload/pdf/ICOM_News/2004-1/ENG/p4_2004-1.pdf.

2 For example, the explicitly titled International conference on The Return of Cultural Property to its Countries of Origin in Athens in 2008; or The Conference on International Cooperation for the Protection and Repatriation of Cultural Heritage (April 2010), where representatives from 22 countries came together to 'discuss how best to work together to return objects stolen in the past and to prevent future theft' and produced recommendations including on 'strengthening international cooperation for repatriation effort' (Supreme Council of Antiquities, http://www.sca-egypt.org/eng/RST_ICHC.htm), followed by a Second Conference in October 2013 in Peru; and the collaborative agreement between China and Egypt for 'the Protection and Restitution of Stolen Cultural Property Transferred Illicitly' (October 2010; Zahi Hawass, http://www.drhawass.com/blog/press-release-egyptian-chinese-agreement-cultural-repatriation).

on legal and political issues.[3] Although such texts are useful in framing debates, they often ignore the challenges that claims and discussions of restitution present to museums. The manner – reactive or proactive – in which museum professionals address claims for restitution have not been adequately voiced. Indeed, the developing debates around restitution call for a clearer account of how museums confront the issue. It is vital, therefore, for museum perspectives and practices to be reflected upon. This book does precisely this: it examines contemporary approaches to the subject from the viewpoint of museums and professionals, focusing on new ways in which these institutions are addressing the subject.

Restitution is a highly charged, political subject, entangled within shifting power relations between, and within, countries. Museums are, and have always been, political instruments. National museums, especially, operate as symbols of cultural identity, pride, history and wealth (Dubin 1999, Kaplan 1994, Karp and Lavine 1999, Knell et al. 2011, Macdonald 1998). Museums are part of the apparatus of power within society, reflecting and representing dominant ideologies (Bennett 1995, Tythacott 2010). Yet the museum landscape around the world is increasingly varied and developing as never before. Museums have become ever more complex sites of cultural production, whether they be nationals or smaller, private institutions. Each has its own particular agenda, collection history, form of governance, and each may respond to restitution claims and discussions differently (although this may be less true for countries where public museums are centrally administered by a Ministry of Culture or equivalent). The chapters in this volume demonstrate the diversity of approaches and institutions currently engaged with restitution practices. Although requests for restitution have largely affected museums with ethnographic and archaeological collections, other types of objects have been the subject of claims too.[4]

The public museum is a European creation. The earliest museums of the sixteenth and seventeenth centuries developed out of scholarly and aristocratic collections of the Renaissance (Hooper-Greenhill 1992, Impey and MacGregor 1985, MacGregor 2007). In the eighteenth and nineteenth centuries, increasingly unequal global power

3 See for example Greenfield's (1989) *The return of cultural treasures,* which discusses the historical, legal, and political issues surrounding high profile case studies. Renfrew's (2000) *Loot, legitimacy and ownership: the ethical crisis in archaeology,* focuses on archaeology and the illicit trade in antiquities, while Merryman's (2006) *Imperialism, art and restitution,* includes chapters from museum professionals, academics and legal professionals and emphasizes the legal mechanics for resolving cultural heritage disputes, as does Vrdoljak's (2006) *International law, museums and the return of cultural objects.* Cuno's (2008) *Who owns antiquity?: museums and the battle over our ancient heritage,* is the first extended defence of museum perspectives in the struggle over antiquities. Turnbull and Pickering's edited volume, *The long way home: the meaning and values of repatriation* (2010), includes the work of researchers from a wide range of disciplines in the humanities and social sciences who reflect critically on the historical, cultural, ethical and scientific dimensions of repatriation.

4 For example Nazi war loot and art. See Katenhusen (Chapter 10) in this volume.

relations enabled European countries to accumulate huge numbers of ethnographic and archaeological objects which found their way into their burgeoning museums (Gosden and Knowles 2001, Henare 2005). The collections established during this period were formed under conditions and ideological regimes that bear little relationship to today's. In the nineteenth century, in particular, colonialism shaped the profile of numerous collections (Barringer and Flynn 1997, Penny 2002, Thomas 1991). As a consequence of the growing dominance of social Darwinism in the late-nineteenth century, museum displays became ever stronger instruments of the dominant ideologies – such as evolutionism, with its clear racist overtones (Bennett 2004, Coombes 1994, Shelton 2000, Tythacott 2011a). Ethnographic museums, in particular, have been the keepers of other people's cultures, imposing their own classifications and interpretations onto objects from different peoples around the world: indigenous groups almost never had a voice. Artefacts were even removed from communities in the late-nineteenth century–early-twentieth century on the basis that their cultures would become extinct, as a result of the 'inevitable' march of Westernization. But certain cultures are still thriving and want their objects back.

While in some cases museums were imposing their own interpretation onto objects collected from around the world, in others they were acquiring antiquities, whose interpretation has been severely limited due to poor documentation or complete lack of their archaeological context. The Grand Tour, antiquarianism and related systematic purchases in the antiquarian market and excavations in Greece, Italy, Turkey and elsewhere resulted in the formation of vast archaeological collections by scholars and collectors, which in turn contributed to the building of large museum collections, mainly in Europe and the USA (Dyson 2006). Such acquisitions were often of objects with no provenance or no or little archaeological context, which is often seen as a sign of possible looting. Authors, such as Renfrew, have explicitly argued that looting has both destroyed the archaeological record and served the 'lucrative market in illicit artefacts' (Renfrew 2000: 9).

Nevertheless, the idiosyncratic or systematic collection of Greco-Roman, Egyptian and Asian antiquities by large national museums contributed to the construction of different notions of value (cultural, aesthetic and economic) around the objects, the cultures represented by them and the hosting countries. This not only shaped the development of the Western cultural perspectives (Chippindale, Gill, Salter and Hamilton 2001, Whitehead 2009) but also, either directly or indirectly, fed the emergence or maturity of cultural and national consciousness in countries of origin. Indeed, the rise of the nation states and the process of the nationalization of cultural heritage in the nineteenth and twentieth centuries led to an increasing awareness and attention to the role of archaeological sites and objects (including museum objects) in constructing or affirming notions of cultural and national identity (Hobsbawm and Ranger 1983, Diaz-Andreu and Campion 1996, Meskell 1998). This coincided with the ongoing acquisition of archaeological objects, on behalf of collectors and museums in other countries, and authors have argued that this collecting activity was seen, even at the time, as 'plundering' or 'vandalism'

(Tolias 2008 stresses that in relation to Greece) or as undermining the status and pride of the hosting country (as in the case of the Ottoman Empire; Dyson 2006). The publication of the *On the Elgin Marbles* by Miliarakis in 1888 (Miliarakis, 1994) and *Lord Elgin and Earlier Antiquarian Invaders in Greece, 1440-1837. A Historical and Archaeological Treatise*, by Ioannis Gennadios in 1930, for example, indicate this cross-over between the acquisition of antiquities and an effort to introduce them into the contemporary political discourse in Greece.

The collecting and acquiring of objects via systematic excavations and the antiquarian market continued till the mid-twentieth century. The late-twentieth century 'saw a withdrawal as the concerns of the market and of the museums were seen to diverge'; the prices of antiquities in the market were much higher than before and national policies against expatriation of antiquities were put in place (Chippindale, Gill, Salter and Hamilton 2001: 22). This was also the time that more systematic efforts were made to set up international agreements on the movement of cultural property, with the 1970 UNESCO Convention on the Means of Prohibiting and Preventing the Illicit Import, Export and Transfer of Ownership of Cultural Property being the most notable. The UNESCO convention offered both governments and, subsequently, museums a framework for dealing with objects with undocumented provenance (although its ratification by countries in the receiving end of antiquities has taken a long period of time; the UK ratified it in 2002 and Germany in 2007). Also, the establishment and development in the nineteenth and twentieth century of (often national) museums in countries where antiquities originated, were further seen and used as a political and professional opportunity to articulate the value and relevance of both within and outside the country's borders antiquities (Binns 1997, Allen 2010). Accordingly, both the willingness and ability of these countries to care for museum objects offered the backdrop of the intensifying repatriation claims.

From the 1980s on in particular, indigenous peoples and nation states have begun to demand a greater voice in how their material culture is presented in museums (Simpson 1996, Turnbull and Pickering 2010). They began to challenge the right of these institutions to tell the stories of their cultures, to display and store collections which belonged to their ancestors. Such demands for self-representation have been more pronounced in 'White Settler' societies – the US, Canada, Australia and New Zealand – as these countries confront the legacy of internal colonizations. But marginalized groups are to be found within many other nations, and they too have become increasingly vocal. Chapter 4 details the way in which the Sámi in Scandinavia have suffered from being characterized as 'primitive' and 'inferior' in the past, but are now demanding an active role in the representation of their material culture in museums. Van der Maas's chapter discussed how in the nineteenth century, the people of Urk (in what is now the Netherlands), were absorbed into evolutionary debates and conceptualized as the original 'Dutch'. In the twenty-first century, the return of their objects from museums is part of the process of reconciliation.

Recent debates have seen something of a change in the power relationships between museums and source communities – from museums representing indigenous communities to dialogue, listening and the incorporation of voices (Karp and Lavine 1991, Peers and Brown 2003, Simpson 1996, Sleeper-Smith 2009). Some museums have become what James Clifford called 'contact zones' (1997). The traditional aloofness and neutrality of museums has been challenged by previously ignored communities; questions of power and authority, and about who has the right to represent whom, have come to the fore (Kreps 2003: 2). Ethical questions are increasingly voiced – who are the rightful custodians of objects, and who has the right of ownership. The new museology, as Kreps notes, has been particularly concerned with issues of identity, communities and the politics of control over cultural heritage (Kreps 2003: 10). Museums increasingly embody, and not merely reflect, societal values and concerns (Sandell 2002). Many have become more inclusive, seeking out the views of communities in relation to display and storage. Museums and indigenous peoples may work together to redress past imbalances, using collections as a resource for promoting cross-cultural awareness. Besterman (Chapter 2) argues that museums, as the keepers of material cultural heritage, are in a unique position to heal wounds, 'make it good'. He is clear that moral authority for interpreting collections should lie not with museums, but with the 'inheritors of dispossession'. McCarthy too asserts that in New Zealand the needs of the tribal groups are more important than those of the museums (Chapter 5). Concepts of custodianship and community consultation, rather than possession, now tend to mark the language of many.

However, museums seem less able to initiate and sustain such consultations when it comes to cultural heritage that is attached to perceptions and constructions of national identity. In these cases, some museums' rhetoric of a shared authority for interpreting collections and building bridges between cultures tends to be overruled by countries' continuing efforts to push the repatriation agenda. Media have reported for example on an 'aggressive' (and in cases successful) campaign by Turkey to repatriate antiquities currently in museums in Europe and the United States (Bilefsky 2012). It is interesting that campaigns such as Turkey's seem to be part of an organized and broader effort to nurture a national, regional and international interest in the cultural heritage of these countries. In many ways, it seems also an effort to 'regenerate' their cultural identities, primarily in the eyes and minds of national audiences. The intensity and 'aggressiveness' of these requests is also notable and clear by the 'ultimata' that museums are presented with, which are often bypassing or ignoring the UNESCO Convention – at least according to the museums 'under siege' (Bilefsky 2012). At the same time, the rhetoric utilized to support those claims seem not to have moved on from the ownership issue – if anything, it seems that it has gained new momentum: The 'General Principles' agreed by 22 countries at the first *Conference on International Cooperation for the Protection and Repatriation of Cultural Heritage* (Egypt 2010), state that 'cultural heritage belongs to the country of origin, and is essential to its culture, development and identity' and 'ownership of cultural heritage by

the country of origin does not expire, nor does it face prescription' (http://www. sca-egypt.org/eng/pdfs/RST_ICHC_SA%20Communique_2010-08-20.pdf). Or as Turkey's director-general of cultural heritage and museums, Murat Suslu put it, 'We only want back what is rightfully ours' (Bilefsky 2012).

As a result, museums find themselves often trying to develop alternative repatriation practices and simultaneously being under the pressure of material repatriation requests and campaigns. This increasingly points to the argument that museums need to reflect on the nature and the impact of the unequal relationship that their custodianship and ownership of objects have created. It also suggests that 'one size fits all' approach to the museum perceptions and practices of repatriation may not be the way forward in most cases.

Museums are the traditional keepers of material cultural, and restitution thus goes against their basic desire to keep objects in perpetuity. Over the past 30 years, however, we have seen substantial changes in the *modus operandi* of many museums. The major period of the expansion of North American and North European collections was in the late-nineteenth to early-twentieth century, which, as we have seen, coincided with European power relations and colonialism. Since the mid-twentieth century and decolonization, acquisitions in general, and ethnographic and archaeological acquisitions in particular, have greatly diminished. This is not merely due to fewer opportunities for collecting, and increased international regulation, but also reflects reduced museum budgets. Furthermore, many museums, especially in the UK, have shifted their priorities from being predominantly concerned to acquire collections and preserve objects, to engaging with wider agendas of access, inclusion and social responsibility (Hooper-Greenhill 1997, Sandell 2002). Museums are, also, increasingly asking if they need to keep everything (Merriman 2008), although it is interesting that the discussion and increasing practice of disposals has not been clearly linked to repatriation. For example, the UK Museums Association's *Disposal Toolkit. Guidelines for Museums* states that 'The guidelines do not cover in detail disposal through return or repatriation of items. Museums with collections that may be the subject of requests for repatriation or return are advised to create separate policies and procedures to address this' (http://www.museumsassociation.org/download? id=15852). However, the discussion around disposal, given that it emphasizes the benefit for the museum, might offer museums an additional route, to justify to themselves and their communities, a more open approach to discussing repatriation claims that are traditionally seen as a 'threat' by museums.

In recent years we have also seen changes in the approaches of those traditional guardians of museum collections, the curators. A number of papers in this volume question the undisputed authority of these, and other, official experts. Curatorship was traditionally understood as an expert practice, often validated by academic credentials and by the status of the institution they worked in. The curator was the key interpretative authority for collections. Over past decades, the singular voice of curatorship has been challenged, and it is now increasingly the case that rather than exercising absolute authority over objects in their care, curators should

operate as facilitators, opening up access, dialogue and debate. In relation to this, Peers and Brown talk of a new 'curatorial praxis' (2003: 2).

This has coincided with an increased professionalization of museum practice that has created different frameworks of valuing collections within the museum. Audience engagement and learning teams in museums have been shaping the museum's offer and approach to collections and so have contributed to a broader appreciation and articulation of the role and value of museum objects. Visitors and audiences themselves have also become more aware of both the history of collections and the repatriation debates, as examples such as the return of the Ghost Dance Shirt by Glasgow Museums have shown (O'Neill 2006). The amount of relevant information online has led to a better informed 'public' and has also prompted museums to be more forthcoming and open about their collections' biographies, which has allowed them to talk about objects in different interpretive contexts.

Indeed, several contributors to this volume argue that museums should move beyond Western conceptualizations of objects. Curtis describes how the Marischal Museum in Aberdeen tried to avoid Western categories of material culture, for example 'human remains' or 'sacred objects', in their decision to return a split-horn headdress to the Horn Society of the Kanai First Nation of southern Alberta. Curtis talks of the importance of recognizing novel ways of thinking: decisions should not be based on Western frameworks of value, he asserts, but on the recognition of other systems of belief. Bienkowski's chapter too challenges Western museological categories and practices, noting how Western prejudices are manifest when confronted by restitution claims. Robbins highlights how the Native American Graves Protection and Repatriation Act (NAGPRA) of 1990 forced museums in the US to rethink their collections and to enter into a dialogue with tribal groups based on very different ideas of the significance of objects.

There is a growing literature on Non-Western views of objects, and material culture has been reconceptualized as more 'active' (Gell 1998), part of social networks (Latour 2005) and 'polysemic' (Hooper-Greenhill 2000). What are considered merely 'things' in the West[5] may have deep emotional and symbolic meanings to source communities – some may be regarded as animate beings (Clavir 2002, Henare 2005, Kreps 2003, Peers and Brown 2003, Tythacott 2011b). In this volume, Fouseki remarks how the Parthenon Marbles have been characterized by the Greeks as 'animated', 'imprisoned' at the British Museum, 'nostalgic' for their homeland. Matthews (Chapter 8) theorizes her discussion of the life of an Ojibwe drum in relation to anthropological ideas of agency. One of the key problems with restitution arguments, she notes, is they ignore gulfs between Western legal notions of ownership and indigenous concepts of animacy. In order to contemplate the need for repatriation, she contends, Western institutions need to cultivate a dual perspective.

5 In this volume, Van der Maas (Chapter 9) argues that, as Western science interpreted human remains as merely 'artefacts', collection and display in museums was legitimate.

Museums have tended to use the law as a way of supporting retentionist arguments, but many of the authors assert the need to move beyond legal frameworks. Bienkowski and Besterman, in particular, call for a reconsideration of the issue of ownership: Bienkowksi describes this as a 'fetish', and a central problem in restitution debates. Harlin and Olli argue that restitution in relation to Sámi material culture should not focus on legal ownership, but on the responsibility for preservation for future generations. In his discussion of current practice in New Zealand museums, McCarthy advocates a move beyond 'endless legal disputes'. Curtis highlights how legal title was not important in the repatriation of an object from the University of Aberdeen, rather recognition of its significance to the people today was key. Fouseki suggests that for Greek people the debate around the return of the Parthenon Marbles is not so much concerned with legal ownership, but rather ethics and social justice.

Restitution is not only about the loss of objects for museums, but can be about important gains in terms of cultural relationships and knowledge, a concept that is noted in many chapters. Besterman highlights how restitution in museums can take different forms – only one of which is the actual return of objects. Manchester Museum's 'Collective Conversations', for example, is considered a form of restitution, 'in which narrative control is re-explored, challenged, widened and shared'. Restitution, Besterman argues, enriches the museum, and is an 'inclusive process of engagement with the citizen'. Curtis too believes restitution benefits museums in terms of new ways of looking at, and appreciating, material culture: it enables museums to reconsider their activities and categories, and can have a 'profound and long-lasting impact on everyone involved'. For Te Papa in New Zealand, as McCarthy notes, long term relationships established after restitution have been key. Restitution may even allow museums to renew themselves, and be part of an 'important step in a longer process of reconciliation'. NAGPRA has been a means by which museums have established relationships with tribal groups. Museums in the US, as Robbins acknowledges, are now places which engage with indigenous communities. Knowledge, relationships, understanding between cultures, as a result of restitution, can thus be often more meaningful to museums than the possession of objects. Even in cases where the issue of return remains strong for both the host and the claimee, the process of negotiation and exchange of views can lead to fruitful collaborations, such as in the case of the 'Restoring the Acropolis of Athens' Study Day at the British Museum with the collaboration of the Acropolis Restoration Service (October 2010), which led to a book that was edited by staff of the two organizations (Bouras, Ioannidou and Jenkins 2011).

Importantly, the challenges and problems of museum practice in relation to restitution are addressed in this volume. Bienkowski admits that his proposal for democratic processes is neither simple nor easy. Curtis laments the inherent power relations embedded within the restitution process, where museums still act as 'judge' and 'jury'. He also notes as problematic the practical process whereby a community constructs its 'case', and articulates it to the museum.

It can be invidious for certain groups to reveal restricted or secret knowledge to the uninitiated. Robbins concurs with this in relation to NAGPRA, where tribal communities in the US have to provide evidence – and prove – that they are entitled to an item in a museum. NAGPRA, she argues, demands that tribal groups are forced into 'legal boxes', and have to respond to concepts that are not culturally relevant. Furthermore, NAGPRA only covers certain types of things and – like Bienkowski and Curtis – Robbins notes that these are predominantly Western. As a result, museums and tribes do not always agree on what should be repatriated. Van der Maas presents a case of human remains repatriation where the Ethical Committee of The Netherlands Museums Association functioned as the judge between the claimant and the museum. There is also the issue of competing claims and of the rights of different communities: who has the right to request objects, who should own them, and where should they ultimately belong? It can be difficult for museums to do the 'right thing': should they passively respond to requests or actively identify objects for repatriation? Matthews's chapter indicates an over-keenness for some museums to return objects without all the proper checks in place. In turn, Besterman stresses that the law might stand on the way of morally justified restitutions, conditioning thus the range of options that museums have. The same is true in countries where no relevant legislation exists, as Harlin and Olli point out with reference to Scandinavian countries. Harlin and Olli also stress the collection management, conservation and storage challenges that Sámi museums receiving repatriated objects would need to address, and they call for the appropriate support to be put in place. In such cases, repatriation discussions can lead towards the development of broader practices and relevant skills and improvement of facilities in the host museum. Fouseki, through her detailed analysis of the *repatriation* vs the *reunification* arguments of the Parthenon Marbles, indirectly points out the nuanced meanings that these terms and their practices might have for different people and communities and the need of museum professionals to be more aware of these contexts and content of interpretation.

It should be borne in mind that by far the majority of museum collections are not subject to demands for restitution. The notion that changes to restitution laws or museum practices could 'open the floodgates', and that everything would disappear, has been proven unfounded (as in the case of Māori objects, as noted in McCarthy's chapter in this volume). Unlike in the US, UK museums are not bound by legislation[6] and each case is assessed on its own merits. Nevertheless, requests for restitution around the world have increased over past decades, and are now an important consideration. In countries such as US, Canada, New Zealand and Australia, restitution has become an integral part of museum work. Campbell notes how returning human remains is now a routine practice in Scottish museums (see Curtis, Chapter 6). Restitution has also been re-conceptualized as a positive, rather than a negative, process. O'Neill argues that museums should see it 'not as a

6　Except for the Human Tissue Act 2004, http://www.legislation.gov.uk/ukpga/2004/30/contents.

problem which they should avoid'. On the contrary, it is a 'welcome and important part of their role' (O'Neill 2006: 126, cited in Curtis, Chapter 6). McCarthy concurs that returning objects is not necessarily a threat, but an opportunity to reconsider professional practice and develop partnerships. Besterman looks forward to a time when restitution is 'part of the process of constructive engagement between museums and their diverse communities' and has 'ceased to be controversial'. For him, it is time to radically reconsider UK government criteria, changing the rationale from 'why' to 'why not?'

* * *

The papers in this volume attest to the substantial changes that have taken place in museums over past decades. *Museums and Restitution* arises from the views and practices of museum professionals and researchers, who participated in a conference held at the Manchester Museum in July 2010, which was attended by over 100 delegates. The volume divides into three parts. Part I: *Overviews* includes chapters from Besterman and Bienkowski, who provide analyses of the shifting role of museums in relation to the restitution of cultural property. Besterman's chapter criticizes museums which divorce the (often dubious) ethics of acquisition in earlier centuries from the claims of dispossessed people's today. He argues that the 2002 'Declaration of the Importance and Value of Universal Museums' was a way to distance museums from past injustices and moral obligations – thus creating a defence against restitution. Besterman provides an overview of key political and ethical issues in the acquisition and retention of objects in some Euro-American museums, arguing that their collections are inherently political, not only in terms of historic formation, but in relation to ongoing decisions about acquisition, collaboration and display. He documents how art, and its display in prestigious galleries, becomes embroiled in political and ethical issues, often overlooked by staff. He calls for museums to be spaces for the open discussion of ideas, rather than authoritarian institutions predicated upon expertise and rights of ownership. Above all, Besterman proposes a framework of 'social and political accountability' under the term 'cultural equity'.

Bienkowski's chapter is concerned with 'authorized' and 'alternative voices' in restitution debates. He questions who chooses which values will dominate, who is a 'legitimate' claimant, who sets the criteria, and which views count. The final determination, he notes, is usually in the hands of the museum. It is problematic for communities requesting the return of their objects who must 'tick boxes' in order to establish their claims. Decision-making processes, he asserts, are overly bureaucratic and adversarial, overall power being allocated to authoritative experts. Bienkowski advocates instead a 'fairer, more inclusive, non-adversarial process'. He conceptualizes 'museums as loci of deliberative democracy', which ideally should engage all parties in the decision-making process.

Part II focuses on restitution in museums in specific parts of the world – Norway, New Zealand, Scotland and the USA – with chapters contributed by

museum professionals. Harlin and Olli discuss the repatriation of material culture to the Sámi people, a group indigenous to Norway, Sweden, Finland and the Russian Kola Peninsula. Harlin and Olli have both worked in Norwegian museums and have an intimate knowledge not just of the representation and care of Sámi material culture, but of Norwegian museological practice. Importantly, their chapter highlights some of the practical difficulties Norwegian Sámi museums face in terms of conservation and storage of restituted material, especially the objects which have been treated with pesticides. Like Bienkowski and Besterman, Harlin and Olli emphasize the importance of dialogue between peoples. 'The right to administer one's own heritage', they conclude, 'is the right to one's own past.' McCarthy documents case studies and recent initiatives relating to repatriation in New Zealand museums. Here, over the past 30 years there has been a transformation – a 'domestic decolonization' – which had an enormous impact on museum practice. His chapter discusses two high profile examples of restitution in the 1990s, then focuses on a case study of a meeting house – *Te Hau ki Tūranga* – at the Museum of New Zealand Te Papa. He examines practical steps involved in restitution and succeeds in exposing the complexities and the range of opinions.

Curtis's chapter focuses on repatriation in museums in Scotland – human remains, sacred objects, Scottish identity and the development of procedures. The best known example was the return of the Ghost Dance Shirt to the Wounded Knee Survivor's Association by Glasgow Museums in 1999, widely considered a model of good practice. There is no legislation in Scotland compelling museums to make decisions, and as a result most are based on interpretations of what is and is not ethical. In the case of a split-horn headdress to the Horn Society of the Kanai First Nation of southern Alberta, Canada, in 2003, the University of Aberdeen returned this with no conditions attached. Curtis stresses the positive effects of repatriation on museums – for example, a replica Ghost Dance Shirt was received by Glasgow Museums. He also notes the increased understanding which the process enables of museum collections and also, importantly, the development of relationships with source communities. Robbins provides a detailed discussion of both the significance and limitations of the landmark US legislation, the Native American Graves Protection and Repatriation Act (NAGPRA) of 1990. As a result of this, museums with Native American objects were obliged to contact relevant tribes, present them with summaries of collections, return particular categories of objects, open up access to their archives, and develop collaborative projects with tribal groups. This resulted in the repatriation of tens of thousands of human remains, hundreds of thousands of funerary objects and thousands of important cultural items. Despite its positive effects, Robbins highlights that restitution is still a complex, costly and time-consuming process: NAGPRA has been criticized for either failing to do too much or too little, and for giving too much authority to museums. Yet, overall, NAGPRA, in Robbin's view, has an enormous positive impact, bringing about a 'sea change' in museum practice in the US.

Part III: *Reflections on Returns* explores examples of the (real or projected) repatriation of objects from museum collections – the return of Ojibwe objects to

the 'wrong' community in 1999, the restitution of a group of skulls to the island of Urk in 2010, the peregrinations of works by Malevich across museums in Europe and North America, and the perceptions of the possible repatriation, or reunification, of the Parthenon Marbles to Greece. Chapters comprise case studies of the lives of collections, their movements from one site to the next, and their changing meanings over the course of time. All four chapters raise questions about where things rightfully belong – and who should own them. Matthews reflects on the wrongful return of Ojibwe objects in 1999, when over 80 ceremonial artefacts from the University of Winnipeg anthropology museum were given to a cultural revitalization group who had no links with the source community. Her chapter focuses on a water drum, originally owned by a renowned medicine man, Naamiwan, from the community of Pauingassi. In the winter of 1969-70, the drum, along with 234 other artefacts were purchased by a professor for the University of Winnipeg, who assured the community they would be safe at the museum. In 1999, however, 80 objects were given to the spiritual leader of the Three Fires Midewiwin Society, a US-based Ojibwe cultural revitalization group. The justification was that Paungassi elders were thought to be de-cultured, 'white Christians', and not engaging in 'traditional' cultural practices. The Three Fires leader realized he was an inappropriate recipient and passed on the drum to Naamiwan's grandson. Matthews's chapter demonstrates how fraught is the issue of identifying authentic claimants.

Van der Maas discusses the repatriation of a set of human skulls from Urk formerly in the collections of the University Museum of Utrecht. Three skulls were stolen from a grave on the island of Urk in the 1870s, in order to represent ideas of physical anthropology circulating at the time – Urkers were considered to be original, 'authentic', Dutch. When the Committee Skulls of Urk, which was formed in 2007, requested the return of the skulls, the Ethical Committee of the Netherlands Museums Association[7] agreed – and the skulls were returned to Urk in 2010, with a ritual performance and a private funeral. Van der Maas frames the shifts in practice and perceptions of human remains in relation to the concept of the 'return to things' in academia, where objects have 'performative qualities and participate in creating human identity'. Katenhusen documents the journeys of artistic creations by Kazimir Malevich which had been removed from a vault in the State Museum of Hanover, where he had deposited them before returning to Russia in the late 1920s. His dying wish, in 1935, was that the works be returned to his family. Over time, the pieces ended up in different institutions – the Busch-Reisinger Museum at Harvard University, the Museum of Modern Art, New York, and the Stedelijk Museum in Amsterdam. Katenhusen's chapter highlights shifts in relation to ownership and the possession of works of art over the past 80 or so years, and the very different ways in which institutions react to restitution requests.

7 This developed a Code of Ethics for all museums in 2007, which means that 'in principle, human remains may only be exhibited for educational, scientific or research purposes'.

Fouseki's chapter is devoted to claims for the reunification or repatriation of the Parthenon Marbles to Greece, providing an analysis from 100 semi-structured interviews with Athenian residents in 2010. She compares two discourses: one of 'reunification', which stresses re-piecing together the surviving parts of the architectural decoration of the Parthenon and which is 'academically-led', with experts and national authorities attaching tangible values associated with aesthetics, materiality and the monumentality of the Parthenon temple; and the more abstract discourse of 'repatriation', which is concerned with the return of the marbles more broadly to their home or *topos*. Fouseki argues that for most Greeks the issue of restitution is emotional, and about social justice and identity, not about the sculptures as works of art. Fouseki asserts that claims for the restitution of the Parthenon Marbles should, thus, include 'public' as well 'expert' opinions.

The restitution of the Parthenon Marbles is certainly a topical issue. An online poll, which ran on the UK Museums Association's website in June 2012, indicated that 73 per cent of participants agreed to the return; 27 per cent said 'no'.[8] The same month, a debate with the motion 'Send them back. The Parthenon Marbles to be returned to Athens', hosted by Intelligence Squared in London ended with a majority for the motion of of 384 to 125 (Timpson 2012). The Parthenon Marbles are the *cause célèbre* of the growing discourse on museum restitution – and here, surprisingly, public opinion now runs ahead of museum practice. Many authors in this volume argue that museums need both to move beyond their present stances and critically reflect on the value, benefits and challenges of their developing perceptions and practices of restitution. It is hoped that this volume will add to the discussion, as well as demonstrate the richness of approaches and practices evident in a variety of museums around the world.

Bibliography

Allen, R. 2010. Heritage and nationalism, in *Understanding the Politics of Heritage*, edited by R. Harrison. Manchester and New York: Manchester University Press, 197-233.

Barringer, T. and Flynn, T. (eds) 1997. *Colonialism and the Object: Empire, Material Culture and the Museum.* London and New York: Routledge.

Bennett, T. 2004. *Pasts Beyond Memory: Evolution, Museums, Colonialism.* London: Routledge.

Bilefsky, D. 2012. Seeking Return of Art, Turkey Jolts Museums. *New York Times* [Online 30 September] Available at: http://www.nytimes.com/2012/10/01/arts/design/turkeys-efforts-to-repatriate-art-alarm-museums.html [accessed: 15 November 2013].

8 Museums Journal, July/August 2012: 7.

Binns, G. 1997. Restoration and the New Museum, in *The Elgin Marbles. Should They be Returned to Greece?*, edited by C. Hitchens. London and New York: Verso, 93-108.

Bouras, C., Ioannidou, M. and Jenkins, I. 2011. *Acropolis Restored*. London: British Museum Press.

Chippindale, C., Gill, D.W.J., Salter, E. and Hamilton, C. 2001. Collecting the classical world: first steps in a quantitative history, in *International Journal of Cultural Property* 10(1): 1–31.

Clavir, M. 2002. *Preserving what is Valued: Museums, Conservation and First Nations*. Vancouver: University of British Columbia Press.

Clifford, J. 1997. Museums as Contact Zones, in *Routes: Travel and Translation in the Late Twentieth Century*, edited by J. Clifford. Cambridge, Massachusetts and London: Harvard University Press, 188–219.

Coombes, A. 1994. *Reinventing Africa: Museums, Material Culture and Popular Imagination*. New Haven and London: Yale University Press.

Cuno, J. 2008. *Who Owns Antiquity?: Museums and the Battle over our Ancient Heritage*. Princeton and Oxford: Princeton University Press.

Diaz-Andreu, M. and Champion T. (eds) 1996. *Nationalism and Archaeology in Europe*. London: Westview Press.

Dubin, S.C. 1999. *Displays of Power: Controversy in the American Museum from the Enola Gay to Sensation*. New York University Press: New York.

Dyson, S.L. 2006. *In Pursuit of Ancient Pasts. A History of Classical Archaeology in the Nineteenth and Twentieth Centuries*. New Haven and London: Yale University Press.

Gell, A. 1998. *Art and Agency: An Anthropological Theory*. Oxford: Clarendon Press.

Gennadios, I. 1930. *Lord Elgin and Earlier Antiquarian Invaders in Greece, 1440-1837. A Historical and Archaeological Treatise [O Lordos Elgin kai oi pro autou ana tin Ellada kai tas Athinas idios archaeologisantas epidromeis 1440-1837. Istoriki kai archaeologiki pragmateia]*. Athens: Estia.

Gosden, C. and Knowles, C. 2001. *Collecting Colonialism: Material Culture and Colonial Change*. Oxford and New York: Berg.

Greenfield, J. 1989. *The Return of Cultural Treasures*. 1st Edition. Cambridge: Cambridge University Press.

Hawass, Z. Blog. 2010. Press Release – Egyptian/Chinese Agreement for Cultural Repatriation. [Online] Available at: http://www.drhawass.com/blog/press-release-egyptianchinese-agreement-cultural-repatriation [accessed: 15 November 2013].

Henare, A. 2005. *Museums, Anthropology and Imperial Exchange*. Cambridge: Cambridge University Press.

Hobsbawm, E. and Ranger, T. (eds) 1983. *The Invention of Tradition*. Cambridge: Cambridge University Press.

Hooper-Greenhill, E. 1992. *Museums and the Shaping of Knowledge*. London and New York: Routledge.

Hooper-Greenhill, E. 1997. *Cultural Diversity: Developing Museum Audiences in Britain*. London and Washington: Leicester University Press.

Hooper-Greenhill, E. 2000. *Museums and the Interpretation of Visual Culture*. London and New York: Routledge.

Impey, O. and MacGregor, A. (eds) 1985. *The Origins of Museums: The Cabinet of Curiosities in Sixteenth- and Seventeenth-Century Europe*. Oxford: Clarendon.

Kaplan, F. (ed.) 1994. *Museums and the Making of Ourselves: The Role of Objects in National Identity*. Leicester University Press: London and New York.

Karp, I. and Lavine, S.D. (eds) 1991. *Exhibiting Cultures: the Poetics and Politics of Museum Display*. Smithsonian Institution: Washington DC.

Knell, S., Aronsson, P., Amundsen, A.B., Barnes, A., Burch, S., Carter, J., Gosselin, V., Hughes, S., Kirwan, A. (eds) 2011. *National Museums: New Studies from around the World*. London and New York: Routledge.

Kreps, C. 2003. *Liberating Culture: Cross-cultural Perspectives on Museums, Curation and Heritage Preservation*. London and New York: Routledge.

Latour, B. 2005. *Reassembling the Social – An Introduction to Actor-Network-Theory*. Oxford: Oxford University Press.

Macdonald, S. 1998. Exhibitions of power and powers of exhibition: an introduction to the politics of display, in *The Politics of Display: Museums, Science, Culture*, edited by S. Macdonald. Routledge: London and New York, 1-21.

Macdonald, S. and Fyfe, G. (eds) 1996. *Theorizing Museums: Representing Identity and Diversity in a Changing World*. Oxford: Blackwell Publishers.

MacGregor, A. 2007. *Curiosity and Enlightenment: Collectors and Collections from the Sixteenth to the Nineteenth Century*. New Haven and London: Yale University Press.

McCarthy, C. 2007. *Exhibiting Maori: A History of Colonial Cultures of Display*. Oxford and New York: Berg.

Merriman, N. 2008. Museum collecting and sustainability, in *Museum Management & Curatorship*, 17(1): 3-21.

Merryman, J. (ed.) 2006. *Imperialism, Art and Restitution*. Cambridge: Cambridge University Press.

Meskell, L. 1998. *Archaeology Under Fire: Nationalism, Politics, and Heritage in the Eastern Mediterranean and Middle East*. London and New York: Routlege.

Miliarakis, A. 1994. *On the Elgin Marbles [Peri ton Elgineion Marmaron]*. 1st Edition 1888. Athens: Koultoura.

O'Neill, M. 2006. Repatriation and its Discontents: The Glasgow Experience, in *Who Owns Objects: The Ethics and Politics of Collecting Cultural Artefacts*, edited by E. Robson, L. Treadwell and C. Gosden. Proceedings of the First St Cross-All Souls Seminar Series and Workshop, Oxford, October-December 2004. Oxford: Oxbow Books, 105-28.

Peers, L. and Brown, A. 2003. *Museums and Source Communities: a Routledge Reader*. London and New York: Routledge.

Penny, G. 2002. *Objects of Culture: Ethnology and Ethnographic Museums in Imperial Germany.* London and Chapel Hill: The University of North Carolina Press.

Renfrew, C. 2000. *Loot, Legitimacy and Ownership: The Ethical Crisis in Archaeology.* London: Duckworth Publishers.

Sandell, R. (ed.) 2002. *Museums, Society, Inequality.* London and New York: Routledge.

Shelton, A. 2000. Museum Ethnography: An Imperial Science, in *Cultural Encounters: Representing 'Otherness'*, edited by E. Hallam and B. Street. London and New York: Routledge, 155–93.

Sleeper-Smith, S. 2009. *Contesting Knowledge: Museums and Indigenous Perspectives.* Lincoln and London: University of Nebraska.

Supreme Council of Antiquities, Egypt. 2010. *Conference on International Cooperation for the Protection and Repatriation of Cultural Heritage.* [Online] Available at: http://www.sca-egypt.org/eng/RST_ICHC.htm [accessed: 15 November 2013].

Thomas, N. 1991. *Entangled Objects: Exchange, Material Culture and Colonialism in the Pacific.* Cambridge, Massachusetts and London: Harvard University Press.

Timpson, T. 2012. Stephen Fry's Parthenon Marbles plea backed in debate vote, *BBC News* [Online, 11 June] Available at: http://www.bbc.co.uk/news/uk-18373312 [accessed: 15 November 2013].

Tolias, G. 2008. National heritage and Greek revival: Ioannis Gennadios on the expatriated antiquities, in *A Singular Antiquity. Archaeology and Hellenic Identity in Twentieth-Century Greece*, edited by D. Damaskos and D. Plantzos. Athens: Benaki Museum, 55-65.

Turnbull, P. and Pickering, M. 2010. *The Long Way Home: The Meaning and Values of Repatriation.* Oxford: Berghahn.

Tythacott, L. 2010. The Politics of Representation in Museums, in *Encyclopedia of Library and Information Sciences*, edited by M.J. Bates and M.N. Maack. Third Edition, 1: 1. London: CRC Press (Taylor & Francis Group), 6, 4230-41.

Tythacott, L. 2011a. Race on Display: The 'Melanian', 'Mongolian' and 'Caucasian' Galleries at Liverpool Museum (1896-1929), in *Early Popular Visual Culture*, 9(2) May. London and New York: Routledge, 131-46.

Tythacott, L. 2011b. *The Lives of Chinese Objects: Buddhism, Imperialism and Display.* Oxford and New York: Berghahn.

Vrdoljak, A.F. 2006. *International Law, Museums and the Return of Cultural Osbjects.* Cambridge: Cambridge University Press.

Whitehead, C. 2009. *Museums and the Construction of Disciplines. Art and Archaeology in Nineteenth-Century Britain.* London: Duckworth.

PART I
Overviews

Chapter 2

Crossing the Line:
Restitution and Cultural Equity

Tristram Besterman

On a warm spring day in 2009, an unusual flag flapped lazily in the breeze above the throng of tourists ambling along London's South Bank. Its geometry was reassuringly familiar but the colours created an unsettling dissonance, as national histories collided in a wilful cultural confusion. Made in 1996 by the artist, Mark Wallinger, *Oxymoron* rebrands the flag of the United Kingdom in the colours of the Irish tricolour (and Côte d'Ivoire). In the artist's looking-glass world, Wallinger applies the logic of the visible spectrum, substituting orange and green for their primary complementary counterparts of blue and red. With a flick of the artist's brush, an iconic motif is appropriated from two separate nations and is transformed into something that is at once emblematic of both and of neither, by the simple device of conjoining opposites. Through the appropriation of that defining symbol, the national flag, a line is crossed, a border blurred and our understanding of national identity and its representation is challenged. Its location in so public a place, in sight of the Houses of Parliament, left this author pondering how many other nations would have tolerated such a work in the heart of their capital city. In London, if it was noticed at all, it probably attracted little more than a bemused shrug.

An oxymoron, according to the Oxford Dictionary, is 'a figure of speech with pointed conjunction of seemingly contradictory expressions' (Sykes 1976: 789). This is a rhetorical device used to great effect by Shakespeare, who, no doubt anticipating the restitutional tug of love, has Juliette murmuring in her lover's ear, 'parting is such sweet sorrow' (Sisson 1960: 887). Loss and enrichment, violation and remedy, dispossession and empowerment, the rational and the numinous: these are just a few of the uneasy bedfellows of cultural restitution. When considering the voices of the dispossessed (a term that applies as much to the holding museum as the claimant), we might also call to mind the witches of Macbeth, 'Fair is foul, and foul is fair' / Hover through the fog and filthy air' (Sisson 1960: 970). In matters of restitution, the rules of engagement are rarely fair, the process is often subject to cries of 'foul!', and the atmosphere, if not actually filthy, is usually fogged with obfuscation. On a more positive note, Shakespeare's 'weird sisters' deliver their ominous prophecies in 'an open place', which, despite the long shadow cast by fiscal austerity, remains, happily, an accurate description of most museums.

Wallinger's playfully subversive flag was hoisted as part of the exhibition *The Russian Linesman*, curated by the artist at the Hayward Gallery in 2009. Football buffs require no explanation of that title. But for those who do not follow the Beautiful Game[1] and who might need reminding, the back-story is illuminating. We must go back to 1966 when England is playing West Germany in the final of the World Cup. The score is two-all. Geoff Hurst powers the ball towards the German goal, where it hits the bar, glancing sharply downwards and ending up outside the goalmouth. The Swiss referee is undecided whether a goal has been scored and defers to the linesman who decisively points his flag in England's direction. The goal is declared and England sails to a triumphant 4-2 victory (http://en.wikipedia. org/wiki/Tofik_Bahramov).

To this day, that goal is contested, German supporters viewing the decision as a mistake, English fans maintaining that the linesman's call was irrelevant to the outcome, since they would have won anyway. By the next day, the linesman, one Tofik Bahramov, who was actually from Azerbaijan, was dubbed by the international press 'The Russian Linesman', demonstrating the media's characteristic disregard for fact in the interests of a good headline (notice how quickly history is fogged). Years later, when asked why he had given the decision against the West German side, it is said that Bahramov replied on his deathbed with the one word, 'Stalingrad'. Born in 1926, Bahramov would have been 16 years old and a citizen of the Soviet Union when that bloodiest of battles was fought between the Red Army and Hitler's invading battalions.

Apocryphal or not, this alleged deathbed admission reminds us that the past has a way of catching up and impacting on the present in ways that are sometimes impossible to foresee. The story of the Russian Linesman (sic), revolving, as it does, around the disputed trajectory of a spherical object, reveals a truth about the power of culture, where the personal, public and political coalesce and the past and the present collide. For history's after-shocks can reverberate across time and space, even after a period of relative quiescence.

In the debate around contested objects, the past plays a role far more powerful in the motives, attitudes and actions of living claimants than some museums allow or understand. The provenance entered in a neat hand in the accession register may refer to an unhealed wound in the claimant community today. For a profession whose business is to understand context, this blindness to contemporary human sensitivity is both disturbing and indefensible. Museums which refuse to 'get it' are not only behaving unprofessionally, but are also, for that very reason, inherently unsustainable. I will give three examples that illustrate the kind of human disconnect still to be found in museums.

The first two also have their origins in the Second World War. The Commission for Looted Art in Europe reports (Webber 2009) conversations with individuals whose relations were murdered by the Nazis. As I have reported elsewhere:

1 Manchester, the venue for the conference, seemed to invite a footballer's parable.

> Their experience of some European museums that possess property looted from their family by the Nazis was of institutions focused exclusively on ownership of objects; whereas behind the object the human stories that mattered to the family were apparently of no concern to the museum. In some cases, acknowledgement of the human suffering was all that was sought, and its denial by the museum created a sense of continued violation, echoing in its absence of empathy the brutal, institutionalised and officially sanctioned attitudes of the era in which the looting occurred. (Besterman 2011: 242)

The second example is more specific. Soon after the end of the war, the British Museum acquired three Old Master drawings, which turn out to have been the property of a Dr Feldmann in Brno, from whom they were stolen by the Gestapo in 1939 (Hirst 2006: 6). This history is not disputed by the Museum. However, to return them to the heirs of Dr Feldmann, who had entered a claim for restitution, would entail a breach of the *British Museum Act* 1963, whose statutory provisions prohibit deaccessioning except under certain conditions prescribed under the Act (UK Parliament 1963: 2). That interpretation of the law was upheld in the High Court in 2005 (Hirst 2006: 1), thereby ruling out the possibility of restitution (though an *ex-gratia* payment was made to the claimants from the public purse).[2]

Since the law unintentionally trumped the moral basis of the claim, it follows that there is a strong moral argument to change the law. Fortunately, we have in the UK parliamentarians who recognize an injustice when they see it, and as a result of a private members' bill, the *Holocaust (Return of Cultural Objects) Act* 2009 (UK Parliament 2009a) entered the statute books. It allows 17 named museums to transfer from their collections objects looted by the Nazis. The conditions are prescribed and the Act's so-called 'sunset clause' ensures that the legislation expires ten years from the day on which it was passed.

When the Bill was debated in Parliament, Baroness Deech made an impassioned speech:

> Art is an ethical issue. Displaying looted art, once it is known to be such, is not just an invasion of privacy and a demonstration that wrongdoers may indeed profit from their crimes; it is also putting on show something that the owners never meant to be seen in such circumstances. It has ceased to be an object of beauty and one that museums can be proud of or use for educational and aesthetic aims. The spectator cannot look at it without seeing the pain and betrayal that led it to be situated there in a national museum. It taints the spectators who knowingly take advantage of the presence of the picture there and it speaks to

2 A further undisclosed sum was paid to the heirs of Arthur Feldmann 'following the discovery that a drawing in its collection had been seized by the Gestapo in March 1939'. This drawing was in addition to the three referred to above and came to light as a result of research by Uri Peled, one of the Feldmann family heirs. In return, 'the drawing will remain in the museum's print and drawings collection' (Steel 2013).

them of loss and war, not creativity and insight. (UK Parliament 2009b: column
908, para. 1)

This echoes the observation made to a UK Parliamentary Select Committee by
Anne Webber, co-chair and co-founder of the Commission for Looted Art in
Europe, who 'questioned whether it was appropriate for looted art to be hanging
on the walls of a museum' (UK Parliament 2000: para. 188).

The fact that Parliament had to intervene to find a statutory remedy to a great
injustice discovered in its national museums is not of itself remarkable. That is,
after all, how parliamentary democracy works. What is disappointing is that the
necessary legislative changes were brought about despite, rather than because of,
the lead given by one of our great national museums (Steel 2008). In a letter to
the Commission for Looted Art in Europe the British Museum explained their
opposition to a change in the law to allow restitution on the grounds that 'we
do not believe that de-accession is the essential remedy to holocaust-spoliation
claims [...] having regard always to our first duty to keep our collection intact, we
feel strongly that it is the right one for us to adopt' (cited in Webber 2009). Note
how, in one sentence, a legalistic defence is elevated to a righteous justification.

The British people as well as those dispossessed by the Nazis were better
served by Parliament than by their national museum, which cannot claim to have
acted in their name. Placing the need to keep the museum's collections intact
above all other considerations was, in this case, not a defence of integrity but its
betrayal. Behaviour that seeks justification within a retentionist dogma is exposed
as an unedifying derogation of ethical leadership.

Norman Rosenthal, former exhibitions secretary at the Royal Academy in
London, exemplifies this kind of wilful deafness to present claims on the past,
despite – or perhaps because of – members of his own family having been victims
of the holocaust. With breathtaking insouciance, he unilaterally declares a kind of
moral amnesty on the wrongs of past dispossession: '[...] history is history and
you can't turn the clock back or make things good through art [...] grandchildren
or distant relations of people who had works of art or property taken by the Nazis
do not now have an inalienable right of ownership [...]' (Rosenthal 2008: para. 2).

Such a cavalier disregard for the claims of the dispossessed has long informed
the Royal Academy's exhibition policy, from the display of George Ortiz's
collection of antiquities ('In Pursuit of the Absolute' in 1994) to Russian art
('From Russia: French and Russian Master Paintings 1870-1925 from Moscow
and St Petersburg' in 2008), to name but two. In the former exhibition, many of the
pieces lacked provenance and had been collected in an era when such material was
almost certainly illicit, purchased in contravention of international Convention
(UNESCO 1970), an activity that fuels the market in looted art. By displaying
such a collection, the Royal Academy provides a spurious cloak of institutional
respectability and an enhanced saleroom value to objects, which, in the absence of
information to the contrary, must be assumed to be looted.

Selective curatorial memory continues to inform the approach taken by some curators to acquisition, in a way that has been dubbed 'volitional amnesia':

> The procedures of the art market have contributed to a situation in which some looted art has found its way into museums and galleries across the world. In the past, research by museums and galleries prior to acquisition has focused on authenticity rather than ownership; provenance in its fullest sense has been neglected or has proved too difficult. In the United States, [...] curators [...] had never asked about the provenance of gifts on the principle that 'one does not count the teeth of a gift horse'. The art world chose to forget about the problems associated with looted art in an act [...] termed 'volitional amnesia'. (UK Parliament 2000: para. 178)

Such 'volitional amnesia' on the part of the unscrupulous curators of well known public museums,[3] particularly in the US, has resulted in notorious acquisitions, with consequential prosecutions, threats of prosecution and restitution of looted antiquities to source nations. A useful summary of recent cases is set out by Matsuura (2007). A sudden increase in the traffic of looted antiquities resulted from conflict in Iraq and Afghanistan, in which Western forces have been a major participant in the last decade. This has resulted in the widespread plunder of important archaeological sites. Apart from the irreplaceable loss of contextual information along with the artefacts, the harm came full circle: the same objects that were looted in the lawlessness that resulted from the conflict fetched high prices in the Western market, providing the insurgents with the funds they needed to kill coalition forces. The alleged complicity of dealers, collectors and curators in the US in military adventures that have not only killed thousands but have effectively erased entire chapters in the history of human civilization has been well documented by Rothfield (2009). The 'no-questions-asked' ethic of some museums in pursuit of the exquisite and valuable has now been sufficiently discredited for Rush (2010) to be able to describe some of the lessons learned in the military and the measures taken, one hopes, to avoid such looting in war zones in future.

The physical restitution of an object involves, by definition, a formal process of disposal – or deaccessioning – from the museum, by which legal title passes from the governing body of the museum to another party. Many of the most difficult deaccessioning decisions for museums result from ill-considered acquisition. Higher standards of due diligence by today's curators should avoid those difficulties for their successors down the line.

In the case of the exhibition of art from Russia, many of the works are known to have been 'liberated' by the Soviet state from private hands during the Russian

3 By 'public museums' I refer to those that are part of the public realm, instituted under a legal instrument of trust (regardless of how reliant they are on support from the public purse). All such museums have fiduciary obligations to society, on whose behalf they hold collections and for whose benefit they make those collections publicly available.

revolution and from various sources when the Red Army advanced into Nazi Germany. Bearing in mind the appalling carnage inflicted on Russia by Nazi Germany, on a point of museum ethics, let alone international politics, who can weigh a picture against a human life?

> The Russian point of view [...] is that Germany lost the war after looting many thousands of art treasures from the Soviet Union, which won the war and looted in return. 'It's a big question for us', said the Deputy Culture Minister, Mikhail Shvydkoi. 'Our whole country was destroyed: 20 million people, 500 museums and so on'. (Erlanger 1995: para. 16)

The Russian government, in an audacious act of brinkmanship, cancelled the loan to the Academy at the eleventh hour, because of fears that in Britain, third party action could result in confiscation of disputed works in the show. Only when the British government hurriedly issued a legal guarantee of immunity, did the Russian state allow the show to go ahead.

Art exhibitions of this kind are big business and a great deal of money was at stake; so were intergovernmental relations between Russia and Britain. Let us not delude ourselves that museums are ever a-political; nor should they be, if they are a meaningful part of the public realm.

The moral authority to forgive and to move on from past misappropriation lies, I suggest, not with the curator but with the inheritors of dispossession. And it should be on terms agreed with them, not dictated by the museum. I am humbled by the words of Aunty Ida West, a Tasmanian Aborigine, who died in 1995 after a life of struggle for indigenous rights. As though gently reproving Rosenthal, the inscription on her memorial on Flinders Island[4] ends with her words: 'Where the bad was, we can always make it good.' Museums can go much further than the apology coaxed from a politician to atone for past wrongs: museums are in a unique position of being custodians of the material manifestation of appropriation that opens up practical avenues to 'make it good'.

Living indigenous communities provide my third example of peoples for whom the past is no distant reverberation, but the cause of an all too keenly felt social dislocation in the here and now. In parts of Australia, Aborigines live at or beyond the margins of society in a self-destructive spiral of abuse and addiction. Chloe Hooper, an investigative journalist, suggests a cause of the cycle of abuse that goes down the generations 'must be people being forcibly taken from their parents, who had in turn been taken from their parents, who'd been taken from theirs' (Hooper 2008: 244). The programme of state-sponsored indigenous assimilation, now referred to as the 'Stolen Generation', involved some 100,000 Aboriginal children who were taken from their families to be raised in institutions or adopted

4 Flinders Island lies just north of Tasmania, in the Bass Strait south of Australia. There is a cemetery there, where a number of unmarked graves are the sad reminder of the Tasmanian Aborigines re-settled there in the nineteenth century under British 'protection'.

by white families between about 1880 and 1960. Tom Trevorrow, an Elder of the Ngarrindjeri nation in South Australia, makes the connection with the grave-robbing that supplied museums with the bodies of his nation's Old People in the nineteenth century. 'The "First Stolen Generations" were torn from their country and resting places in much the same way as indigenous children were stolen from their families. For Ngarrindjeri people, the pain and suffering caused by these acts of racialized power has been handed down through generations' (Hemming and Wilson 2010: 186). The narrative of the stolen generations of the nineteenth and twentieth centuries is really a debate about the place of indigenous peoples living in Australia today.

Museums that are insensitive to the impact of their behaviour on people whose personal or group narrative is vested in objects in the museum's care break one of the fundamental tenets of professional ethics, that is, non-maleficence: doing no harm. This lies at the heart of the museum's responsibility to its many constituencies. Not everyone agrees. 'We should recognize that objects acquired in earlier times must be viewed in the light of different sensitivities and values, reflective of that earlier era' (Karp et al. 2006: 247). Thus in the first paragraph of the Declaration of the Importance and Value of Universal Museums is the museum distanced from past iniquity, whilst disdaining the proposition of contemporary resonance, and claiming absolution from any moral obligation today.

The authors of the Declaration – members of the so-called Bizot Group of museum directors[5] – who met in Munich in 2002, were motivated, it appears, by the need to develop a rationale for the existence of self-styled encyclopaedic museums. It was intended as a defence against the rising tide of criticism from those concerned with these museums' complicity in the illicit trade in looted antiquities, against claims for restitution and against the new museology within the profession. Neil MacGregor, Director of the British Museum, is quoted in the Art Newspaper as saying, 'At our Munich meeting there was grave alarm at the way Greece was applying political pressure over the Marbles and the idea that *one Western country could build a museum to house objects belonging to another*' (Bailey 2002: para. 7) (emphasis added). Whether this statement by the Director of the British Museum demonstrates a monumental chutzpah or an extraordinary lack of irony must be for others to decide. Most assuredly there has been ample cause for reflection on such public disavowals and it is unsurprising that there is recent evidence of the signatory museums distancing themselves from the universalist doctrine of the Declaration. None of them currently provides

5 Named after Irène Bizot, former head of the *Réunion des Musées Nationaux* who founded the group, the Bizot Group of directors of some 40 museums of national standing in the Western hemisphere meets annually to discuss issues of common concern. In 2002, 18 members of the Group signed the so-called 'Declaration on the Importance and Value of Universal Museums'. Very much a unilateral declaration, published without any consultation outside the Group, it has been criticized and even repudiated elsewhere within the museums and wider cultural community both in the West and beyond.

access to the Declaration on their institutional websites. More subtle techniques of proselytizing the universalist doctrine are in evidence. The hugely successful and much lauded radio series, 'A History of the World in 100 Objects', was made jointly by the BBC and The British Museum and broadcast in 2010 (http://www. bbc.co.uk/ahistoryoftheworld/). In it, the Director of the Museum, who is a skilled and compelling storyteller, controls the selection of objects and the narrative, and in so doing projects the authority of the museum as the universal repository of knowledge as well as objects. The listener is cleverly seduced into believing that the story they hear is the definitive one. The possibility of other narratives and other voices is hardly acknowledged, let alone heard.

Much as such encyclopaedic museums would prefer to dismiss the circumstances under which objects were acquired as an irrelevant (or vexatious) distraction, my contention is that original and current context raise important questions of the democratic *locus* of the contemporary museum. The tenets of universalism should be analysed, understood and if necessary challenged, if the international probity of the Western museum is to be maintained or even regained. As an alternative proposition, I offer an ethical framework of social and political accountability for museums, under the banner of 'cultural equity'. Far from being a threat to museums and their collections, the ethic of cultural equity opens up for museums the opportunity for more creative interactions with their constituencies to the long term benefit of all. In short, it will ensure a more sustainable model of the Western museum in a century of increasingly globalized cultural inter-activity and accountability.

Museums with encyclopaedic collections have the capacity to be an inspirational celebration of the human spirit. We need, I feel, to lift the debate from antagonism to the kind of constructive engagement for which relational museums pride themselves. Casting universal museums in the ethical raiment of 'the other' is unhelpful, a mindset in their detractors that only reinforces the very fears that led to the articulation of the Declaration in the first place. It is time for universal museums to come in out of the cold and join the rest of the museums community and humanity. Perhaps they are ready to do just that.

To that end I offer an alternative set of values, intended to unite the Western museum in an ethic of enlightened self-interest, as a means of framing the restitution debate constructively.

Museums and Sustainable Stewardship

Across the world, people are experiencing the effects of living unsustainably. From climate change and environmental degradation to irrational money markets and corrupt regimes, what is unsustainable seems self-defining and increasingly predictable. The increased polarization between the haves and have-nots, both within and between nations, is socially unsustainable, leading to instability and unrest. Nations whose politics are based on bullying, oppression and social

disenfranchisement are unsustainable, as the uprisings from 2010 onwards in North Africa and parts of the Arab world demonstrate.

Opinion on what constitutes a sustainable alternative, however, is usually divided: certainly, the one-size-fits-all approach is equally misguided and unsustainable. Regardless of how it is defined, living sustainably means that humanity will be held to account by future generations for the responsible stewardship of the planet and its resources. Whilst the ability of museums to save the planet is necessarily limited, museums are in the business of the stewardship of tangible cultural resources (scientific, technological and artistic) for the benefit of this and future generations. In museums are concentrated some of the finest material that exemplifies humanity's long quest for meaning, beauty and understanding in the world. That is not a criticism: it's their job.

However, the vast imbalance between those who benefit from the finite natural and cultural capital of the world and those who suffer the consequences of its inequitable exploitation, fuels a resentment towards the West and gives a moral edge to the politics of sustainability. It is unsustainable, I submit, for Western museums to act as though they are above the maelstrom: they are part of it. Cultural equity in the museum can become a beacon of twenty-first century enlightenment, as a means to mitigate the destabilizing differentials in society that they may otherwise represent.

Cultural equity describes the values of the sustainable museum, reflected in the transparency and democratic accountability of its conduct. Equity in this context means both 'fairness; recourse to the principles of justice to correct or supplement the law' (Sykes 1976: 350) and a shared interest in an enterprise. To the extent that it supplements the law, cultural equity lies precisely in the purview of ethics; in the words of Gary Edson (1997: 9), 'Laws restrict activities and define methods or means of compliance. They serve as the minimum standards of social behavior. Ethics defines and describes correct actions for persons working in a specialized profession.'

Cultural equity in the museum is intergenerational and embodies a democratic principle of universal entitlement, of citizens participating in the museum, which does not presume to a monopoly on knowledge and authority, and is concerned with the accountable exercise of power. The challenge for museums with encyclopaedic collections is to go beyond the polemics of ownership, control and inter-cultural aesthetics and instead to open a more democratic debate around trans-cultural accountability.

Crossing Frontiers of Accountability

Restitution in the museum comes in many forms, only one of which necessarily involves the physical transfer of an object out of the collections of the museum. Restitution, when framed by the values of cultural equity, becomes an inclusive process of engagement with the citizen, with 'communities of identity', which can

be defined as those communities whose sense of self is to some degree represented in the material culture held by the museum. This ethic demands of the museum the confidence, maturity and generosity of spirit to let go, to take risks and to cede, or at least to share, control of the narrative vested in and around the object; and to involve the citizen in selection: the opaque, idiosyncratic and largely undisclosed process by which objects are acquired and exhibited by the museum. Communities of identity are, in effect, shareholders in the cultural equity of the museum, peoples connected non-exclusively with objects and the museum through proximity, rational enquiry, creativity, philosophy or tradition.

A source community denied a voice in the communication of its own culture, suffers a continuing misappropriation. That is what happens when a museum presumes to speak for the people whose forebears made, used or are to some degree 'represented' by an object. Kenyan activist and Nobel Laureate Wangari Maathai describes a process of self-expression in which indigenous people break through the identity projected onto them by outsiders:

> The time has come for them to hold up their own mirror and find out who they are [...] Until then, (they) have looked through someone else's mirror – the mirror of the missionaries or their teachers or the colonial authorities who have told them who they are and who write and speak about them – at their own cracked reflections. They have seen only a distorted image, if they have seen themselves at all! (2004: para 16)

Museums must be careful of the mirrors they hang in the gallery.

The Victoria and Albert Museum's gallery tours during Refugee Week in 2010 (http://www.vam.ac.uk/contentapi/logotron/refugee-week) were much trumpeted by the media. Personal and moving narratives of refugees illumine collections in new ways, but the participation of diaspora communities in encyclopaedic museums elsewhere in the UK happens 52 weeks of the year. Many regional museums across the UK have embedded these values in their developing practice over the last decade, in a profound and sustained way. The Manchester Museum's own Collective Conversations enables a non-exclusive exploration of the relationship between people and objects, whose output is universally accessible on YouTube (http://www.youtube.com/ManchesterMuseum). This form of restitution, in which narrative control is re-explored, challenged, widened and shared, not only empowers the narrator but also enriches the museum and its many users in unforeseen ways. The scholarly voice of the museum is not excluded or side-lined: it, too, is represented on YouTube – as an entirely valid community of identity – alongside the voices of the museum's many other constituencies, just as their voice is heard within the museum itself.

For those who fear that admitting the outside, 'non-academic' voice risks undermining the scholarly credentials of the museum, the academic outcomes of a visual repatriation project are instructive. At the University of Oxford's Pitt Rivers Museum, there is a collection of 33 photographic portraits of the Kainai First

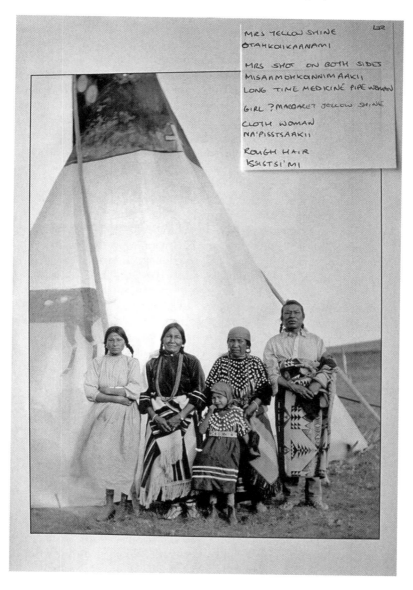

Figure 2.1 **A photograph of a group of Kainai people taken in c.1925, in the collection of the Pitt Rivers Museum. The post-it note, annotated by Alison Brown in 2002 with the names of the people in Blackfoot and in English, results from a visual repatriation project. Pitt Rivers Museum BB.A3.67, taken by Beatrice Blackwood, 1925. Photograph reproduced courtesy Pitt Rivers Museum, University of Oxford**

Nation taken by Beatrice Blackwood, an anthropologist who worked in Alberta, Canada in the 1920s. Laura Peers and Alison Brown have devised, in partnership with the Kainai people today, a visual repatriation project that gives back to the source nation control of the narrative around these images. As the authors explain, '[...] communities need to reinterpret historical documents and photographs in their own way, for their own purposes, and to ensure that their histories are presented in their own words' (Peers and Brown 2009: 124). For the photograph (Figure 2.1) the project revealed the names of everyone depicted. Moreover, the Kainai told the researchers that the people posed so artfully in front of 'their' tipi neither lived in tipis nor dressed like this in the 1920s; they would not have done so willingly, so it is likely that they were coerced into this pose.

A historical misappropriation and misrepresentation has been rectified through a process of mutual good will and respect. A photograph taken by a Western anthropologist 85 years ago cannot be taken at face value; it has been deconstructed and re-interpreted by those in the best position to know, and is consequently now a far more valuable scholarly source for contemporary anthropology. The research methodology, developed collaboratively, is described fully in Brown, Peers et al. (2006).

Museums that work with communities of identity as equal partners mediate a form of participatory democracy. The challenge for encyclopaedic museums is to extend that notion of participation beyond the normal political boundaries of democratic accountability. Encyclopaedic museums which are maintained in the public realm of a Western democracy, and purport to reflect the 'world under one roof' (Cuno 2009: 39), cannot reasonably draw a line of democratic accountability at the borders of their own nation state. Indeed, the most vociferous apologist for universalism, James Cuno, attacks the very idea of national patrimony in his defence of the right of the encyclopaedic museum to retain all that they have (and to acquire more of the same). 'It is the promise of the encyclopaedic museum to counter the nationalisation of culture and its claim on antiquity' (Cuno 2009: 28). If national boundaries are set at nought in the universalist canon to resist claims for restitution, it is illogical to invoke those same boundaries in defence of the sovereignty of the encyclopaedic museum.

My own work in helping the indigenous voice to be heard and respected in the UK has been prompted in large part by an awareness of the exclusion of peoples outside the UK from the normal entitlements accorded to its own citizens by the democratic state. In UK museums, the systems and rules of engagement privilege some communities of identity – the traditional museum and scientific communities – whilst disadvantaging originating peoples. In both language and tone, the criteria and guidance against which claimant communities are required to test the validity of their claim, speaks not of a welcome for a respected partner but of the need to repel an unwanted invader.

It is time to review quite radically the kind of criteria set out in government guidance and the policies of museums, so that culturally offensive language and assumptions are removed; the onus is transferred from the claimant to justify

'why' to the museum to justify 'why not'; and evidence of consent of communities of identity should be a key determinant in resolving claims for repatriation. University College London (2007: 11-12) demonstrates best practice in its policy and procedures for dealing with claims for the restitution of human remains: 'Negotiations between UCL and claimant representatives will normally proceed from a stance that is sympathetic to the case for return, when evidence of consent is non-existent, unproven or equivocal.'

If criteria such as these were applied to addressing rationally the contested location of the sculptures removed from the Parthenon by the Earl of Elgin in the early nineteenth century, the case for retention in Bloomsbury might be adjudged rather more equivocal than the British Museum would have us believe. There are many communities of identity involved, from the British people generally, the residents of Bloomsbury in particular, and of course, the Greek people themselves. Regardless of how unscientific the self-selected sample of nearly 130,000 votes cast in a poll run by the Guardian newspaper (Edemariam 2009) after the opening of the Acropolis Museum in 2009, the fact that 94.8 per cent of respondents said 'yes' to the return of the sculptures to Athens and only 5.2 per cent voted 'no' indicates an issue that should, at the very least, be properly and publicly debated with the museum. Unlawful though it may be, because of its statutory shield, for the British Museum to dispose of objects except under the circumstances prescribed in the Act (UK Parliament 1963), as in the case of human remains and spoliated Nazi art, Parliament can change the law when it sees fit.

Keeping Museum Collections in the Public Realm

In teasing out the ethical strands of physical restitution, we should distinguish between cases that involve removal of material from the public domain and those which don't. In the former category we can place an indigenous group that reclaims one of their forbears for reburial and the family that re-possesses a painting looted by the Nazis. Arguably, such items should not have entered the public domain in the first place, so the museum's overriding responsibility is to remedy that injustice. In the latter category, many claims are made by or on behalf of museums, where repatriation would merely transplant cultural objects to another part of the public domain.

When we consider cultural equity in the public realm, we should also distinguish content from tangibility, as the philosopher James O. Young points out:

> Perhaps certain items of intellectual property may belong to all humanity, but the suggestion that tangible property belongs to everyone is not helpful [...] The artistic commons is composed of those artistic elements (styles, motifs, general plots and so on) that anyone is free to appropriate. If we are dealing with tangible property such as individual works of art, the situation is different. All of humanity can share some item of intellectual property in a way that they cannot

share a sculpture or a stele. Even if we say that something belongs to humanity,
the question of who ought to have custody of it still remains. (Young 2008: 66-7)

Similar issues arise with what one might call the scientific commons.

It is a tenet of science that all of humanity has a share in scientific discovery,
but that doesn't equate to communal ownership of scientific evidence. In 2005
I was invited by the British Council to work with colleagues in Buenos Aires.
I took a day out to go to Patagonia to give to the Museo Carmen Funes in Plaza
Huincul some fragments of dinosaur eggshell. These fossils had come to light in
the palaeontological collections of the Manchester Museum, of which I was then
Director. The specimens had been exported illicitly from Argentina and purchased
by the Museum after 1970, so their presence in the Museum's collections was
unethical and against its own acquisition policy. To my great surprise, the
repatriation was front page news in Argentina (Picabea 2004), the Culture Minister
in person thanked me, and the mayor of Plaza Huincul hosted a press conference
when I arrived. What galvanized politicians, media and local people was the idea
that a museum in a distant, rich and powerful European nation should concern
itself with the restitution of their cultural patrimony. Science, too, was well served
by an act of restitution that has kept objects in the public domain and facilitated an
international research partnership.

As these examples illustrate, more than one community of identity can
benefit when control of narrative or object is repatriated by the museum. New
partnerships, based on mutual respect, can open up hitherto unexplored avenues
of research, leading to fresh insights and discovery. In addition, as with the Kainai
photographs, a sense of dignity and self-determination is restored to the source
community – a point also made by Australian indigenous communities when their
Old People are returned by museums. Speaking in an African context, Wangari
Maathai nonetheless articulates a universal truth:

> Culture gives a people self-identity and character. It allows them to be in
> harmony with their physical and spiritual environment, to form the basis for
> their sense of self-fulfilment and personal peace. It enhances their ability to
> guide themselves, make their own decisions, and protect their interests. It's their
> reference point to the past and their antennae to the future. Conversely, without
> culture, a community loses self-awareness and guidance, and grows weak and
> vulnerable. It disintegrates from within as it suffers a lack of identity, dignity,
> self-respect and a sense of destiny. (Maathai 2009: 160-61)

I began with a parable, a narrative of our times and of times past told by an artist.
What goes round, comes round. In the story of the Russian Linesman the past
collides with the present in a fusion of the personal, public and political. I will end
with an artistic parabola: Andy Holden's 'Pyramid Piece and Return of Pyramid
Piece', exhibited at Tate Britain in 2010. Occupying and dwarfing a gallery space
was a magnified fragment of rock, whose surface was slavishly knitted by an army

of the artist's friends (Figure 2.2). It represents a piece of the Great Pyramid of Cheops, removed by the artist as a souvenir when he was taken there as a boy. Over the subsequent 13 years this piece of Egyptian limestone sat on a shelf in the artist's bedroom, where it became swollen with the weight of guilt associated with its theft. Holden recently repatriated the piece and enlisted the assistance of a local to film his attempt to find the exact location from which the piece originated. The shaky, amateur video of this impossible quest formed part of the installation at the Tate, a part of which is included in an interview with the artist available on-line (http://channel.tate.org.uk/media/76364862001). Through this personal narrative, the artist explores whether significance is always contingent on context. Without the association of the pyramid, it is just a piece of stone. Holden references his work to Aldous Huxley's essay, 'Meditation on the Moon', in which the author points out that there is 'nothing to prevent the moon from being both stone and god' (Carey-Thomas 2010: 2). As Tate curator Lizzie Carey-Thomas observes:

> Holden's fragment undergoes a continuous metamorphosis linked to time and circumstance: a stone in the ground, a fragment of an edifice, a relic of a lost civilisation, a tourist icon, a stolen souvenir, an object of guilt – from the sacred to the profane and back again. Holden's art not only reveals the relationship of the fragment to the whole, but also to a complexity of plots and subplots spreading out in infinite directions. (2010: 2)

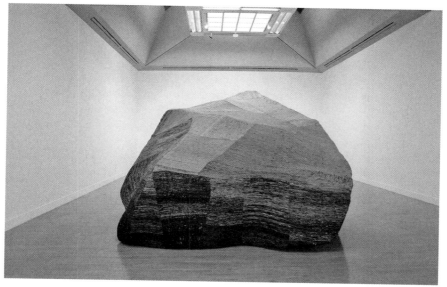

Figure 2.2 **'Pyramid Piece' by Andy Holden, installation at Tate Britain, 2010. Made of knitted wool on an armature. Reproduced by kind permission of the artist**

The ethics around contested objects in museums are many layered and touch, as Huxley would remind us, on the numinous as well as the rational. Whilst the restitution debate must inevitably consider national and international laws, and institutional ethics, Holden's work reflects the importance of the individual's personal narrative, moral compass and sense of accountability. Cultural equity, if you like, starts at home.

These thoughts are offered in the hope that they might provide a useful point of departure for a debate in which there is a 'complexity of plots and subplots spreading in infinite directions' (Carey-Thomas 2010: 2). I look forward to a time when restitution has ceased to be controversial, a position we might achieve if museums were to practice ethical acquisition. Restitution will then become what it should be: part of the process of constructive engagement between museums and their diverse communities of identity.

Bibliography

Bailey, M. 2002. *Shifting the Blame.* [Online: Forbes.com]. Available at: http://www.forbes.com/2003/01/21/cx_0121hot.html [accessed: 4 October 2011].

Besterman, T.P. 2011. Cultural equity in the sustainable museum, in *The Routledge Companion to Museum Ethics*, edited by J. Marstine, London and New York: Routledge, 239-55.

British Museum 2009. Letter from Director's Office to Anne Webber, Co-Chair, Commission for Looted Art in Europe.

Brown, A., Peers, L. and members of the Kainai Nation. 2006. *Pictures Bring Us Messages/Sinaakssiiksi Aohtsimaahpihkookiyaawa: Photographs and Histories from the Kainai Nation.* Toronto: University of Toronto Press.

Carey-Thomas, E. 2010. *Andy Holden: Pyramid Piece and Return of Pyramid Piece, 9 January–10 April 2010.* Handout. London: Tate Britain.

Cuno, J. 2009. *Whose Culture: The Promise of Museums and The Debate Over Antiquities.* Princeton: Princeton University Press.

Edemariam, A. 2009. How G2's Parthenon marbles poll went global. *The Guardian* [Online, 8 July]. Available at: http://www.guardian.co.uk/artanddesign/2009/jul/08/parthenon-marbles-guardian-poll [accessed: 13 October 2011].

Edson, G. 1997. Ethics, in *Museum Ethics*, edited by G. Edson. London and New York: Routledge, 3-17.

Erlanger, S. 1995. *Hermitage, in its Manner, Displays its Looted Art.* New York Times. [Online, 30 March]. Available at: http://www.nytimes.com/1995/03/30/arts/hermitage-in-its-manner-displays-its-looted-art.html?pagewanted=all&src=pm [accessed: 14 October 2011].

Hemming, S. and Wilson, C. 2010. The First 'Stolen Generations': repatriation and reburial in Ngarrinderi Ruwe (country), in *The Long Way Home: The Meaning and Values of Repatriation*, edited by P. Turnbull and M. Pickering. Oxford and New York: Berghahn Books, 183-98.

Hirst, D. 2006. *Report of the Spoliation Advisory Panel in Respect of Four Drawings Now in the Possession of The British Museum* [Online: House of Commons]. Available at: http://www.culture.gov.uk/images/publications/HC1 052_SAPreport.pdf [accessed 10 October 2011].

Hooper, C. 2008. *The Tall Man.* Victoria: Penguin Group.

Karp, I., Kratz, C.A., Szwaja, L. and Ybarra-Frausto, T. 2006. *Museum Frictions: Public Cultures/Global Transformations.* Durham, North Carolina: Duke University Press.

Maathai, W. 2004. The Cracked Mirror. *Resurgence.* [Online, 11 November]. Available at: http://www.greenbeltmovement.org/wangari-maathai/key-speech es-and-articles/the-cracked-mirror para. 16 [accessed 29 July 2013].

Maathai, W. 2009. *The Challenge for Africa: A New Vision.* London: Heinemann.

Matsuura, K. 2007. *Recent Examples of Successful Operations of Cultural Property Restitutions.* [Online: UNESCO, 12 June]. Available at: http://www. unesco.org/en/movable-heritage-and-museums/features/recent-examples-of-successful-operations-of-cultural-property-restitutions-in-the-world/ [accessed: 2 October 2011].

Picabea, M.L. 2004. Un museo inglés devolvió al país piezas fósiles robadas. *Clarin* [Online, 8 September]. Available at: http://www.clarin.com/diario/2004/09/08/ sociedad/s-03201.htm [accessed: 8 October 2011].

Rosenthal, N. 2008. The time has come for a statute of limitations. *The Art Newspaper*, 2008. [Online, 11 December]. Available at: http://www.theartnews paper.com/articles/The-time-has-come-for-a-statute-of-limitations/16627 [accessed 29 July 2013].

Rothfield, L. 2009. *The Rape of Mesopotamia.* Chicago: University of Chicago Press.

Rush, L. 2010. *Archaeology, Cultural Property and the Military.* Woodbridge: The Boydell Press.

Sisson, C.J. (ed.) 1960. *William Shakespeare: The Complete Works.* London: Odhams Press.

Steel, P. 2008. NMDC fights spoliation legislation. *Museums Journal*, October, 9.

Steel, P. 2013. BM settles Gestapo loot case. *Museums Journal*, 2013. [Online, 11 October]. Available at: http://www.museumsassociation.org/museums-journal/news/08102013-british-museum-settles-gestapo-loot-case?utm_ source=ma&utm_medium=email&utm_campaign=11102013.

Sykes, J.B. (ed.) 1976. *The Concise Oxford Dictionary of Current English.* Oxford: Oxford University Press.

UK Parliament 1963. *British Museum Act* [Online: House of Commons]. Available at: http://www.britishmuseum.org/PDF/BM1963Act.pdf [accessed: 12 October 2011].

UK Parliament 2000. *Seventh Report of Culture Media and Sport Committee: Cultural Property – Return and Illicit Trade.* [Online: House of Commons]. Available at: http://www.publications.parliament.uk/pa/cm199900/cmselect/ cmcumeds/371/37108.htm [accessed: 8 October 2011].

UK Parliament 2009a. *Holocaust (Return of Cultural Objects) Act* [Online: House of Commons]. Available at: http://www.legislation.gov.uk/ukpga/2009/16/pdfs/ukpga_20090016_en.pdf [accessed: 9 October 2011].

UK Parliament 2009b. *Holocaust (Return of Cultural Objects) Bill* – Second Reading House of Lords Debate, 10 July 2009, column 908 Available at: http://www.publications.parliament.uk/pa/ld200809/ldhansrd/text/90710-0005.htm#09071034000199 [accessed 29 July 2013].

UNESCO 1970. *Convention on the Means of Prohibiting and Preventing the Illicit Import, Export and Transfer of Ownership of Cultural Property.* [Online: UNESCO]. Available at: http://portal.unesco.org/en/ev.php-URL_ID=13039&URL_DO=DO_TOPIC&URL_SECTION=201.html [accessed: 14 October 2011].

University College London. 2007. *Policy, Principles and Procedures for the Care and Treatment of Human Remains at UCL.* [Online]. Available at: http://www.ucl.ac.uk/museums/further-info/documents/humanremainsfeb10.pdf [accessed: 15 October 2011].

Webber, A. (Commission for Looted Art in Europe) and Besterman, T. 2009. *Pers comm*, telephone 6 July and emails 18- 31 July.

Young, J.O. 2008. *Cultural Appropriation and the Arts.* Malden MA, Oxford and Carlton Victoria: Blackwell Publishing.

Chapter 3

Authority and the Power of Place: Exploring the Legitimacy of Authorized and Alternative Voices in the Restitution Discourse

Piotr Bienkowski

In *The Return of Cultural Treasures*, her pioneering study on the legal, political and historical aspects of cultural restitution, Jeanette Greenfield writes:

> [...] it is clear that cultural property is most important to the people who created it or for whom it was created or whose particular identity and history is bound up with it. This cannot be compared with the scholastic or even inspirational influence on those who merely acquire such objects or materials. (2007: 411)

Nevertheless, current restitution processes tend to privilege the universalist claims of science, the nation state, and an essentialist view of cultural groups. This means that the search for knowledge is the most important criterion, self-evidently of universal benefit, transcending national and cultural borders – this assumes too that there must be preservation of, and unrestricted access to, objects and sites for the purposes of knowledge, education, and research, which are for the benefit of all humanity. It means there is a general assumption, or perhaps a starting point, that cultural heritage is the property of the nation state rather than belonging to any groups or communities below the level of the state. It means that cultural groups or communities must tick several boxes to be accepted as authentic and legitimate: they must practice a 'pristine' culture, lead a traditional lifestyle, and be able to demonstrate genealogical links and close cultural continuity with past cultures.

Furthermore, current restitution processes are adversarial: they are framed in terms of 'rights' and 'claims', pitting the claimant, side A, against the current owner, side B, where side A has to 'prove' its legitimacy and right to ownership by showing how it fits certain pre-selected criteria – criteria, incidentally, that are not universal or in any sense value-free, but which invariably have been framed by side B from its position of ownership and a sense of its own legitimacy and from the perspective of its own values. While I acknowledge that the Native American Graves Protection and Repatriation Act (NAGPRA) in the US has to a certain extent ameliorated some of these issues, the case of Kennewick Man

brought them sharply to the fore again (Thomas 2000): unless human remains, cultural property and communities neatly fit their essentialist museum-designed boxes, the universalist claims of science and the nation state tend to come up trumps.[1]

My intention is to explore and challenge these often self-evident categories, and also the adversarial process, by focusing on three issues: value, legitimacy and authority and ownership. Not only is there much overlap between these three issues – they are totally interconnected, and it is difficult to keep discussion about them separate – but a considerable amount has been written about them in recent years. I intend to incorporate and occasionally comment on the main strands of that existing research, then conclude by exploring the potential of a fairer, more inclusive, discursive and non-adversarial process which I think addresses all the issues and which sits better within the role of museums today than the current adversarial restitution processes which compromise the ability of museums to do what they most crucially need to do.

Value

Heritage objects have different value to different individuals, communities and institutions. We can characterize these varying values in different ways: as tensions between scientific and spiritual needs, between universalist and symbolic importance, or between economic value and experiential value. While it is true that such tensions are not always in binary opposition, they can nevertheless be characterized as points along a spectrum: and that spectrum can be characterized as a tension between utilitarian value at one end and social value at the other end. Broadly, utilitarian value favours:

- The good of the greatest number of people
- Economic productivity
- Universal access to knowledge
- Outputs of scientific research, in principle available to all
- Measurable value, often in monetary terms
- Preservation.

1 Until recently, NAGPRA has been interpreted tightly, with remains and artefacts only being returned to tribes which could prove a direct connection. Rule 43 CFR 10.11 on 'Disposition of Culturally Unidentifiable Native American Human Remains', which became law in March 2010, extends repatriation to American Indian remains currently in the possession of federal museums, even when the tribal origin of those remains has not been identified. Those remains will be returned to the tribe that has a proven presence on the land where the remains were found: http://www.nps.gov/nagpra/mandates/.

Social value favours:

- Individual or community experience
- Spiritual and religious experience
- Connection to place, ancestry, and specific cultural practices
- Sense of individual or communal identity
- Value that is difficult to measure or 'prove'
- More openness to natural processes of decay.

While Western museology is concerned with an object's 'physical integrity and attributes as evidence of cultural, historical or scientific phenomena' (Kreps 2003: 93), many Native Americans, for example, are concerned with 'an object's spiritual integrity and meaning and function within its community' (Cobb 2008: 340). When the National Museum of the American Indian in Washington, DC opened in 2004, with displays which foregrounded the social values of the American Indians – the nature of the sacred and human relationships with the environment – the media reacted extremely negatively, criticizing the lack of traditional linear history and Western-style scholarship, the lack of a traditional sense of order with the objects not being arranged chronologically or geographically, and rejected indigenous knowledge as illegitimate (e.g. Jonaitis and Berlo 2008). To give another example, we can cite the sacred Ahayu:da figures of the Zuni people of New Mexico. When these objects are taken from their sacred shrines, put into museums, and indefinitely conserved against natural decay, the Zuni perceive them as being partly destroyed and that harm has been done to them as a people. But when the Ahayu:da are allowed to deteriorate physically in their sacred places, until they disintegrate completely and return to the earth, they are preserved as meaningful heritage and as religious objects sacred to the Zuni (Colwell-Chanthaphonh 2009: 144-6). This brings out the ways in which preservation is a cultural construct and part of a value system, but not a universal ethic (Colwell-Chanthaphonh 2009: 152).

Who chooses which value will dominate, and how do we choose between courses of action that uphold some but compromise other values? That museums remain at heart – or instinctively – scientific and utilitarian institutions committed to collecting, preservation and public dissemination of a universalist form of knowledge is not surprising: rather, it is to be expected.[2] Museums developed directly from the Enlightenment period in the West in the seventeenth and eighteenth centuries during which the academic disciplines developed around concepts of rigid order, measurement, classification and objectification. Crucially, the scientific approach, and with it museums, excluded all 'occult' phenomena and 'natural magic', which essentially meant, and in most cases continues to mean today, excluding emotion, memory, and direct experience of ancestors and of the non-human and non-animal world (Hooper-Greenhill 1992; Easlea 1980: 110-14).

2 For values as an essential component of knowledge, and in relation to relativism, see Feyerabend 1987: 24-30.

Denis Byrne (2009: 69, 84) has commented that the rejection of the 'magical supernatural' by the mechanical philosophy, within which the archaeological and heritage discourse is constituted (indeed, on which it is largely founded), prevents archaeologists today from even acknowledging the ways in which people attribute magical supernatural qualities to the material past, and the same is true of the majority of museums. This is why social value is so difficult to establish: it is largely experiential, immeasurable, often within a timeless present – concepts that have been deliberately excluded by rational and institutionalized processes of decision making.

Chip Colwell-Chanthaphonh (2009) has explored these different ideas of value in an attempt to propose a middle way: he looks at social value (calling it the argument of proximity), utilitarian value (calling it the argument of inclusivity), and a middle ground (which he calls the argument for rooted cosmopolitanism). The argument of proximity is based on the notion that those individuals and communities most closely connected, in social or cultural ways, to an object will have the most intense emotional experiences with it and as a result have the greatest rights to it. But Colwell-Chanthaphonh (2009: 153) cannot see that the way people *feel* connection to objects necessarily implies that they *ought* to have more rights to them. The argument of inclusivity states that we should maximize the preservation of cultural heritage objects for the good of the greatest number of people. But Colwell-Chanthaphonh (2009: 155-6) sees problems with this too, since such a principle disregards the reasons why we value heritage objects, that is, for the experiences they evoke and for their connections to their source communities. So he suggests a middle ground, the argument for rooted cosmopolitanism, that we should maximize the integrity of heritage objects for the good of the greatest number of people, but not absolutely (Colwell-Chanthaphonh 2009: 160). However, his discussion of this is very theoretical and he does not propose how such a process and such compromises would work in practice. More generally, he frames the discussion not in terms of values, but entirely in the adversarial language of claims, rights and control. Yet, when he proposes that, for practical purposes, the starting point of any discussions should be an assumption that all humanity is the beneficiary of cultural heritage, he omits to mention the issue of ownership and does not say anything about processes or mechanisms, who makes the decisions in any particular case, or who should be involved in such decision making. There is no sense of consultation, inclusive dialogue and discourse, only of competing claims. Rightly, though, he recognizes that decisions must be established through a political process, an issue I will consider below.

Legitimacy

Who is a legitimate voice or claimant, and who is not, and who sets the criteria and on what basis? It is generally true that museums, on the basis of their existing 'ownership', set criteria to which other communities must conform. These criteria

normally comprise essentialist elements such as kinship, cultural continuity, and age of the human remains or cultural property, criteria which the museums themselves do not usually meet. Not only is this process adversarial, but the final decision almost always lies in the hands of the museum itself, which is of course self-interested.

What seems to be happening is that, on the one hand, judgements in these situations are informed by a distinction between religions or deep connections to places that are perceived as traditional, as having a requisite historical connection with the contested human remains or cultural property, and those religious beliefs and connections that are considered to be invented, or re-invented, or perhaps even 'bogus' traditions. On the other hand, there are cases in which those distinctions are either inverted or completely ignored. There are huge inconsistencies in the ways criteria are applied (Bienkowski and Coleman 2013).

For example, for groups such as Aboriginal and Torres Strait Islanders, the concept of place is central to their religion and cultural tradition. It is the land which binds together the living, the dead, the human and the non-human as a community (Coleman 2013: 156). Although human remains illicitly removed from source communities in Australia to UK and other European museums are now being repatriated at an unprecedented rate (see Pickering 2010: 165), as Tristram Besterman has pointed out some institutions 'remain deaf to the voices of descendants, whose feelings of violation can be deepened by uninformed and thoughtless treatment by the holding institution' (2009). Such institutions hide behind formal criteria and make assumptions about which groups are, or are not, authentic and therefore legitimate claimants. Both in the contestation of human remains and of rights over places regarded as sacred, a certain type of historical continuity is asked for. Some communities – for example the Ngarrindjeri – have been accused of being inauthentic, culturally extinct, inventing traditions and of moving away from 'traditional' or pristine beliefs and rituals (Kenny 1996, Weiner 1997, Ryan 1996).

Many of the Aborigines who have been the most visible in repatriations of human remains have been those who are perceived externally as 'non-traditional' or 'urban' people, and have been accused of making claims largely for political purposes rather than genuine cultural and religious concerns (Hubert 1992: 124). As Cressida Fforde has recorded (2002: 37), such accusations were commonly linked with the assertion that such requests were invalid because they had no basis in 'traditional' beliefs and were being made by 'non-traditional' people. This was of course particularly the case with Tasmanian Aborigines, with their history of the state denying Aboriginal status to its indigenous population (Fforde 2002: 38-9, Cove 1995: 102-35, Hubert 1992: 109-10).

But the resistance to repatriation uncovers the perception, or prejudice, that only 'traditional' Aborigines are somehow 'real' Aborigines, and that they must practice a 'pristine' (i.e. pre-contact) Aboriginal culture and lead a traditional lifestyle to be accepted as legitimate. Arguments opposed to repatriation on these grounds illustrate the ossification of 'true' Aboriginal culture in a static and

timeless past, and thus the denial of truly authentic Aboriginality to many people living today (Fforde 2002: 37). There has been a similar ossification of Native Americans, and such a stance appears to contend that authenticity is static, that mutability and tradition are mutually exclusive (Fforde 2002: 38). The fact that a group reinterprets or 're-creates' their tradition is sufficient reason to consider their claims to be in some sense 'invalid' (Weiner 1997).

Of course, indigenous groups are not the only people who claim specific connection with places and their dead and with objects that are part of their landscape. In the United Kingdom in recent years there have been several examples of communities either requesting reburial of human remains – such as Pagan groups or the parish council of Melbourn in Cambridgeshire (Bienkowski 2007) – or requesting restitution of objects from national museums – such as the Hilton of Cadboll stone in Scotland (Jones 2005).

Pagan involvement in human remains issues has been criticized, with Pagans explicitly rejected as legitimate claimants, and their 'claims' called 'bogus' and invalid. They have been accused of romanticizing the past, having no valid link with contested human remains, and being unable to demonstrate continuity in customs and beliefs (Smith and Mays 2007). It is worth pointing out that, despite the different conditions, or the issue considered, the criticisms of the Australian Aboriginal and British Pagan claims are very similar. In particular, there is an emphasis on the idea that the religious belief of the group needs to have the right kind of historical continuity to be considered legitimate. We can contrast that with the Melbourn case, where a community's claim was not based on explicit religious or spiritual grounds, but on a feeling of connection to human remains through the experience of inhabiting the same land. What is perhaps surprising is that, despite this being a fairly high profile case, there was no overt published criticism of Melbourn parish council's request for reburial, no accusations of their illegitimacy as claimants and lack of authentic connection to the Anglo-Saxon remains.

So, while claims or approaches from religious groups such as some Australian Aborigines and British Pagans are subject to considerable criticism for their lack of genealogical or religious validity, there has been no explicit criticism of the Melbourn claims (despite the fact that the contested remains are well over 500 years old, making any genealogical and cultural link hard to prove): why is there such a distinction? I wonder if there may still be some intolerance of spirituality being accepted as a principal argument in the restitution and repatriation debate, and indeed such motivations are often dismissed as purely political posturing by marginalized communities (Hubert 1992: 124, Layton 1994: 13-15, Woodhead 2002: 342-5).

More specifically, though, it seems that it is certain kinds of religious expressions that are particularly accused of lacking legitimacy. Where it is believed that the claims are 'invented' either for political gain or from romantic sentimentality, they are undermined as 'religious' beliefs. A certain kind of continuity with the past is considered necessary for those groups to have claims over certain human remains or cultural property, but also for their religious claims to be taken seriously.

Inevitably, however, indigenous traditions are constantly in the process of transformation. In the face of public assumptions that Native Americans fear change and are only really Indian as long as they do not change, a Comanche curator at Washington's National Museum of the American Indian writes: 'Evidence argues that we love change, have always changed, and that change is the key to our survival' (Smith 2008: 140).

The cosmopolitan discourse within archaeology notes that, although indigenous and connected communities have certain rights and claims to culture, 'they are not trapped by ancient identities and necessarily expected to perform them in the present [...] there is no single path to cultural legitimacy' (Meskell 2009: 23). However, when such groups do reinterpret their culture and beliefs, these reinterpretations are criticized for their lack of authenticity and their depth. A problem of this line of reasoning over the history and tradition of the religious beliefs, where we only protect the religion of those indigenous groups that have maintained their tradition, is that it means that precisely those indigenous groups that have been the most affected by colonization, and that have lost most of their culture, are disadvantaged in relation to cultural recognition, and their ability to make claims for restitution (Brown 2003: 197-202).

But this distinction between 'traditional' and 're-created' indigenous belief is also important in that it highlights the difference we make between different metaphysical beliefs, and the respect that they deserve. There is a significant emphasis on tradition and custom, and it is just this lack of tradition that is criticized in Pagan spiritualities.

In summary, the problem for determining which kinds of views count – and whether they are 'traditional' indigenous views, or the traditional views of those groups – is in part a proxy for determining whether this is the kind of religious belief of which we approve, and which metaphysical beliefs will be privileged. People with the 'wrong' beliefs may be subject to ridicule and prejudice and exclusion from negotiations. The criteria we use in determining which groups are entitled to be regarded as legitimate reflect and expose a deep-seated prejudice towards certain kinds of religious expressions, at the same time as disadvantaging the very groups that are the most affected by colonization. But the basis of our concern about these groups also exposes another significant problem with adopting that approach, in that it is based on a deep-seated prejudice against those who practise beliefs that lack an institutional framework and basis in a certain kind of tradition.

Such prejudices come to a head when judgements have to be made about particular restitution claims, and whether a particular group is 'legitimate' or not. Therein lies the problem. Claim rights give the right holder control over what may occur, and other people have a duty or obligation to acknowledge the right (Thomson 1992: 39-41). It is therefore necessary under the language of claim rights to identify which people or groups are the legitimate rights holders. In restitution cases, this then becomes a bureaucratic adversarial process, with pigeon-hole style criteria, devised by the museums themselves, reflecting all of their values and prejudices, which claimant communities have to meet. I think such adversarial

processes act counter to the purposes of museums, and below I propose a more inclusive dialogue and decision-making process that involves any individual or community with an interest in a restitution issue, rather than being caught up in the essentialist bureaucracy and prejudices of legitimacy criteria.

Authority and Ownership

There is a general assumption worldwide that cultural heritage is the property of the nation state, notwithstanding John Henry Merryman's argument that objects of cultural heritage belong to nations or, independently of national borders, to humanity (Merryman 1986), and Watkins' addition of a third pole of ownership, enclaves within nations, particularly indigenous communities (Watkins 2005). The ultimate property rights of the nation state in relation to heritage are enshrined in UNESCO's documents regarding World Heritage Sites (Hodder 2009: 191).

John Carman (2005: 76) has charted how acquisition of cultural property by the state converts the symbolic or social value of a community's sense of heritage into that of a 'national heritage': state ownership of heritage does not fulfil the original purposes of the heritage, but instead gives greater prestige and authority to the state as an institution. Thus heritage is converted from having symbolic or social value to a community, to having utilitarian value to the state. This utilitarian approach, grounded in ideas of economic value and functional utility, leads to restrictions on access, for example putting objects in a museum, justified by the needs of preservation – but by this means ownership of the object is at the same time removed from those people and communities who lay claim to it as their heritage (Carman 2005: 119). A good example, once again, is the Hilton of Cadboll stone, with the Historic Hilton Trust refusing to recognize ownership by the National Museums of Scotland (Jones 2010). National museums in particular are a symbol of the nation state, existing to communicate official meanings, to consolidate the relationship between national territory, state, and the population associated with a given national territory – often accomplished by promoting ideas about a shared national culture, heritage and identity (Anderson 1991, Delugan 2008: 386). Indeed, by acquiring cultural property, the state affirms its own authority as if it is the natural and only legitimate carrier of a sense of community (Carman 2005: 76). The state is often viewed as the privileged apex of collective identity, but in modern complex society we are as fully members of a family, a neighbourhood, a religious community or of a social movement as we are members of a state (Benhabib 2002: 169). Duncan Ivison (2006) questions why states are perceived to possess legitimate and exclusive sovereignty over all their territories, while Lynn Meskell (2009: 17-18) asks why we should presume that state institutions – especially those dealing with distributive justice, including restitution – are legitimate, or, indeed, why we have states at all. It is self-evident that not all individuals and communities recognize the legitimacy of the state. For example, we can certainly assume no allegiance to the state for Aboriginal

peoples in Australia, who were excluded from citizenship until 1967 and represent hundreds of small linguistic and cultural entities across the continent (Lydon 2009: 34).

Although it may seem self-evident, it needs to be (re-)stated clearly that, in restitution cases, ownership is an issue, state ownership is an issue, and the legitimacy of state ownership is an issue. In an article entitled 'The Rosetta Stone can be shared where it is', Roy Clare, then Chief Executive of the Museums, Libraries and Archives Council, argued that 'ownership of particular artefacts is now far less significant than the fact that people can enjoy them, be enlightened, entertained and brought closer to a real understanding of the inheritance that binds us all. And nowhere is that better achieved than in the galleries of the British Museum' (2009). He states further that the Trustees of the British Museum could decide to loan the Rosetta Stone to Egypt, but that no such request has been received, and that various criteria would be assessed before agreeing to such a loan – including the likelihood of its return. He fails to acknowledge that the essential concept of a 'loan' implies ownership, and the setting of criteria (by the British Museum) implies authority and control over the object. From that perspective, one might argue that it is not at all surprising that the Egyptians have not put in a loan request, since by so doing they would legitimate the British Museum's ownership. This example underlines why ownership is significant, and in this and other cases it is precisely ownership that is the problem.

There are, of course, very well-known examples where communities have to some extent successfully challenged the state's authority over cultural heritage. In 1998, the Mirarr Aboriginal community approached UNESCO to intercede in its fight against the Jabiluka uranium mine which threatened their community and its way of life. The UNESCO World Heritage Committee Mission visited the area and later agreed that the mine posed serious threats to the cultural and natural values of the Kakadu World Heritage Area, which abuts the mining area. The threat of placing the site on the World Heritage 'in danger' list, without permission of the host country, was unprecedented, and caused huge embarrassment to the Australian government – and while that threat was never carried out, to date mining has not taken place in that area (Lydon 2009: 40-45).

Cornelius Holtorf (2009: 674) argues that population movements in Europe in the past few decades have so drastically altered the ethnic make-up of the population in different countries that the very idea of the nation – and with it of a national heritage – has become anachronistic, with heterogeneous cultures, languages, religions and origins of citizens and residents. In European countries the idea of national heritage no longer unites but increasingly distinguishes different population groups within one and the same state, in the sense that the idea of national heritage can marginalize and exclude immigrants. He cites Burström's (1999) suggestion, as an alternative to a search for unifying cultural and national roots, to focus on the area you live in – a particular place – its past and present and those who have lived there before, which contains a cultural diversity that would strengthen the notion of cultural pluralism in the present.

This focus on place as a way of creating intercultural understanding comes close to what, in my view, is the main role of museums today, and I wish to explore the premise that heritage can 'belong' to 'place' and be an essential part of a landscape. The cosmopolitan discourse in archaeology and heritage acknowledges attachments to place and the particular social networks, resources and cultural experiences that occur within that space, although such attachments to place are often compromised or even sacrificed in the abstract framing of world heritage, transacted solely by and among nation states (Meskell 2009: 3-4). Nevertheless, section 3 of the Aboriginal Land Rights (Northern Territory) Act of 1976 provides a model for acknowledging attachment and responsibility to place, defining traditional Aboriginal owners, in relation to land, as: 'a local descent group of Aborigines who have common spiritual affiliation to a site on the land, being affiliations that place the group under a primary spiritual responsibility for that site and for the land'. It further defines Aboriginal tradition as including: 'those traditions, observances, customs and beliefs as applied in relation to particular persons, sites, areas of land, things or relationships'.

In this way it recognizes that sites, objects and persons cannot be disassociated from the land or from a responsibility towards it. This makes tangible and intangible heritage all inclusive, just as in other parts of the world objects are part of a landscape which has spiritual significance through ancestor veneration, kinship relationships and sacred locations, and this is true for Australia and many different parts of the world, for example Ghana (Kankpeyeng, Insoll and MacLean 2009: 189), and, for slightly different reasons, Scotland, with the Hilton of Cadboll stone, where there is nevertheless a powerful sense of belonging to place, with notions of inheritance and the right of occupation. Objects *can* belong to place and to the people of that place, insofar as they are experienced by communities as being integral to those places (Jones 2010).

Indeed, Johnston (1994: 7) has defined social value as a measure of collective attachment to place. He defines such places as those which provide a sense of connection with the past, tie the past affectionately to the present, provide an essential reference point in a community's identity or sense of itself, help give a disempowered group back its history, provide a sense of collective attachment to place, 'loom large in the daily comings and goings of life' and are 'places where people gather'.

George Nicholas et al. (2009: 263) argue that the utilitarian approach and the concept of ownership assume that cultural property and the knowledge associated with it can be detached from the landscapes in which it arises, and ignore – or see as less significant than economic benefit – the link between landscapes, cultural practices, and the passage of knowledge between generations:

> cultural heritage usually includes things such as artifacts, as well as places, stories, and songs that are the manifestations in the present of things and times we consider 'past', including creator beings and ancestral spirits. Concepts of

'ownership', 'property', 'past', and 'present' may well be inadequate to describe these relationships. (Nicholas et al. 2009: 264)

Museums as Loci of Deliberative Democracy

The problem is encapsulated in the 'expert culture' of museums framing their ownership of cultural property, highlighting its utilitarian value, and pronouncing on the legitimacy of external communities, in a bureaucratic and adversarial process.[3] In what way does this serve the purpose of museums? The only thing it serves is continued ownership – so in that sense ownership is a fetish, and can be defined as the central problem.

It is increasingly recognized that in many contexts the claims of connected communities can be considered primary and should be given greater weight than other stakeholders. Museums are not the primary stakeholders or arbiters of culture, and they cannot expect to control and own culture (Meskell 2009: 5-7). The current adversarial processes undermine what must be museums' key role in this globalized and fractured world: using their collections in innovative ways to foster understanding between communities and cultures. Fetishizing ownership, insisting on the cultural purity of source communities, and automatically privileging utilitarian value over social value through bureaucratic processes create conflict, not understanding. In this sense museums are obviously political spaces, and so the solution to these problems should be sought through political processes, not bureaucratic ones. How do the different interests interrelate, how can they be included in a discursive/political process, and what is the role of museums in facilitating this?

I propose that museums set aside bureaucratic processes that ask claimant communities to prove their legitimacy, relinquish an *a priori* assumption of their right to ownership,[4] and become loci of deliberative democracy. This can be defined as recognition of the right to equal participation between conversation partners, i.e. all whose interests are actually or potentially affected by the courses of action and decisions which may ensue from such conversations (Benhabib 2002: 37). It offers a different, more inclusive model for museums to follow, in which those interested in or affected by museum collections or policies, including the museums themselves, can be involved in reasoning and persuading one another about the values or course of action to be taken: crucially, this deliberative view contrasts with decision-making processes that are adversarial or in which power is delegated to authoritative experts (Fung 2006: 17).

3 For a critique of expert cultures, see Feyerabend 1987: 54-9.

4 I acknowledge that not all museums 'own' collections in the legal sense – in the United Kingdom, for example, collections in local authority museums are owned by the parent local authority and not by the museum itself.

How might this work in practice? Deliberative democracy is all about a dialogue, involving all those affected in a decision, based on fairness, in which all key issues have been delegated for decision to the group participating in the dialogue. It is not an easy process. The most effective deliberative democratic processes are based on top-down legitimation, neutral facilitation, some training of the participants, minimizing domination by, or exclusion of, some groups due to inequalities of power and voice, and in particular taking into account and minimizing differences based on different communication styles and cultural norms of argument and discourse (for example, possibilities of dominating the discussion through educational differences, aggressive communication styles, claims to expertise, gender and racial differences, and privileging of analytical argument over more poetic approaches) (Fung 2006: 71-2). All participants have an equal right to suggest topics of conversation, to introduce new points of view, questions and criticism into the conversation, and to challenge the rules of the conversation insofar as these seem to exclude the voice of some and privilege that of others. As Jürgen Habermas argues, the instrumental rationality of the Enlightenment approach has caused 'cultural impoverishment' through expert cultures monopolizing most of our activities, but this can be balanced or even resisted through debate, reflection and talk (White 1988: 116-17, Dryzek 1990: 3-25). This seems to be both a model for what a museum should be – a locus for open, respectful, egalitarian dialogue and participation around issues of interpretation of the past, personal and group identity, and rights to ownership of culture – and a model for the process to follow – a conversation to which all those affected or even interested are invited on the basis of universal respect and egalitarian reciprocity.[5]

The possibility of radical disagreement and conflict as a result of mutually exclusive and contradictory beliefs tends to make museums shy away from creating such open opportunities for dialogue. But agreement by everyone involved is not necessarily the product of such conversations. There is a problem that people from different cultural backgrounds do not share norms and values and might be unlikely to come to agreement (and this is particularly the case in restitution cases): but participants can still reach consensus based on reasoned disagreement by striving to understand the cultural tradition and/or conceptual framework of the other participants (Dryzek 1990: 42). Even when some participants disagree with group decisions, they may be more easily reconciled to the outcomes because others have justified the bases of their positions in good faith. It is a process of understanding through familiarization with other ways of thinking, and a struggle to reach mutual understanding, if not agreement, through discussion, which is surely more in keeping with the purpose of museums than adversarial and expert decision making (Valadez 2001: 91, Fung 2006: 17).

5 For case studies of various mechanisms of empowered participation in deliberative democracy, see Fung and Wright 2003 and Fung 2006.

For museums involved in restitution issues, an open and transparent deliberative democratic process to resolve the claims would be more beneficial than the bureaucratic and essentialist process of establishing criteria of ownership and rights, with its colonialist demands of proof and legitimacy. A deliberative democratic process minimizes the automatic privileging of the universalist claims of science and of the nation state, and an essentialist view of cultural groups. It offers museums a practical framework for how to include different voices and values and forms of knowledge. It acknowledges the importance of places, landscapes and their connected communities. Finally, it offers a model of how to work by bringing together all interested parties in a facilitated dialogue based on universal respect and egalitarian reciprocity. I also suggest that it offers a practical application of Tristram Besterman's call for museums to act as beacons of cultural equity, embodying fairness, participation, and relinquishing a presumption to a monopoly on knowledge and authority (see Besterman, Chapter 2). The aim of such deliberative dialogue is not (necessarily) agreement by all on the action to be taken, but to foster understanding and familiarization between individuals and cultures, which are the crucial roles of museums in today's world.

Bibliography

Aboriginal Land Rights (Northern Territory) Act 1976 [Online]. Available at: http://www.austlii.edu.au/au/legis/cth/consol_act/alrta1976444/ [accessed: 10 May 2011].

Anderson, B. 1991. *Imagined Communities: Reflections on the Origins and Rise of Nationalism*. London: Verso.

Benhabib, S. 2002. *The Claims of Culture: Equality and Diversity in the Global Era*. Princeton, NJ/Oxford: Princeton University Press.

Besterman, T.P. 2009. Returning a stolen generation. In proceedings of UNESCO Conference on the Return of Cultural Objects, Athens, March 2008. *Museum International*, May, 107-11.

Bienkowski, P. 2007. Authority over human remains: genealogy, relationship, detachment. *Archaeological Review from Cambridge*, 22(2), 113-30.

Bienkowski, P. and Coleman, E.B. 2013. Contesting 'claims' on human remains: which traditions are treated as legitimate and why?, in *Global Ancestors: Understanding the Shared Humanity of our Ancestors*, edited by M. Clegg, R. Redfern, J. Bekvalac and H. Bonney. Oxford/Oakville: Oxbow Books, 81-101.

Brown, M.F. 2003. *Who Owns Native Culture?* Cambridge MA: Harvard University Press.

Burström, M. 1999. Cultural diversity in the home ground: how archaeology can make the world a better place. *Current Swedish Archaeology*, 7, 21-6.

Byrne, D. 2009. Archaeology and the fortress of rationality, in *Cosmopolitan Archaeologies*, edited by L. Meskell. Durham/London: Duke University Press, 68-88.

Carman, J. 2005. *Against Cultural Property: Archaeology, Heritage and Ownership*. London: Duckworth.

Clare, R. 2009. The Rosetta Stone can be shared where it is. *The Telegraph* [Online] Available at: http://www.telegraph.co.uk/comment/personal-view/6776328/The-Rosetta-Stone-can-be-shared-where-it-is.html [accessed: 10 May 2011].

Cobb, A.J. 2008. The National Museum of the American Indian as cultural sovereignty, in *The National Museum of the American Indian: Critical Conversations*, edited by A. Lonetree and A.J. Cobb. Lincoln/London: University of Nebraska Press, 331-52.

Coleman, E.B. 2013. Contesting religious claims over archaeological sites. in *Appropriating the Past: Philosophical Perspectives on the Practice of Archaeology*, edited by G. Scarre and R. Coningham. Cambridge: Cambridge University Press, 156-75.

Colwell-Chanthaphonh, C. 2009. The archaeologist as world citizen: on the morals of heritage preservation and destruction, in *Cosmopolitan Archaeologies*, edited by L. Meskell. Durham/London: Duke University Press, 140-65.

Cove, J.J. 1995. *What the Bones Say: Tasmanian Aborigines, Science, and Domination*. Ottawa: Carleton University Press.

Delugan, R.M. 2008. 'South of the border' at the National Museum of the American Indian, in *The National Museum of the American Indian: Critical Conversations*, edited by A. Lonetree and A.J. Cobb. Lincoln/London: University of Nebraska Press, 384-404.

Dryzek, J. 1990. *Discursive Democracy: Politics, Policy, and Political Science*. Cambridge: Cambridge University Press.

Easlea, B. 1980. *Witch Hunting, Magic and the New Philosophy: An Introduction to Debates of the Scientific Revolution 1450-1750*. Sussex/New Jersey: The Harvester Press/Humanities Press.

Feyerabend, P. 1987. *Farewell to Reason*. London/New York: Verso.

Fforde, C. 2002. Collection, repatriation and identity, in *The Dead and their Possessions: Repatriation in Principle, Policy and Practice*, edited by C. Fforde, J. Hubert and P. Turnbull. London/New York: Routledge, 25-46.

Fung, A. 2006. *Empowered Participation: Reinventing Urban Democracy*. Princeton, NJ: Princeton University Press.

Fung, A. and Wright, E.O. 2003. *Deepening Democracy: Institutional Innovations in Empowered Participatory Governance*. London: Verso.

Greenfield, J. 2007. *The Return of Cultural Treasures*, 3rd Edition. Cambridge: Cambridge University Press.

Hodder, I. 2009. Mavili's voice, in *Cosmopolitan Archaeologies*, edited by L. Meskell. Durham/London: Duke University Press, 184-204.

Holtorf, C. 2009. A European perspective on indigenous and immigrant archaeologies. *World Archaeology*, 41(4), 672-81.

Hooper-Greenhill, E. 1992. *Museums and the Shaping of Knowledge*. London/New York: Routledge.

Hubert, J. 1992. Dry bones or living ancestors? Conflicting perceptions of life, death and the universe. *International Journal of Cultural Property*, 1, 105-27.

Ivison, D. 2006. Emergent cosmopolitanism: indigenous peoples and international law, in *Between Cosmopolitan Ideals and State Sovereignty*, edited by R. Tinnevelt and G. Verschraegen. New York: Palgrave, 120-34.

Johnston, C. 1994. *What is Social Value? A Discussion Paper*. Australian Heritage Commission Technical Publication 3. Canberra: Australian Government Publishing Services.

Jonaitis, A. and Berlo, J.C. 2008. 'Indian Country' on the national mall: the mainstream press versus the National Museum of the American Indian, in *The National Museum of the American Indian: Critical Conversations*, edited by A. Lonetree and A.J. Cobb. Lincoln/London: University of Nebraska Press, 208-40.

Jones, S. 2005. Making place, resisting displacement: conflicting national and local identities in Scotland, in *The Politics of Heritage: 'Race', Identity and National Stories*, edited by J. Littler and R. Naidoo. London/New York: Routledge, 94-114.

Jones, S. 2010. 'Sorting stones': monuments, memory, and resistance in the Scottish Highlands, in *Interpreting the Early Modern World: Transatlantic Perspectives*, edited by M. Beaudry and J. Symonds. New York: Springer, 113-42.

Kenny, C. 1996. *'It would be nice if there was some women's business'*. Pots Point: Duffy and Snellgrove.

Kreps, C. 2003. *Liberating Culture: Cross-cultural Perspectives on Museums, Curation, and Heritage Preservation*. New York: Routledge.

Layton, R. 1994. Introduction: conflict in the archaeology of living traditions, in *Conflict in the Archaeology of Living Traditions*, edited by R. Layton. London/New York: Routledge, 1-21.

Lydon, J. 2009. Young and free: the Australian past in a global future, in *Cosmopolitan Archaeologies*, edited by L. Meskell. Durham/London: Duke University Press, 28-47.

Merryman, J.H. 1986. Two ways of thinking about cultural property. *American Journal of International Law,* 80, 831-53.

Meskell, L. 2009. Introduction: cosmopolitan heritage ethics, in *Cosmopolitan Archaeologies*, edited by L. Meskell. Durham/London: Duke University Press, 1-27.

Nicholas, G., Bell, C., Bannister, K., Ouzman, S. and Anderson, J. 2009. Intellectual property issues in heritage management. Part 1: Challenges and opportunities relating to appropriation, information access, bioarchaeology, and cultural tourism. *Heritage Management*, 2(2), 261-86.

Pickering, M. 2010. Despatches from the front line? Museum experiences in applied repatriation, in *The Long Way Home: The Meaning and Values of Repatriation*, edited by P. Turnbull and M. Pickering. New York/Oxford: Berghahn Books, 163-74.

Ryan, L. 1996. Origins of a royal commission. *Journal of Australian Studies*, 48, 1-12.

Smith, M. and Mays, S. 2007. Ancestors of us all. *Museums Journal*, 107(1), 18.

Smith, P.C. 2008. Critical reflections on the Our People's exhibit: a curator's perspective, in *The National Museum of the American Indian: Critical Conversations*, edited by A. Lonetree and A.J. Cobb. Lincoln/London: University of Nebraska Press, 131-43.

Thomas, D.H. 2000. *Skull Wars: Kennewick Man, Archaeology, and the Battle for Native American Identity*. New York: Basic Books.

Thomson, J.J. 1992. *The Realm of Rights*. Cambridge, MA: Harvard University Press.

Valadez, J.M. 2001. *Deliberative Democracy, Political Legitimacy, and Self-determination in Multicultural Societies*. Boulder, CO: Westview Press.

Watkins, J. 2005. Cultural nationalists, internationalists, and 'intra-nationalists': who's right and whose right? *International Journal of Cultural Property*, 12(1), 78-94.

Weiner, J.T. 1997. 'Bad Aboriginal' anthropology: a reply to Ron Brunton. *Anthropology Today*, 13(4), 5-8.

White, S.K. 1988. *The Recent Work of Jürgen Habermas: Reason, Justice and Modernity*. Cambridge: Cambridge University Press.

Woodhead, C.C. 2002. The repatriation of human remains: more than just a legal question. *Art Antiquity and Law*, 7(4), 317-47.

PART II
Perspectives from Around the World

Chapter 4
Repatriation:
Political Will and Museum Facilities

Eeva-Kristiina Harlin and Anne May Olli

The *Sámi* Peoples

The Sámi[1] are the only indigenous people living in the European continent. Today, the Sámi inhabit the northern parts of Norway, Sweden, Finland and the Russian Kola Peninsula,[2] an area that is called *Sápmi*, the Sámi land. The Sámi land covers a vast area from the Atlantic Ocean of the Norwegian coast, across the Scandes mountain range between Sweden and Norway, the tundra of the Barents Sea coast, the bogs of Northern Sweden, the lakes and rivers of Finland to the tundra and taiga of the Kola Peninsula. According to historical sources, such as tax documents, the Sámi area was considerably larger than it is today (Aikio 2003: 39, Ojala 2009: 74). The Sámi area is divided by four different nation states and subjected to four different legal regimes and four different ways of managing cultural heritage. The definition of who is a Sámi varies from country to country. The overall population size is uncertain due to the fact that the Sámi are registered as Finnish, Norwegian, Swedish and Russian citizens. In the Nordic countries the definition is based on self-definition, language spoken by at least by one grandparent, or if one of the parents has the right to vote in the Sámi Parliament's elections. In Russia, citizens over 16 have a self-determined right to decide which nationality they belong to. It is estimated that the number of Sámi in Norway is between 30,000-50,000, Sweden 15,000-25,000, Finland 6,000-7,000, with 1500-2000 in Russia (Ojala 2009: 71, 74-5, Lehtola 2004: 10).

The Sámi languages belong to the Finno-Ugric language family. Nowadays ten different Sámi languages can be identified: they are divided into the eastern and western Sámi language groups. The western Sámi languages are North Sámi, *Lule* Sámi, *Pite* (*Arjeplog* Sámi), *Ume* Sámi and South Sámi. The eastern languages are *Inari* Sámi, *Skolt* Sámi, *Akkala* Sámi, *Kildin* Sámi and *Ter* Sámi. The languages also have different dialects and six of the languages have their own written form.

1 There is no established transliteration for the long 'a' of the North Sámi language in English. The sound can be transcribed either as á or aa. Here we use the form á, as in the word Sámi.

2 It is possible to see the geographical area at www.norgeskart.no. Sápmi is the northern part of four countries.

Ter and Akkala Sámi languages have no native speakers remaining and Ume and Pite Sámi are seriously endangered (Svonni 2008: 236 in Ojala 2009: 74). Due to the assimilation policies practised by the various nation states from the early nineteenth century onwards, many of the Sámi have lost their language. For example it is estimated that in Norway around 25, 000 people use the Sámi language (Solbakk 2006: 15, 69). North Sámi is the most extensive language spoken, with variants much fewer. Though today there are laws protecting the language, the situation is far from satisfactory. Consequently, many of the smaller and endangered languages are being rehabilitated, for example with help of special language nurseries (Solbakk 2006: 212).

Traditionally, the Sámi peoples are seen as reindeer herding nomads, but in reality only a small minority practised large-scale reindeer herding. Reindeer herding, fishing in the sea, rivers or inland lakes, small scale farming and foraging were practised depending on the geographical area and the available resources. Many practised a combination of these pursuits. Today, many work in service occupations, public services or in other professions; only a minority herd reindeer as their main occupation (Lehtola 2004: 10-12). Due to historical factors, the South, Ume, Pite, Lule, North and Inari Sámi belong to the Lutheran Church, as the Skolt, Akkala, Kildin and Ter Sámi have been members of the Russian Orthodox Church (Solbakk 2006: 49-50, 73-4). The Finnish Skolt Sámi are members of the Finnish Orthodox Church. After the Second World War the Finnish Orthodox Church has autonomy under the protection of the Patriarchate of Constantinople (www.ort.fi).

The Sámi Parliaments and the Administration of Cultural Heritage

Today, the Sámi are recognized as indigenous peoples and their linguistic and cultural rights are secured in the constitutions of Norway, Finland and Sweden. Each country has its own Sámi Parliament with elected members and civil servants. The political status of the Sámi peoples, and hence the Sámi Parliaments, vary between the different countries (Ojala 2009: 71). Together the Sámi Parliaments form the Sámi Parliamentary Council, to which the Russian Sámi Association of the Kola Peninsula also belongs (Lehtola 2004: 69). In 2007 the United Nations 'Declaration on the Rights of Indigenous Peoples' was adopted by the General Assembly. The Nordic countries voted in favour. However, only Norway has ratified the 'Indigenous and Tribal Peoples Convention', the so called ILO 169 convention. Whether to ratify or not is still under discussion in Sweden and Finland (Ojala 2009: 231). Although the Sámi are one people, and therefore have similar challenges in each country, in this chapter we concentrate on the situation of repatriation in Norway. Initial discussions about repatriation began internally among the Norwegian Sámi during the 1980s. At the International Council of Museums (ICOM) General Conference held in Stavanger, Norway in 1995, the reigning president of the Norwegian Sámi Parliament, Ole Henrik Magga, requested that repatriation of Sámi cultural heritage should happen. However,

no claims were made (Pareli 19.1. 2012 email). In a report about museum development in Norway in 2000, it was mentioned that the Sámi Parliament has the responsibility to enhance the discussion of repatriation of the Sámi collections in Norway (Norsk museumsutvikling 2000: 42). From the beginning of the twenty-first century, the *Sámi Museasearvi*[3] began active discussions regarding repatriation. In the annual meeting in 2003, co-operation between Sámi peoples, for example, in the matter of repatriation, was addressed. Here it was decided that Finland, Norway and Sweden would apply EU-finance to a common repatriation project, 'Recalling Ancestral Voices' (Harlin 2008b: 5). In Norway the debate on repatriation has perhaps been more active than in Finland[4] and Sweden,[5] and in Norway negotiations on repatriation are underway (see for example Harlin 2008a, 2008b, Ojala 2009). As employees in the oldest Sámi museum – the Norwegian Sámi Museums, *RiddoDuottarMuseat-Sámiid Vuorká-Dávvirat* established in 1972 – we are well acquainted with the situation in Norway (Solbakk 2006: 99). The Norwegian Sámi Parliament has the task of dealing with the range of language and culture-related issues that affect the Sámi. However, the Sámi Parliament is only an advisory organ. Sámi cultural heritage encompasses a variety of issues, from archaeological sites to artifacts, cultural landscapes, sacred sites, buildings, handicrafts, languages, folklore, and other forms of traditional knowledge (Ojala 2009: 231). In 1994, Sámi cultural heritage came under the administration of *Sámi kulturmuitoráđđi*, the Sámi Cultural Heritage Council, a management body organized under the Sámi Parliament. From 2001, due to the reorganization of the Sámi Parliament, the Department of Environment and Cultural Heritage took over the management of cultural heritage (Solbakk 2006: 173, 179). Nowadays the geographical administration stretches from Finnmark to Hedmark, which is a large area.[6] Since 2002, the Sami Parliament has been responsible for the political administration of Sámi museums in Norway.

3 The Sámi museums society consists of all Sámi museums in Norway, as well as Norwegian museums with collections of Sámi objects. The Finnish and Swedish Sámi museums participate at annual meetings.

4 The Finnish Sámi Museum, Siida, administered the EU-financed Interreg-project, 'Recalling Ancestral Voices', between 2006 and 2008. However the question of repatriation was brought up by the director of the Finnish Sámi museum, for example, at a conference about repatriation of Sámi cultural heritage in Ájtte, the Swedish Mountain and Sami Museum, in 2000 (Duoddaris 2002: 35-6).

5 In 2000 a conference about repatriation of Sámi cultural heritage took place in Ájtte, the Swedish Mountain and Sami Museum, where Finnish and Norwegian Sámi representatives also participated (Duoddaris 2002). Ájtte, the Swedish Mountain and Sami Museum, and the Swedish Sámi Parliament decided to start a project relating to the repatriation and survey of Sámi collections in Swedish and European museums (Edbom 2005: 3).

6 This area is approximately 160,000 m^2 (www.norgeskart.no, accessed 13 February 2012).

Sámi Cultural Objects and Collections: Background and Meaning

The Sámi area is rich in natural resources and the exploitation of these resources has brought about a long tradition of documenting, collecting and studying the Sámi area and culture. After Olaus Magnus's, *Historia de gentibus septentrionalis* (Historia om de nordiska folken), was published in 1555, Northernmost Europe became interesting for outsiders. These activities were mainly carried out by non-Sámi people, such as priests, teachers or scholars (Lehtola 2004: 16-17). Thus, the majority of written histories have been produced by people who have rarely had the will or the capability to understand the diversity of Sámi culture. This has of course led to many stereotypical perceptions, which are still current today. Due to the active collecting of tangible and non-tangible Sámi culture, the vast majority of the older objects are to be found in museums and institutions outside the contemporary Sámi area. Some of the objects were traded, but, for example, sacred objects, such as religious drums, were taken forcibly by priests or as a result of legal proceedings during the seventeenth and eighteenth centuries (Westman 2002: 55). In practice, there is a wide diversity of cases, each with different circumstances. But the collections are nevertheless tainted by being part of the legacy of a history in which the Sámi people were considered to be 'exotic', 'primitive' and 'inferior'. This fact makes the collections value-loaded and their existence sometimes even traumatic for the Sámi people. The most brutal example is the collection of osteological material. Grave robberies, for the purpose of anatomical research, were conducted as late as the 1950s (for more information see Ojala 2009).[7] This kind of action was never accepted by the Sámi themselves and in the Orthodox Christian areas, the priests also resisted it (Schanche 2002a: 99-100, Schanche 2002b: 30, Ojala 2009: 228, 242-9, 267, 228).

However, collecting Sámi material culture and folklore, and storing it in museums, also preserved it. The Second World War had a massive impact on the Sámi areas in Norway and Finland. The 'scorched earth' policies of the Germans and the ensuing forced evacuation of the peoples from the native areas destroyed

7 In Norway, Sámi human remains are physically situated at the Schreinerske Samlinger (The Schreiner Collections), at the Anatomical collections of Oslo University Anatomical Institute. Since 1998, the Norwegian Sámi Parliament has had the right to decide who can use or study the collections of Sámi human remains. Sámi human remains are preserved separately from other collections in the anatomical collections (Schanche 2002b: 29-30). In Finland, the University of Helsinki returned parts of Sámi human remains from the anatomical collections to Inari where they were reburied in 1995. The rest of the collection of Sámi human remains was returned in 2001 from the University of Helsinki. The human remains are stored at Siida, Sámi museum, and they are administered by the Sámi museum and Sámi Parliament. However, they do not have the right to reburial (Harlin 2008: 196). In Sweden there are several anatomical collections with Sámi human remains. There have been some examples of successful repatriations and reburials, while other cases are still being discussed between the Swedish Sámi Parliament and negotiating parties (Ojala 2009: 251-64).

a great deal of the material culture of the Finnish and Norwegian Sámi peoples. For example, the period of evacuation and the influence of Norwegian and Finnish culture had the effect of changing the use of traditional clothing for good, from every day wear to festive wear (Lehtola 2004: 55). After the Second World War and the period of evacuations, the Sámi themselves began to collect their own cultural heritage. Hence, the Sámi museums have collections that represent the material culture dating from the post-war era, as the older material remains in museum collections outside the core Sámi area (Jomppanen 2002: 35).

The Repatriation and Survey of Collections

Towards the end of the twentieth century, the issue of repatriation became increasingly important for indigenous peoples around the world, including the Sámi. It was evident that, like other indigenous groups, the Sámi themselves were best qualified to represent their own culture, and to mediate it to future Sámi generations, as well as to the population at large. Even so, repatriation has not been widely discussed in the Nordic countries until recently (Duoddaris 2002, Edbom 2005, Harlin 2008a, 2008b, Ojala 2009). In Russia cultural heritage management and rights of indigenous peoples are rather different than that in Scandinavian countries. Only in recent years has there been some discussion of repatriation and reburials amongst anthropologists and archaeologists (Ojala 2009: 268).

To progress the debate on the repatriation of material culture from museum collections to the Sámi museums in the Nordic countries, it is necessary to clarify the history, nature and situation of the objects and collections. In Sweden, surveys were conducted (for example Edbom 2005). In 2006, a two year project, 'Recalling Ancestral Voices – Repatriation of Sámi Cultural Heritage' was initiated, a collaborative project between three Sámi museums: *Várjjat* in Norway, *Siida* in Finland and *Ájtte* in Sweden (Harlin 2008a, 2008b). The aim of 'Recalling Ancestral Voices' was to collect information about Sámi cultural objects in the Nordic countries and to create a database that would be accessible on the Internet. In particular, the goal was to give Sámi people, Sámi organizations and handicrafts an opportunity to get to know their own cultural heritage, and to gain information on their collections and history. One important aim was to have the name of the objects rendered in the Sámi language appropriate to their place of origin. In many areas the terminology is vanishing, which is regrettable, since often the Sámi terms are more explanatory than, for example, the Norwegian names. It was also the intention to initiate discussions about future repatriations, and to discuss the best way, and the most appropriate institution to house Sámi collections. Mutual respect and understanding were keywords (Harlin 2008a, 2008b).

During the survey of non-Sámi museums, it became evident that knowledge of Sámi culture and Sámi objects was often inadequate. In many cases, it was difficult to define whether the objects were Sámi or not. Material culture used, for example, in fishing and agriculture is often similar in different groups. It is

clear that in such cases a person having the cultural knowledge will be able to determine more information – for example from the location of the collecting site (Harlin 2008b). This example shows that repatriation should be seen as a process of dialogue and the exchange of knowledge and experience between parties in order to create new understanding amongst them (for example Ojala 2009: 229).

According to the 'Recalling Ancestral Voices – Repatriation of Sámi Cultural Heritage' survey, it was estimated that there are around 25,000 Sámi objects in non-Sámi museums and approximately 11,000 Sámi objects in Sámi museums in Norway. In Sweden, the estimated figure is 25,000 in 39 non-Sámi museums and around 11,000 in Sámi museums or institutions. In Finland, there are approximately 5,000 objects in 24 non-Sámi museums and 4,200 in one Sámi museum. Probably the figure is a lot greater (Harlin 2008b). In order to interrogate information on the Sámi objects and collections, a database with a web browser was established. Unfortunately, due to lack of time and the large amount of work to be done, only a part of the collections were available on the www.samicollection.org. The Internet browser functioned until the end of 2010, when funding ran out.

By the end of the project in early October 2007, a seminar in Inari on the subject of repatriation at the Finnish Sámi Museum, *Siida* was arranged. A variety of speakers came from Alaska, Finland, Greenland, Denmark, Norway and Sweden. They represented Sámi and non-Sámi researchers, Sámi politicians, Sámi and non-Sámi museum professionals and local traditional craftsmen or *duojárat*.[8] The seminar offered the possibility for each group to present their views on repatriation. During the discussions, the importance to researchers, and especially Sámi craftspeople of gaining access to museum collections was emphasized. Real cultural elements such as clothing, which has already disappeared due to colonization and assimilation policies practised before the Second World War, as well as the forced evacuation, have been revived by studying old collections. Representatives from national museums, which administer the largest and oldest Sámi collections, also presented their viewpoints. The high point of the seminar was when representatives from the Norwegian Norsk Folkemuseum (The Norwegian Museum of Cultural History) and the Swedish Nordiska Museet announced that they were ready to discuss the repatriation of parts of their collections to Sámi museums. The Norsk Folkemuseum and the Nordiska Museet administer the largest collections of Sámi objects located outside Sámi regions. However in Finland, the question of repatriation of the largest Sámi collections located in non-Sámi areas, has yet to be discussed (Harlin 2008a, 2008b).

8 Duojár is a North Sámi word for a person who makes traditional handicrafts.

The Repatriation and Use of Museum Collections

Repatriation has not been an issue of great currency in Scandinavian countries. No legislation exists regarding the repatriation of cultural heritage, and only a handful of claims have been made to museums. There is a small number of examples of repatriation to the Sámi (Mulk 2002, Söderholm 2002, Edbom 2005, Schanche 2002b). The repatriation cases mostly relate to old anatomical collections in Finland, Norway and Sweden. In Finland the anatomical collections are currently situated at *Siida*, the National Museum of the Finnish Sámi, and some have been reburied (Söderholm 2002: 3, 6-7). In Norway and Sweden, the Sámi parliaments are working with the issue (Ojala 2009: 257-61). In Norway, in particular, the anatomical collections of the Skolt Sámi were interred in the old graveyard in Neiden at the end of September 2011 (www.sor-varanger.kommune.no).

Some of the more recent Sámi museums, such as *Várjjat Sámi Musea*, Varanger Sami museum and *Árran julevsáme guovdásj*, Árran lulesami centre, both of which were established in 1994, are located in places that have been strongly assimilated, for example in the coastal Sea Sámi areas (www.varjjat. org, www.arran.no). This means that the Sámi material culture characteristic of these areas has already disappeared and is only to be found in non-Sámi museum collections. In the 1990s it became popular to recreate traditional costumes. This was done with the help of museum collections situated outside Sámi areas. In 2010, *Áltta Sámi Giellaguovddáš*, the Alta Sámi Language Centre produced a photographic exhibition, 'Du skal ikke leite lenge før komagtuppan stikk fram' on the reconstructed costumes. Material culture, handicrafts, Sámi *duodji*[9] have always had an important place in Sámi culture. *Duodji* has a strong role in preserving both language and culture (Lehtola 2006: 12). Today, Sámi ethnicity is expressed through material objects, especially clothes. The traditional costume, *gákti*,[10] is worn on many occasions, and is one of the most distinct symbols of the Sámi people. The *gákti* identifies the geographical area, marital status, sometimes even the family of the wearer. It contains 'sign language' and meanings that are recognized by the peoples themselves, but not by outsiders (Aikio 2010: 16-17, Lehtola 2004: 12). Therefore, clothing is important not only for individuals, but for Sámi society as a whole. The *gákti* communicates the identity of the wearer (Dunfjell 2003: 166-7). Nowadays it is very popular to try new materials when making traditional costume; inspiration is taken, for example, from the museum collections. In the North Sámi area it has been popular to model costumes on nineteenth-century ones. Young people, especially, articulate their ethnicity by wearing parts of the traditional costume in daily life. This is done in a way that respects traditional values and beliefs.

9　Sámi *duodji* is the North Sámi word for traditional handicrafts.
10　*Gákti* is the North Sámi word for traditional clothing.

Problematic Repatriation

The Sámi Parliament has begun negotiations over the repatriation of Sámi objects to Sápmi and Sámi museums. However, the politicians are not necessarily taking into account whether the museums are able to manage all the practical issues entailed by repatriation. One of the main problems is with pesticides. The majority of Sámi objects are made of organic material – fur, leather, wood, textiles, bone and antler (see Figures 4.1 and 4.2). Conservation has been necessary in order to preserve the objects. However, pesticides used have been shown to be hazardous to health. For example, Dichlorodiphenyltrichloroethane, or DDT, has been in use from the mid-1930s to 1987 as a very effective insecticide. Studies have shown that DDT is complicit in the development of lung and throat cancer, as well as brain damage (Schmidt 2001: 92). Sámi museums were unaware of this until recently.

The information Sámi museums have on pesticides is mainly from research and repatriation cases in the USA and Canada. Miriam Clavir (2002) has discussed research in Canada, the USA and New Zealand that takes into consideration indigenous perspectives. Clavir also mentions the handling of contaminated objects, both in storage management, exhibitions and repatriation.

While Sámi museums have the responsibility of preserving such items if repatriated, this will, however, expose the lack of trained conservators in these institutions and their inadequate awareness of the potential hazards of handling such contaminated material. Many museums in Norway do not have the necessary facilities to manage pesticide issues.

In Norway, only one Sámi museum has an object conservator. Some of the museums have modern storage areas, and even modern conservation laboratories, but no collections. It makes things difficult when the resources are not located in the same place. Some of the museums, situated in the core Sámi areas, also lack adequate storage facilities. In other words, at present, the Sámi museums do not have the resources to manage pesticides appropriately. No research on pesticides has been conducted in Sámi museums or in the Sámi collections of the Norwegian museums. Nor has any research been done in this field from a Sami perspective. The Sámi museums would like to maintain the Sámi traditional knowledge in treating, for example, skin and fur objects. In such work, the problem of pesticides must be considered.

The Norwegian Sámi Parliament established a working group in 2009, which will confront the challenges faced in the repatriation of Sámi objects from the *Norsk Folkemuseum* (The Norwegian Museum of Cultural History) to Sámi museums in Norway. The working group consists of representatives from the Sámi Parliament and Norsk Folkemuseum, while the *Samisk Museumslag* (Sámi Museum Society), is also represented. The working group is considering how to repatriate in practice, and also the particular challenges of dealing with the rightful ownership of different objects. The committee is looking to the *Utimut* project – the repatriation of objects from Greenland to the National Museum in Nuuk from the Danish National Museum. Bjarne Grønnow and Einar Lund Jensen (2008: 180-91)

Figure 4.1 *Duodji. Muituiguin/Med minnen* **(with memory). Skin bag made of reindeer skin and goat fur, textile and reindeer horn. Artist: Anna Stina Svakko (2007). Sámi contemporary art collection (SVD-da 0776). Photographer: Marvin Pope. Copyright: RiddoDuottarMuseum**

Figure 4.2 *Duodji. Saltflaske* (saltbottle), made of roots from birch,
 reindeer horn and reindeer skin. Artist: Ellen Kitok
 Andersen (2005). Sámi contemporary art collection
 (SVD-da 0737). Photographer: Marvin Pope. Copyright:
 RiddoDuottarMuseum

have written on this project, which is a very good example of how repatriation should be conducted. The conservation undertaken in this project indicates that many of the objects had been treated with a wide variety of insecticides. This includes DDT, which had proved effective against numerous insect infestations and, as mentioned earlier, was the major insecticide until around 1987 (Schmidt 2001: 92). It can be assumed that the Sámi objects have also been treated similarly to the Greenland objects, since the majority of the artefacts are organic.

Since the 1980s, Sámi peoples have also taken an active role in scientific endeavours. A great deal of research has been published from an emic point of view, produced for example in Sámi University College (*Sámi Allaskuvlla*) in Kautokeino *Guovdageaidnu*,[11] Norway 1989. At present, methods for collecting and repatriating traditional knowledge in a manner proper to Sámi societies are under study in a project known as *Árbediehtu*,[12] led by Sámi Allaskuvlla. *Árbediehtu* is a collaborative project with the Sámi institutions *RiddoDuottarMuseat, Árran, Saemien Sijte, Sjøsamisk Kompetansesenter* og *Fávllis – samisk fiskeri forskningsnettverk*,[13] It emphasizes ownership of traditional knowledge by local Sámi societies (www.arbediehtu.no). Throughout this project, the RiddoDuottarMuseat focused on skin materials (2009-11), and demonstrated that it is possible for Sámi museums to preserve traditional techniques as well as the objects. The Sámi have traditionally treated skin and fur in special storage systems, in small houses outdoors (*áiti*).[14] Modern museums frequently use a cold room storage system, often in a basement with concrete walls. The problem with such basements is incorrect humidity and salt blooms. At the same time, the air circulation is bad and fungus may become an additional problem. The interviews with traditional informants[15] in the Árbediehtu project concluded that fur would be better off in traditional storage instead of museum storage. However, the museums need to study the consequences for different types and combinations of materials. In a storage cottage outdoors, the museum would have greater challenges with pest control, and pesticides would be a larger issue than they are today. The climate is also changing, as suggested in the ACIA (Arctic Climate Impact Assessment) study, with warmer winters in the north; insects that were not present in the far north are now adapting to these habitats (ACIA 2004). Traditionally, in winter, fur was suspended from the ceilings of these small cottages, where air circulation is

11 Guovdageaidnu is the Sàmi name of Kautokeino.

12 *Árbediehtu* is the North Sámi term for traditional knowledge.

13 These are Sámi names of institutions in Norway. RiddoDuottarMuseat, Árran and Samien Sijte are Sámi museums. Sjøsamisk Kompetansesenter means coastal Sámi centre, and samisk fiskerinettverk means Sámi fisheries network, named Fàvllis.

14 *Áiti* is the North Sami word for small storage cottages.

15 In the *Árbediehtu* project Marit Hætta Sara, Kautokeino and Berit Marie Kemi, Karasjok were interviewed as bearers of traditional knowledge (elders) about storage. Their conversations were filmed in 2010.

good and where in summer they are protected against mice and insects in wooden boxes (*giisát*[16]). The summers are – or were – short and the fur survived well.[17]

A good understanding of objects is, of course, essential when it comes to management, handling and treatment of aboriginal skin objects, interpreting the various aspects of the materials and substances used, and the effect they may have on the preservation of the objects (Klokkernes and Olli 2008: 109). This understanding applies to traditional treatment, and also to pesticide treatment over the years.

If Sámi museums receive pesticide infected objects in their collections, a plan of how to manage contaminated objects must be made. As is well known, many museum records contain incomplete information on former treatment of objects. Insecticide treatment may not always be mentioned, which necessitates archival research on, for example, chemicals used, correspondence with other institutions or receipts of purchase (Harlin 2008a, 2008b). The Sámi museums do not have the equipment or human resources to manage this kind of work and are therefore dependent on external funding. Another possibility is that donor museums with adequate facilities and resources conduct the identification and cleaning of possible insecticides before actual repatriation. As mentioned earlier, repatriation is the responsibility of the Sàmi Parliament in Norway and the Sámi museums are under the administration of the Sámi Parliament.

In 2007 a workshop about Pesticide Mitigation in Museum Collections was held at the Smithsonian Museums Conservation Institute (MCI). In 2010, the proceedings from the MCI workshop were publicized. Here, research on different cleaning methods was presented. One example noted the use of liquid and supercritical carbon dioxide as a cleaning and decontamination agent (Tello and Unger 2007: 35). The Sámi museums do not have equipment or professionals for using such advanced techniques and they must be content with methods such as dry-cleaning (vacuum cleaner) and good air filter-utensils. Nonetheless, contamination management plans need to be formulated for each and every museum.

Conclusion

At the moment Sámi museums are working with the issue of making their collections more visible to the public. In the future, the Norwegian Sámi museums will be able to register the collections in Sámi languages in the *Primus* database, which is used in the majority of Norwegian museums. As more museums start to use *Primus*, more Sámi objects situated in non-Sámi museums will be visible on the Internet. The Sámi museums in Norway have for many years been working

16 *Giisá* is the Northern Sámi word for medium size wooden boxes, which the Sámi people traditionally have used for storage.

17 Conclusion from interviews with Marit Hætta Sara and Berit Marie Kemi 2010.

with the issue of getting *Primus* written in the North Sámi typeface (see for example Harlin 2008b). Currently the test version of the programme is in use in the Norwegian Sámi museums. The programme is now able to handle North Sámi typeface although the programme itself is still in Norwegian. After the collections are registered in *Primus*, it is possible to use the Internet browser, *Digital Museum*, which enables the collections to be seen and registered in a variety of Sámi languages. This is very important, as it will not only strengthen the use of Sámi terminology, but also emphasizes the importance of Sámi languages and thus helps to strengthen Sámi identity.

Repatriation is not only a question of the transfer of ownership, control over artefacts or human remains. It is also a question of traditional knowledge and values (Ojala 2009: 229, Schanche 2002b: 31-2). Sámi museums do not wish to repatriate everything back to Sápmi and Sámi museums. However, it is considered important to get the oldest and rarest objects returned. Such material includes sacred remains of traditional religions which have a symbolic meaning. Returning older objects to Sámi museums will enable people to study ancient techniques and methods, and therefore retrieve lost knowledge, as exemplified in the project 'Long Ago Sewing We Will Remember', by Judy Thompson and Ingrid Kirsch (2005). The aim of this project was to revitalize the skills and knowledge used to make traditional clothing. The organization of this project shows a new way of co-operating between indigenous peoples and museums. As mentioned earlier, such cooperation is already familiar between the Sámi museums and the local peoples.

As described earlier, information about collections and objects, such as costumes, is important: knowledge of one's own cultural heritage is power. We acknowledge that it is important to present Sámi culture in non-Sámi museums, but we argue that it should be done in collaboration with Sámi peoples. As Norwegian Sámi archaeologist Audhild Schanche (2002b) emphasizes, claims for repatriation should not be understood foremost as a discussion of the legal ownership of the Sámi heritage but rather as the responsibility for the heritage and its future. In non-Sámi museums, Sámi culture is occasionally presented in ways that can be offensive. For example traditional clothing is put together incorrectly, elements from different regions are presented together or even gender-related clothing is displayed in relation to the wrong gender. All in all, this shows incompetence or ignorance to cultural norms. The museum visitor is given an interpretation of Sámi culture through foreign eyes, an interpretation that may be foreign to the Sámi themselves, and thus perpetuates stereotypes. We believe that good dialogue can help non-Sámi museums show Sámi culture in an accurate manner – after all, the right to administer one's own heritage is the right to one's own past.

Bibliography

ACIA. 2004. *Key Finding #3: Arctic Vegetation Zones Are Very Likely to Shift, Causing Wide-ranging Impacts* [Online]. Available at: http://amap.no/acia/ [accessed: 30 August 2011].

Aikio, A. 2003. The geographical and sociolinguistic situation, in *Siiddastallan – Siidoista kyliin*. Publication of the Inari Sámi Museum 5, edited by J. Pennanen and K. Näkkäläjärvi. Siida Sámi Museum, Inari: Pohjoinen, 34-40.

Aikio, Á. 2010. Johdanto, in Suoma Sámegávttit. Suomen saamelaispuvut. Inari: Sámi Duodji ry.

Arbediehtu project [Online]. Available at: http://www.arbediehtu.no/article.php?id=126 [accessed: 23 February 2012].

Árran Julevsámi guovdásj. Árran lulesami-center [Online]. Available at: http://www.arran.no/frontpage.43226.en.html [accessed: 17 January 2012].

Clavir, M. 2002. *Preserving What Is Valued – Museums, Conservation, and First Nations*. Vancouver: University of British Columbia Press.

Dunfjell, M. 2003. Samekofte som verdi, in *Árvvut Árvo Vierhtie* Samiske verdier, edited by E. Hætta Eriksen. Árvokommišuvdna. Verdikomisjonen. Karasjok: Davvi Girji OS, 163-8.

Duoddaris 2002. *Vem Äger kulturarvet? Anföranden vid konferens om återföringsfrågor vid Ájtte, Svensk Fjäll-och Samemuseum 6-8 juni 2000*. Duoddaris 20. Jokkmokk.: Ájtte, Svensk Fjäll-och Samemuseum.

Edbom, G. 2005. Samisk kulturarv i samlingar. Rapport fra ett projekt om återföringsfrågor gällande samiska föremål. *Arkeologisk rapport*: 1 (2nd version): Ájtte, Svensk Fjäll- och Samemuseum.[Online]. Available at: http://www.ajtte.com/wp-content/uploads/2010/10/Samiskt_kulturarv_i_samlingar.pdf [accessed: 24 February 2012].

Grønnow, B. and Jensen, E.L. 2008. Utimut: Repatriation and collaboration between Denmark and Greenland, in *Utimut. Past Heritage – Future Partnerships – Discussions on Repatriation in the 21st Century*, edited by M. Gabriel and J. Dahl Copenhagen, Denmark: Eks-Skolens trykkeri, 180-91.

Harlin, E-K. 2008a. Repatriation as knowledge sharing – returning the Sámi cultural heritage, in *Utimut. Past Heritage – Future Partnerships – Discussions on Repatriation in the 21st Century*, edited by M. Gabriel and J. Dahl, Copenhagen, Denmark: Eks-Skolens trykkeri, 192-201.

Harlin, E-K. 2008b. *Recalling Ancestral Voices – Repatriation of Sámi Cultural Heritage. Prosjektets Interreg IIIA Slutrapport*. Siida Sámi Museum, Inari. [Online]. Available at: http://www.samimuseum.fi/heritage/svensk/Loppuraportti/Slutrapport.pdf [accessed: 24 February 2012].

Jomppanen, T. 2002. Current Situation of the Sámi Heritage in Finland, in *Vem Äger kulturarvet? Anföranden vid konferens om återföringsfrågor vid Ájtte, Svensk Fjäll-och Samemuseum 6-8 juni 2000*. Duoddaris 20 Ájtte, Svensk Fjäll-och Samemuseum Jokkmokk, 29-34.

Klokkernes, T. and Olli, A.M. 2008. Understanding Museum Artifacts; The Role of Tradition Bearers and Material Analysis in Investigating Skin Processing Technology. *Preserving Aboriginal Heritage: Technical and Traditional Approaches.* *Proceedings of Symposium 2007*, edited by. C. Dignard et al. Canadian Conservation Institute, Canada. 109-14.

Lehtola, J. et al. 2006. *Sámi Duodji. Saamen käsityö.* Sámi Handicraft. Sámi duodjesearvvi 30-jagi ávvudančájáhusa čájáhuskataloga. Saamen-käsityöyhdistyksen 30-vuotisjuhlanäyttelyn näyttelyluettelo. Catalogue for the Jubilee Exhibition of the Sámi Handicraft Association's 30th Anniversary. Sámi museum – Saamelaismuseosäätiö and Sámi Duodji ry. Saarijärvi: Saarijärven Offset.

Lehtola, V-P. 2004. *The Sámi People – Traditions in Transition.* Inari: Kustannus-Puntsi.

Mulk, I-M. 2002. Samiska museer och förvaltningsorgan – identitet och kulturarv, in *Vem Äger kulturarvet? Anföranden vid konferens om återföringsfrågor vid Ájtte, Svensk Fjäll-och Samemuseum 6-8 juni 2000.* Duoddaris 20. Jokkmokk,: Ájtte, Svensk Fjäll-och Samemuseum, 11-20.

Norgeskart, Statens Kartverk [Online], Available at: http://www.norgeskart.no/adaptive2/default.aspx?gui=1&lang=2 [accessed 23 February 2012].

Norsk Museumsutvikling, 2000. *Utlån og avhending av materiale fra museenes samlinger.* Norsk Museumsutviklings skriftserie 5: Norsk museumsutvikling, 39-43.

Ojala, C-G. 2009. Sámi Prehistories. The Politics of Archaeology and Identity in Northernmost Europe. *Occasional Papers in Archaeology* 47. Uppsala Universitet. Institutionen för arkeologi och antikk historia: Uppsala Universitet.

Olaus Magnus 2001. *Historia om de nordiska folken.* Hedemora: Gidlunds Förlag.

Pareli, L. 2012: Personal communication, email 19.01.2012.

Schanche, A. 2000. *Graver i ur og berg. Samisk gravskikk og religion fra forhistorisk til nyere tid.* Karasjok: Davvi Girji.

Schanche, A. 2002a. Knoklenes verdi: om forskning på og forvaltning av skjelettmateriale fra samiske graver, in *Samisk forskning og forskningsetik.* Publikasjon nr. 2. Oslo. Den nasjonale forskningsetiske komité for samfunnsvitenskap og humaniora. Oslo: Aktiv Trykk as, 99-133.

Schanche, A. 2002b. Museer, gjenstander, rättigheter, in *Vem Äger kulturarvet? Anföranden vid konferens om återföringsfrågor vid Ájtte, Svensk Fjäll-och Samemuseum 6-8 juni 2000.* Duoddaris 20 Ájtte, Svensk Fjäll-och Samemuseum Jokkmokk, 29-34.

Schmidt, O. 2001. Insecticide Contamination at The National Museum of Denmark; A Case Study. *Collection Forum,* 16, 92-5.

Söderholm, N. 2002. *Den anatomiska bensamlingen vid Helsingfors universitet.* Pro gradu –avhandling, Unpublished magister thesis in archaeology. University of Helsinki.

Solbakk, J.T. 2006. *The Sámi People – A Handbook.* Karasjok: Davvi Girji OS 2009.

Sør-Varanger Kommune, 2011, *Verdig og respektfull gjenbegravning i Neiden* [Online]. Available at: http://www.sor-varanger.kommune.no/verdig-og-respekt full-gjenbegravning-i-neiden-.4964283.html. [accessed: 24 February 2012].

Suomen Ortodoksinen Kirkko. *Orthodox Church in Finland.* [Online]. Available at: http://www.ort.fi/en/kirkkotutuksi/orthodox-church-finland [accessed: 16 January 2012].

Svonni, M. 2008. Sámi languages in the Nordic countries and Russia, in *Multilingual Europe: Facts and Policies,* edited by G. Extra and D. Gorter. Berlin and New York: Mouton de Gruyter, 233-49.

Tello, H. and Unger, A. 2010. Liquid and Supercritical Carbon Dioxide as a Cleaning and Decontamination Agent for Ethnographic Materials and Objects. In *Pesticide Mitigation in Museum Collections: Science in Conservation. Proceedings from the MCI Workshop Series 2007,* edited by A.E. Charola and R.J. Koestler. Washington DC. Smithsonian Institution Scholarly Press, 35-50.

Thompson, J. and Kritsch, I. 2005. *Yeenoo dài' k'è 'tr 'ijilkai' ganagwaandaii = Long ago sewing we will remember: the story of the Gwich'in Traditional Caribou Skin Clothing Project.* Gatineau, Québec: Canadian Museum of Civilization.

Várjjat Sámi Musea. *About the museum.* [Online] Available at: http://www.varjjat. org/web/index.php?sladja=79&giella1=eng [accessed: 17 January 2010].

Westman, A. 2002. Samiska trummor, vilken är deras betydelse i dag, in *Vem Äger kulturarvet? Anföranden vid konferens om återföringsfrågor vid Ájtte, Svensk Fjäll-och Samemuseum 6-8 juni 2000.* Duoddaris 20. Ájtte, Svensk Fjäll-och Samemuseum Jokkmokk, 55-8.

Chapter 5

The Practice of Repatriation: A Case Study from New Zealand

Conal McCarthy

In New Zealand as elsewhere, there has been a great deal of apprehension among museum professionals about the apparent threat repatriation poses to their museum collections. At the Museums Aotearoa Conference in Gisborne in April 2009, the second day of the conference was spent at Whāngārā marae, a local tribal community centre, where issues of importance to Māori were discussed. After a long day of being welcomed, wined and dined and hosted with typical generosity, Api Mahuika (tribal leader and chairman of the local museum's Board of Trustees) stood to speak. A skilled orator, he simultaneously defused the tension and reminded everyone of the underlying reason for this charm offensive, earning a laugh from the professionals present when he urged them to eat, drink and make themselves at home. I recall his final words very well. 'We want you to have a *really* good time', he declared, 'so that when we come along and say we want to repatriate some of our *taonga* (treasures), you will say...Take it away!'

Humour is a useful asset with this sensitive topic, which generates so much emotion among indigenous people, consternation among professionals, and more heat than light among both. I cannot explore repatriation in any detail here, but attempt to make some general observations about developments in current policy and practice that push beyond the endless legal disputes, circular arguments of right and wrong and highly theoretical defences of Western cultures of collecting (Brown 2003, Conn 2010). It seems to me that debate about repatriation and restitution, while lively and wide-ranging, is often too academic and isolated from real objects, people and situations. A notable exception was the conference at the University of Manchester in July 2010 that gave rise to this volume which featured several papers about the practical processes of working through particular cases of repatriation in post-settler nations like Australia and Canada which offer ways of illuminating this complex and contested topic.

After some background on the particular historical and social context of New Zealand society, this chapter surveys recent initiatives in the repatriation of artefacts and human remains in museums, and then analyses a case study concerning the meeting house *Te Hau ki Tūranga* at the Museum of New Zealand Te Papa Tongarewa (Te Papa). In drawing out lessons from this case, the argument moves away from the common themes in the literature on this topic – representation, the politics of identity, cultural property – and instead explores the practical steps that

museum professionals are taking to work with source communities to achieve negotiated outcomes that in the process transform museum practice (Fforde, Hubert and Turnbull 2002, Pickering 2010, O'Hara 2012).

Repatriation in New Zealand Museums

How do museums in former settler colonies take account of a historical legacy of conflict and dispossession as well as the contemporary demands of restitution and reconciliation? In Aotearoa New Zealand the last 30 years has seen a complex and contested process of 'domestic decolonization' in which public institutions have reoriented themselves around the principle of 'partnership' between the Crown and the indigenous Māori people promised in the Treaty of Waitangi signed in 1840 (Belich 2001: 466-87). The settlement of Treaty claims by tribes (*iwi*) has given rise to difficult political issues such as the co-management of cultural and natural heritage, the compiling of '*taonga*' databases (inventories of ancestral treasures), and the building of independent cultural centres. The 'R' word, repatriation, is a hotly debated aspect of this changing scene, whether it is the actual return of disputed museum collections or the virtual sharing of data through digital repatriation (McCarthy 2011: 216-21). This situation is full of fruitful complexity but unfortunately it is not possible here to consider the many questions that arise. In the effort to put things right, do museums risk creating new problems? Is there a difference between possession and ownership? Do arguments over the spoils of restitution by different tribes divert attention from constructive engagement with the state and mainstream institutions? (Fleras and Spoonley 1999, Fleras and Maaka 2005).

However, several distinctive factors appear to have allowed these difficult issues to be resolved to a greater degree in New Zealand than elsewhere. These include: historical precedents of interaction between museums and their local Māori communities; active Māori involvement in the process on both sides (i.e. both inside and outside museums); and the direct involvement of government as a broker for resolving individual claims. The reference to the Treaty in museum legislation, policy and governance arrangements, for example Auckland Museum's 1996 Act, provided a mechanism for *tangata whenua* (local people) to have a say in museum activities, and take practical steps to deal with repatriation (Kawharu 2002: 11, Tapsell 2005). If Māori were increasingly active internally as museum professionals, externally museum collections were now the focus of tribes seeking the settlement of their historical claims to the Waitangi Tribunal, the body set up in the 1980s to investigate breaches of the Treaty (Waitangi Tribunal, Butts 2007). As well as land and other resources, collection items in museums have became embroiled in legal wrangles over cultural property and were subsequently included in Crown settlements of those claims along with cash and management rights handed back to claimants. This vexed issue of the restitution of alienated cultural patrimony is related to international policies such as the Draft Declaration

on the Rights of Indigenous People in 1994 (Mana Tangata: Draft Declaration), and a strong Māori statement of ownership articulated in the Mataatua Declaration of 1993 (Mataatua Declaration).

Two high profile examples of repatriation in the 1990s illustrate the New Zealand situation. In the first, the Ngāti Awa people sought the return of their *wharenui* (house) *Mataatua* from the Otago Museum as part of their Tribunal claim. This beautiful carved meeting house was opened in the 1870s near Whakatāne and subsequently 'bought' by the government and sent to the Sydney and Melbourne international exhibitions in 1879-80. It then ended up in London where it resurfaced in the collections of the Victoria and Albert Museum in the 1920s. Displayed at the Empire Exhibition at Wembley in 1924, and then the New Zealand and South Seas Exhibition at Dunedin the following year, the house was subsequently restored and installed in the Otago Museum (Mead 1990: 62). In the end, despite soured relationships between tribal representatives and museum staff, government compensation made it possible to return the whare in 1996. In September 2011 the restored carvings were installed into a new tribal cultural centre that opened in Whakatāne. As far as Ngāti Awa were concerned, this was a positive outcome that enabled them to close this dark chapter of their history, and use the reclaimed heritage of the past as a springboard for social and economic development (McCarthy 2011: 224). Professor Hirini Hirini commented that if *Mataatua's* walls could talk, they would speak of 'damage and aching loneliness for home, but also of hope'. They would say: 'Here we are. We've been through a lot […] but we're here today ready to face the future […]' (Tahana 2011).

In 1997 another high-profile repatriation occurred when *Pūkākī*, an ancestral gateway from Ohinemutu in Rotorua, was returned to the Te Arawa people from Auckland Museum. As Paul Tapsell eloquently explains, this *taonga* is regarded as the actual ancestor himself, and not merely a representation, and his homecoming was therefore an event of enormous significance (Tapsell 2000). However this last example also illustrates some of the problems associated with the redemptive politics of restitution which can ironically put cultural heritage itself at risk. Originally installed in the District Council Offices as a statement of local Māori authority, it was later found that the old wooden carving was deteriorating, and *Pūkākī* has recently had to be moved back into the local Rotorua Museum where conditions allow it to be better cared for. Problems like this confirm for some people the difficulties of repatriation, but, based on my interviews with museum professionals, it has to be said that most agree with returns in principle if not in practice. Museum director David Butts has commented that there was widespread concern in the sector about 'a wave of repatriation requests' in the 1980s but this did not eventuate. 'I think part of the reason that didn't happen was because museums made significant changes and began to employ Māori staff', he said, 'I think there were other things happening within the Māori world that meant that the focus was on bigger issues, much more important issues about survival in some cases, education and health and Treaty claims' (Butts 2008).

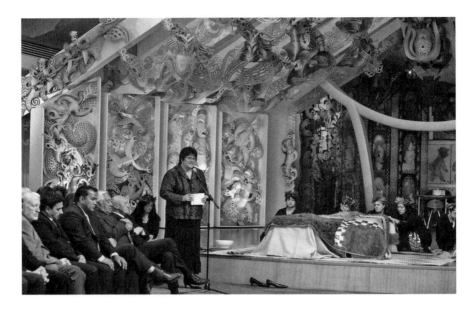

**Figure 5.1 Māori human remains from overseas, contained in caskets
draped in feather cloaks, are welcomed home in a dramatic
ceremony on the marae at Te Papa. With kind permission of
The Museum of New Zealand Te Papa Tongarewa**

Today, repatriation in the New Zealand museum sector includes the more
common return of human remains and the less frequent return of artefacts. Although
repatriation has been discussed by museum professionals and carried out by Māori
individuals for many years, it has only been formalized in official policies in the
past two decades. The Ngāi Tahu tribe formulated a policy on human remains in
the 1990s, and the Whanganui Regional Museum wrote policies on repatriation
in the 2000s, but actual examples of successful implementation are still rare.
Institutions like the Tairāwhiti Museum in Gisborne pursue voluntary domestic
repatriation, returning artefacts from other parts of the country to museums in
the tribal region of the source community and sometimes into the custodianship
of tribes themselves, and expect that other museums will reciprocate with *taonga*
from Gisborne tribes. Nationally, the return of human remains from international
museums has been spearheaded by Karanga Aotearoa, a special unit within the
Museum of New Zealand Te Papa Tongarewa (Te Papa) which was set up in 2003
by the government for this purpose (Repatriation: Karanga Aotearoa). Guided
by an expert group of elders, and working with Māori staff, Karanga Aotearoa
work very hard to facilitate the repatriation of dried heads and skeletal material
(*toi moko, kōiwi*) back to Te Papa where they are welcomed home in emotional
ceremonies on the *marae* (see Figure 5.1). If the provenance is unknown and
they cannot be returned to *iwi* for burial, they are respectfully stored in a secure

repository for sacred objects. According to Te Herekiekie Herewini, it is very important that the whole process is managed very carefully, from the delicate negotiation with institutions, to the handling of the remains, which are regarded as people not scientific specimens, and as such are accorded the full respect due to revered ancestors (Herewini 2009, O'Hara 2012).

Case Study: *Te Hau ki Tūranga*

In the 1840s the famous carved meeting house (*whare whakairo*) named *Te Hau ki Tūranga* (the spirit or breath of Tūranga) was built near Gisborne. To the Ngāti Kaipoho *hapū* (sub-tribe) of the Rongowhakaata people it was a *taonga* (treasure) which symbolized tribal unity and mana, literally embodying the ancestor's bosom in which descendants gathered together to express an emerging sense of cultural identity in response to colonization. The carved meeting house is now universally regarded as the oldest and finest example of Māori carving in existence (Walker 2001: 43, Brown 1995, Barrow 1976). In 1867 the *whare* came into the possession of the colonial government during the New Zealand wars on the east coast of the North Island, or as the director James Hector admitted privately: 'It is the finest Carved Ho. the Maories [sic] have built and the Govt. very wisely took the occasion of their turning rebel to confiscate it & transfer it to my care for preservation' (Hector 1868). To its carver Raharuhi Rukupō, however, the *whare* was a 'great *taonga*', or treasured possession. Rukupō, master carver and chief of the Rongowhakaata tribe, protested vigorously when the house was forcefully removed by the government:

> This petition of your true and faithful friends, some of the people of Tūranga, prays that you will look into one of our troubles. Our very valuable carved house has been taken away, without pretext, by the Government; we did not consent to its removal. (Petition 1867)

Petitions in 1867 and 1878 were presented for the return of the house, but the only satisfaction the tribe received was a payment of £300. For the next 50 years *Te Hau ki Tūranga* was displayed to a predominantly *Pakeha* (European) audience at the Colonial Museum established in 1865, which later became the Dominion Museum in 1907, then the National Museum in 1972 and Te Papa from 1998. It was described by the Director James Hector in the 1860s as a 'specimen' of native carving, and the panels on display as very 'curious' (Hector 1867?). In 1936 it was rebuilt as a traditional meeting house in the splendid surroundings of the Māori hall in the new Dominion Museum, a symbol of the prehistory of a modern settler state. By 1986 *Te Hau ki Tūranga* was the backdrop to a renaissance of the Māori culture, as the people and their heritage were fused together when the famous '*Te Maori*' exhibition returned home from its tour of the US to be greeted by large crowds. It was now seen as art, appreciated for the beauty of its carving,

and regarded once again as a *taonga*, by all Māori but particularly the original creative community who had maintained interest in the house for over a century (McCarthy 2007).

In 1998, the house was once again reconstructed at the new national museum Te Papa, this time with the full participation of the Rongowhakaata people themselves. This exercise in collaboration was typical of the Antipodean version of the new museology, in which an arguably dated ethnographic approach to Māori culture was replaced by a collaboration with the source community in an exhibition aimed at a broad audience. One of the most popular exhibits in the museum, especially with overseas tourists, and a centrepiece of the Māori collection, the carefully restored house was presented in the exhibition 'Mana Whenua' as a statement of tribal *mana* (power, authority, respect) and at the same time as a national treasure. In its most recent reincarnation, the '*mana taonga*' of the house came to the fore – that is to say the rights to speak for Māori cultural treasures deriving from the ownership of them – which reflected a Māori perspective on museum practice enacted by Māori staff within Te Papa (McCarthy 2011: 97-8, 114-15). But despite all these concessions to indigenous 'consultation', and the idea that the museum looked after Māori collections *on behalf* of the tribes, there was the unmistakeable sense that the museum still 'owned' the prized house.

However matters were gradually taking their course, and slowly and surely *Te Hau ki Tūranga* was being reclaimed by descendents of its makers and owners who were no longer content to leave it in Wellington. Māori staff at the museum, led by Walter Waipara who was also from Gisborne, established a rapport with the Rongowhakaata tribe, who came to Wellington en-masse in 1992 to celebrate the 150th anniversary of the famous carved house by sleeping overnight in it. When plans were unveiled to move the house to the new museum on Wellington's waterfront, discussions were initiated with *kaumātua* (elders) of the tribe. Museum staff, led by Māori artist Cliff Whiting, thought they had secured agreement in the mid 1990s for the *whare* to remain at the national museum, in return for the handing over of some other artefacts, *kōwhaiwhai* (painted rafters) provenanced to the Tūranga area, to the Tairāwhiti Museum in Gisborne. However a change of generation in tribal leadership, a transition from an older generation of elders with a more conciliatory outlook to younger, more politicized people, brought on a new mood back in Gisborne, with the result that the deal was off. I remember well, when working at Te Papa in the late 1990s, this harder attitude being signalled in no uncertain terms by Tutekawa Wyllie, a member of Ngāti Kaipoho and MP for Te Tai Tonga (the South Island Māori electorate). During a speech on the museum's marae, Tu Wyllie announced bluntly: *'Nōku te whare nei!'* (This house is mine!). This may have come as a shock to *Pakeha* (European) staff, but not really to Māori, who realized it was always possible that people would change their mind. Curator Arapata Hakiwai recalled interviewing the late Heni Sutherland at Manutūke in 1996 and remembers her prophetic words: '*E pai ki a mātou i tēnei wā, Arapata, engari a tōna wā he rerekē te kōrero.*' [To us, its all right at this time (for the house

to remain in Wellington), but when the time comes the talk might be different]'
(Hakiwai 2011).

One of the main drivers for the change in outlook was the Rongowhakaata claim
to the Waitangi Tribunal. As part of the research, hearings, report and settlement
of this claim, the house became the subject of ongoing negotiations between the
Crown (and therefore Te Papa as a Crown entity). The *iwi* consensus was now for
the house to be returned to Gisborne through some kind of arrangement with the
museum who would provide ongoing care. In doing so, *Te Hau ki Tūranga* would
become the centre of Rongowhakaata cultural regeneration. Today there were only
three carvers in the area whereas in Rukupō's day they were famous for their skill
in wood carving. Tribal negotiator and museum professional Jody Wyllie argued
that having the house at home would allow them to 'retrace the footsteps of our
ancestors' and 're-establish' the Rongowhakaata school of carving (Wyllie 2008).

Another tribal member Karl Johnstone, who currently works at Māori cultural
centre Te Puia in Rotorua, had slightly different views. While he appreciated why
others in the tribe wanted it returned, he had a few qualms:

> To request it back is an interesting proposition because we actually don't have
> the resources to care for it nor the expertise, so what do you do with it when you
> get it back? Then I think you have to go back behind wanting the house, whether
> in title or returned, and I'd actually say pretty publically that the house is only
> wood. And while it has a life force and a link to our *tipuna* (ancestors) [...] at the
> end of the day [that] is less important than actually repatriating or redeveloping
> the *knowledge* associated with the carving school, because actually *that* sustained
> the people not the house. In fact the house was in a state of disrepair when it
> was taken, what we actually lost when that house was taken and when Rukupō
> passed [...] was the intellectual property of the Kaipoho carving school which
> actually was the greatest loss.
>
> What I would ideally like to see happen is that the house is returned when
> the carving school is established and in operation and it becomes a centre piece
> and an educational tool. We already have five other *whare* which are difficult to
> maintain, a sixth one isn't necessary but [in] an educational cultural development
> or social development context, I think there is a lot of opportunity. (Johnstone
> 2008)

In addition to believing that cultural knowledge is more important than the material
culture itself, Johnstone also thinks that repatriation needs to be more carefully
considered by Māori instead of defaulting to an automatic 'give everything back'
response. Not all *taonga* in museums were illegally acquired. Sometimes they
are better off in museums because they are too fragile to be looked after in their
original communities:

> I think it's an evolutionary process for *iwi* as well. Museums just shouldn't
> give the *taonga* back as far as I'm concerned; it's on a case by case basis. If

> it was a prominent *taiaha* (long club) that was involved in a particular battle
> or something like that [...] and it was taken rightly or wrongly, whatever, and
> there's an agreement to return it; return it, because a *taiaha* is a little bit easier
> to care for. But our own family have *kahu kiwi* (feather cloaks) for example and
> it causes us endless stress because we've got two in the Tairāwhiti Museum and
> one we keep at home [...] and we're constantly worried it's going to be stolen
> or destroyed in a fire. Surely keeping that connection, managing it somehow
> between ourselves and the museum is the way to do it? (Johnstone 2008)

In my interviews with many Kaitiaki Māori (Māori museum professionals) in
2008-2009, a range of opinions was expressed about the challenging issue of
repatriation. Some *Kaitiaki Māori* (guardian/Māori museum professionals) found
it difficult to talk about, and while they supported the principle of repatriation, they
also saw the practical difficulties from the museum perspective. People told me
stories about having to deal with chauvinistic young men who believed contrary
to any evidence that all taonga in museums were 'stolen' and loudly demanded
their wholesale return regardless of practical considerations for their care and
management. Those who claim grandly that *taonga* should return to mother earth
seem to deny both historical Māori efforts at preservation and contemporary
Māori plans for cultural development. There is indisputably a lot of hot air on
this issue, which simplifies the ambiguities of cultural exchange and the ongoing
social lives of material things, and also much discussion about the 'retrospective
utopia' of the legal history produced by the Tribunal (Ihimaera, Ellis and Mataira
2002, Belgrave 2005, Byrnes 2004, Conn 2010).

However, although there are some reservations about the details of the
historical record in the case of *Te Hau ki Tūranga*, on balance it is hard to deny
the justice of the present day call for the house to return to the area where it was
created. Regardless of past circumstances the present needs and desires of the
tribe are demonstrably greater than those of the museum, whatever the finer legal
and historical points of the case. It is simply good museum practice to have any
object cared for, contextualized, and interpreted in the best possible way, and it is
undeniable that it is preferable to do this in the tribal homeland by descendants of
the ancestor house themselves. As Jody Wyllie put it 'I'm of the belief that *taonga*
should really go back to the people that created it. If you want to give life to a
particular carving [...] it would be best to come from the people who created it'
(Wyllie 2008).

After all the debate internally and externally – within the tribe, between the
tribe and the museum and amongst museum staff – matters finally came to a head
when the claim, originally lodged in 1989, was heard by the Tribunal in 2002. The
hearings were marked by the usual incendiary language of such occasions with
claims the house had been 'stolen' by the government and 'desecrated' by Te Papa
(Te Papa has desecrated treasured *whare*). In 2004 the Tribunal's report found that
the house had been acquired in a clear breach of the Treaty, and that there was a
'real question' whether the museum had legal title, but it stopped short of saying

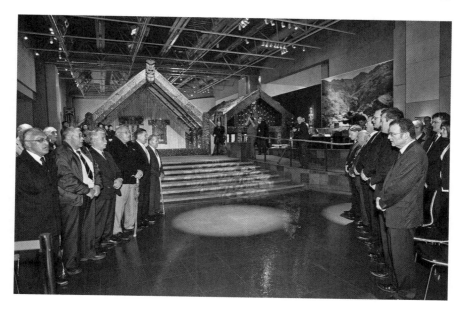

Figure 5.2 **Government and tribal representatives meet to initial a deed of settlement at Te Papa through which the meeting house *Te Hau ki Tūranga*, seen in the background, will be returned to the Ngāti Kaipoho hapū (sub-tribe) of the Rongowhakaata people. With kind permission of Ngāti Kaipoho and the Office of Treaty Settlements**

the *iwi* owned it. The report recommended the museum enter into negotiations about the long term custody and maintenance of the meeting house. The Crown 'honourably' admitted the breach of Treaty principles. The Chair of the museum Board of Trustees John Judge spoke directly to a group of tribal representatives, admitting that the house had been unlawfully taken, acknowledging that ownership rested with them, and committing the museum to a resolution of the issue. Kaihautū (Māori director) Te Taru White said that the museum was keen to be '*kaitiaki* (guardian) of first choice' and to 'establish a long and enduring' relationship with Rongowhakaata (Alley 2004, Tūranga Tangata Tūranga Whenua 2004).

After several more years of negotiation, a milestone was finally reached when, in July 2011, a deed of settlement was initialled at Te Papa between the Crown and the Ngāti Kaipoho *hapū* (sub-tribe) of Rongowhakaata at a moving ceremony at the museum in front of *Te Hau ki Tūranga*.

There was an apology from the Crown, delivered in stark terms by Minister for Culture and Heritage and Treaty Negotiations Minister, Chris Finalyson. 'This settlement puts right a great wrong that has been done to Rongowhakaata', he said, 'the creators and rightful owners of such a beautiful and important *taonga*' (Crown and Tūranga iwi reach agreement 2011). The settlement included the

return of Crown-owned properties in the region, NZD$22m for cultural redress, and NZD$350,000 support for a 'cultural revitalization plan'. Central to the package was the acknowledgement that the house had been confiscated, Te Papa's assistance in the ongoing care of the *whare*, and its eventual return to Gisborne in 2017 along with museum technical assistance and government financial support for relocation to the tune of NZD$4m. Tribal members present at this emotional occasion described it as an 'intimate and momentous affair'. One of them, negotiator Stanley Pardoe, told the *Gisborne Herald* that the deed marked the end of a 'tough journey' that began 22 years before when he first lodged the claim (Putting right 'great' wrong 2011).

Arapata Hakiwai, who has worked at the museum since the late 1980s, and is himself a Rongowhakaata descendant, has observed negotiations over *Te Hau ki Tūranga* for several years and witnessed the ups and downs of the process. Yet he is positive and believes Te Papa has learnt many lessons, perhaps most of all that, despite losing the house, overall the long term relationship is the most important thing. In a recent interview, he told me he felt that Te Papa's positive role in the relationship was reflected in the moving ceremony described above, when Kaihautū (Māori Director) Michelle Hippolite spoke first and welcomed the Crown to the museum (showing they were not simply a silent partner of the government) and when tribal members acknowledged the role the museum staff had played as go-betweens in the negotiation.

In Hakiwai's view, the emotional ceremony was an important step in a longer process of reconciliation. Currently conducting research for his PhD on the links between *taonga* and descendent source communities, he argues that these events can only be understood in the context of contemporary tribal social development. While the *whare* has important intrinsic aesthetic and historical values, for Rongowhakaata today it is also a platform for the future, articulated in their vision of 'restoration, revitalization and return'. Plans include a cultural centre and the revival of carving using *Te Hau ki Tūranga* as a template, obviously a 'huge' attraction for cultural tourism that will provide an economic base for an impoverished tribe in a relatively isolated part of the country. The *whare* has become a touchstone of *Rongowhakaatatanga* (tribal identity), and a symbol of hope, as demonstrated for example in songs composed by local groups at Te Matatini, the national festival of performing arts in Gisborne in February 2011. As Hakiwai puts it: '*Te Hau ki Tūranga* embodies those aspirations, hopes and desires for the future [...] all built on the past' (Hakiwai 2011).

Hakiwai goes on to explain that situations like this should not be seen by professionals as a threat but rather an opportunity for them to transform their professional practice by drawing on indigenous values and working in partnership with Māori people in caring for their heritage. While some in the museum world have misgivings about repatriation and are fearful of what it may bring, he feels that this is where progressive museums are heading anyway:

We should not be afraid of change [...] *Iwi* will get stronger economically, culturally, and will be creating their own structures to present themselves and their *taonga* to the world. I would like to think that enlightened museums can *assist* that process. (Hakiwai 2009)

Conclusion

In this chapter, I have presented a case study of repatriation in the hope that an analysis of the pragmatics of the process, rather than endless debates about the politics, will empower museums to stop talking and act. Current museum practice is moving very quickly with repatriation and seems to be well ahead of museum history and theory, and scholars therefore need to look carefully at what is happening and consider the implications. International museums have much to learn from the New Zealand situation, where several museums are proactively working with tribes to resolve their differences and explore ways of jointly managing their cultural heritage. This is not such a terrifying prospect at all, and may even allow museums to renew themselves, refocus their mission and engage with native audiences as well as the general public. Particular attention needs to be paid to the views of indigenous people themselves, whether working for museums or for tribal authorities. Their voices are often absent from the literature, despite the fact that they speak out clearly whether or not we are ready to listen. In this spirit, I leave the final word to Māori scholar and museum professional Arapata Hakiwai:

> Museums need to relax a little. You mention the word 'repatriation' and people get paranoid! I see it as a *positive* thing, an opportunity [...] I don't think people should be afraid of that, in fact I think museums should *embrace* it. (Hakiwai 2009)

Bibliography

Alley, O. 2004. Te Papa treasure stolen. *Dominion Post*, 2 November.

Barrow, T. 1976. *A guide to the Māori meeting house: Te Hau ki Tūranga.* Wellington: National Museum.

Belgrave, M. 2005. *Historical Frictions: Maori Claims and Reinvented Histories.* Auckland: Auckland University Press.

Belich, J. 2001. *Paradise Reforged: A History of the New Zealanders from the 1880s to the Year 2000.* Auckland: Allen Lane and Penguin.

Brown, D. 1995. Te Hau ki Tūranga. *Journal of the Polynesian Society*, 105(1), 7-26.

Brown, M. 2003. *Who Owns Native Culture?* Cambridge, Mass.: Harvard University Press.

Butts, D. 2007. Māori, museums and the Treaty of Waitangi: The changing politics of representation and control, in *Museum Revolutions: How Museums Change and are Changed*, edited by S.J Knell, S. Macleod and S. Watson. New York: Routledge, 215-27.

Butts, D. 2008. Interview with Conal McCarthy, October 22.

Byrnes, G. 2004. *The Waitangi Tribunal and New Zealand History*. Auckland: Oxford University Press.

Conn, S. 2010. *Do Museums Still Need Objects?* Philadelphia: University of Pennsylvania Press.

Crown and Tūranga iwi reach agreement. 2011. New Zealand Press Association, 21 July.

Fforde, C., J. Hubert and Turnbull, P. (eds) 2002. *The Dead and their Possessions: Repatriation in Principle, Policy and Practice*. London: Routledge.

Fleras, A. and Maaka, R. 2005. *The Politics of Indigeneity: Challenging the State in Canada and Aotearoa New Zealand*. Dunedin: University of Otago Press.

Fleras, A. and Spoonley, P. 1999. *Recalling Aotearoa: Indigenous Politics and Ethnic Relations in New Zealand*. Auckland: Oxford University Press.

Hakiwai, A. 2009. Interview with Conal McCarthy, Febuary 25.

Hakiwai, A. 2011. Interview with Conal McCarthy, August 24.

Hector, J. 1867? (date illegible). Letter 296 to the Colonial Under Secretary, Colonial Museum outwards correspondence, Te Papa Archives, Wellington, MU 94.

Hector, J. 1868. Letter to Sir Joseph Hooker, January 1, Alexander Turnbull Library Micro-MS-Coll-10, Reel 16, exposures 568-71.

Herewini, T.H. 2009. Interview with Conal McCarthy, April.

Ihimaera, W., N. Ellis and K. Mataira. 2002. *Te ata: Maori Art from the East Coast, New Zealand*. Auckland: Reed.

Johnstone, K. 2008. Interview with Conal McCarthy, December 19.

Kawharu, H. 2002. Ngāti Whātua and the Taumata-a-iwi. *Te Ara*, 27(1), 11.

Mana Tangata: Draft Declaration on the Rights of Indigenous Peoples. 1994. Background and Discussion on Key Issues. Wellington: Te Puni Kokiri: Ministry of Maori Development.

Mataatua Declaration. 1993. World Indigenous People's Organisation [Online]. Available at: http://www.wipo.int/export/sites/www/tk/en/folklore/creative_heritage/docs/mataatua.pdf [accessed: 1 Febuary 2010].

McCarthy, C. 2007. *Exhibiting Maori: A History of Colonial Cultures of Display*. Oxford and New York: Berg.

McCarthy, C. 2011. *Museums and Maori: Heritage Professionals, Indigenous Collections, Current Practice*. Wellington: Te Papa Press.

Mead, H.M. 1990. Ngā karoretanga o Mataatua whare: The wanderings of the carved house, Mataatua. *Research report no. 2*. Whakatāne: Te Rūnanga o Ngāti Awa.

O'Hara, C. 2012. Repatriation in practice: A critical analysis of the repatriation of human remains in New Zealand museums. MHST 593 dissertation, Museum and Heritage Studies programme, Victoria University of Wellington.

Petition of natives at Tūranga. 1867. *Appendices to the Journals of the House of Representatives*, G-12.

Pickering, M. 2010. Despatches from the front line? Museum experiences in applied repatriation, in *The Long Way Home: The Meaning and Values of Repatriation*, edited by P. Turnbull and M. Pickering. New York and Oxford: Berghahn Books, 163-74.

Putting right great wrong. 2011. *Gisborne Herald*, 21 July.

Repatriation: Karanga Aotearoa. Wellington: Museum of New Zealand Te Papa Tongarewa [Online]. Available at: http://www.tepapa.govt.nz/aboutus/repatriation/Pages/overview.aspx. [accessed: 21 September 2011].

Tahana, Y. 2011. Ngāti Awa whare comes home. *New Zealand Herald*, 18 September.

Tapsell, P. 2000. *Pukaki: A Comet Returns*. Auckland: Reed.

Tapsell, P. 2005. Out of sight, out of mind: Human remains at the Auckland Museum – Te Papa Whakahiku, in *Looking Reality in the Eye: Museums and Social Responsibility*, edited by R.R. Janes and G.T. Conaty. Calgary: University of Calgary Press, 153-73.

Te Papa has desecrated treasured whare, tribe claim. 2002. *New Zealand Herald*, 25 February.

Tūranga Tangata Tūranga Whenua: The report on the Tūranganui a Kiwa Claims. 2004. Wellington: Waitangi Tribunal, 587-607.

Waitangi Tribunal Te Rōpu Whakamana i Te Tiriti o Waitangi [Online]. Available at: http://www.waitangi-tribunal.govt.nz/treaty/ [accessed: 18 September 2011].

Walker, R. 2001. *He tipua: The life and times of Sir Āpirana Ngata*. Auckland: Viking.

Wyllie, J. 2008. Interview with Conal McCarthy, 22 October.

Chapter 6

'A Welcome and Important Part of their Role': The Impact of Repatriation on Museums in Scotland

Neil Curtis

Introduction

Most writing about repatriation from museums has naturally focused on the benefits to the people to whom ancestral remains or sacred items are being returned. Repatriations have also had a significant impact on museums, sometimes gaining objects for their collections, such as the replica Ghost Dance Shirt donated to Glasgow Museums, and improving the knowledge and understanding that museums have of their collections. Perhaps of greater significance have been the lasting relationships with the communities to whom items were repatriated, leading to exhibitions of mutual benefit, such as the Blackfoot Gallery in the Glenbow Museum in Calgary (Conaty 2003) and the incorporation of traditional practices of care, as in the National Museum of the American Indian (Rosoff 2003) and the Museum of Anthropology of the University of British Columbia, Vancouver (Rowley and Hausler 2008). In New Zealand, this has further developed with the embedding of the interests of indigenous people within museum governance as well as practice, as in the bicultural governance of Te Papa (Butts 2002), though the extent to which this has led to sustainable changes in museum governance in North America has been criticized by some commentators (e.g. Scott and Luby 2007). For museums in Europe 'the context of relationships in the present with the community: the consultation, the human interaction, the willingness to learn, and the investment of time, effort, and money' (Peers and Brown 2003: 13) are much more difficult to build because of the hundreds of potential links around the world that may be faced by each museum.

To explore the impacts of repatriation on museums, this chapter focuses on requests for repatriation from museums in Scotland. There have been 23 recorded repatriation cases involving Scottish museums since 1990, mostly resulting in decisions to repatriate. These have involved eight museums out of the more than 340 museums in Scotland (www.museumsgalleriesscotland.org.uk), of which some 53 are recorded as having ethnographic collections comprising a total of at least 90,000 items (Kwasnik 1994). Despite the small number of museums concerned, the publicity and discussion associated with a few cases, such as

Table 6.1 Recorded Repatriation Requests to Scottish Museums 1990-2010

Museum authority	Description	Request from	Outcome	References
Glasgow City Council	Skulls and skull framents from Queensland	Australian High Commission	Repatriated 1990	CMSC 2000
University of Edinburgh	Tasmanian human remains	Tasmanian Aboriginal representatives	Repatriated 1991	Fforde 2009
University of Edinburgh	Aboriginal Australian human remains	National Museum of Australia	Repatriated 1992	Fforde 2010
Glasgow City Council	Waistcoat said to have belonged to Rain-in-the-Face	Marcella LeBeau	Rejected 1994	CMSC 2000
Glasgow City Council	Benin bronzes and ivories	Oba of Benin per Bernie Grant MP	Rejected 1996	CMSC 2000
University of Edinburgh	3 Tasmanian hair samples		Repatriated 1997	Fforde 2009
Glasgow City Council	18th century burial from Cambusnethan, Lanarkshire	Central Wishaw Community Council	Rejected 1997	CMSC 2000
Glasgow City Council	Ghost Dance Shirt	Wounded Knee Survivors Association	Rejected 1995; Repatriated 1999 to South Dakota Historical Society	CMSC 2000
Angus Council	2 necklaces from the Cook Islands	Cook Islands National Museum	Decision to repatriate 1999	Angus Council 1999
University of Edinburgh	Aboriginal Australian human remains	National Museum of Australia	Repatriated 2000	Fforde 2009
University of Edinburgh	Hawai'ian human remains		Repatriated 2000	Fforde & Parker 2010
University of Aberdeen	Kainai split horn headdress	Blood Tribe Horn Society	Repatriated to Mookaakin Heritage Foundation 2003	Curtis 2008a
University of Edinburgh	Ethiopian Manuscripts	Association for the Return of The Magdala Ethiopian Treasures	Rejected 2003	University of Edinburgh 2004

		descendents of Jewish owners	Payment following 2004 Spoliation Advisory Panel judgement	Glasgow City Council 2005
Glasgow City Council	Still Life attributed to Chardin	descendents of Jewish owners	Payment following 2004 Spoliation Advisory Panel judgement	Glasgow City Council 2005
Glasgow City Council	3 toi moko and 1 kōiwi tangata	Te Papa Tongarewa Museum of New Zealand	Repatriated 2005	Herewini 2009; CPA n.d.
Perth & Kinross Council	2 toi moko	Te Papa Tongarewa Museum of New Zealand	Repatriated 2005	Herewini 2009; Perth & Kinross Council 2005
Glasgow City Council	5 skeletons from Torres Straits	National Museum of Australia for return to Mer Island	Repatriated 2007	Torres Straits Regional Authority 2007
University of Aberdeen	9 toi moko	Te Papa Tongarewa Museum of New Zealand	Repatriated 2007	Herewini 2009; Curtis 2008a
National Museums of Scotland	6 skulls	Ngarrindjeri people and Australian Government	Repatriated 2008: 4 to Ngarrindjeri people, 2 to Australian Government	McLaughlin 2008
University of Edinburgh	Ear bone	Ngarrindjeri people	Repatriated 2008	McLaughlin 2008
National Museums of Scotland	4 toi moko , 4 skulls and 2 mandibles	Te Papa Tongarewa Museum of New Zealand	Repatriation 2008 converting 1999 permanent loan	Te Papa 2009
National Museums of Scotland	Skull	Tasmanian Aboriginal Centre	Repatriated 2008	Tree 2009
University of Glasgow	4 toi moko	Te Papa Tongarewa Museum of New Zealand	Repatriated 2009	Tree 2009

the return of the Ghost Dance Shirt by Glasgow Museums in 1999, has ensured that the issue has become an important one for museums in Scotland. Table 6.1 summarizes all known repatriation requests from 1990 to 2010, noting their outcomes and with a reference to an online published source for each case from which it is possible to find greater detail and other references. It is striking that most recent cases have been remarkably uncontentious – particularly in contrast to the well-publicized rejection of the initial request for the return of the Ghost Dance Shirt by Glasgow Museums in 1995 when many museum staff were worried about setting a precedent that would lead to the loss of ethnographic collections that could be used for exhibitions and research (Maddra 1999).

The legal basis for repatriation in Scotland is essentially that of property law, as there is no comparable law to the 1990 Native American Graves Protection and Repatriation Act (NAGPRA) which can compel federally-funded museums in the United States to return items to registered tribes, with specific legal recourses for museums that do not comply (see Robbins, Chapter 7). While it would be possible for a claimant to pursue a legal claim through the Scottish courts, this would be difficult and expensive, with the result that 'ethics, not law, prompts hand-over of artefacts' (McLaughlin 2008) and decisions have been made at the discretion of the governing bodies of museums on the basis that the museum has rights of ownership. This chapter therefore discusses how Scottish museums have developed ethical and procedural approaches and how it is now possible to argue that they can see repatriation 'not as a problem which they should avoid 'being dragged into' but as a welcome and important part of their role' (O'Neill 2006: 126). This chapter will argue that, while not having legislation to compel repatriation may restrict the power of a claimant, the development of professional support for engaging with requests can result in a more careful consideration of requests and sympathetic decision making that is not limited to particular types of material or claimants. The complex nature of Scottish history and identities is also explored, considering how support for repatriation from within Scotland can be the result of simplistic ideas of victimhood and empathy with indigenous people. With the re-establishment of the Scottish Parliament in 1999 and debate about full independence, such issues have become more significant as discussions continue about the cultural identity of the nation and its relationship with colonialism.

Human Remains

All but three of the repatriations from museums in Scotland have related to human remains, most relating to government-supported international campaigns. Five were the result of requests from Te Papa Tongarewa Museum of New Zealand between 2005 and 2009, following the New Zealand government's decision in 2003 that Te Papa should act on its behalf to repatriate *kōiwi tangata* (Māori human remains) from around the world (Te Papa 2009) (see McCarthy, Chapter 5). The result was that 24 *toi moko* (preserved human heads) were repatriated from Scotland and it

is now believed that there are no *kōiwi tangata* left in the collections of Scottish museums. Likewise, there were also repatriations of Aboriginal Australian human remains, many of which involved government support from Australia (Fforde and Parker 2001).

The law in Scotland relating to human remains is complex. As in other jurisdictions, it is normally considered that there are no rights of property in human remains (Garratt-Frost 1992), though the law does place limits on how they can be treated, such as the Human Tissue (Scotland) Act 2006 and the long-standing offence of 'violation of sepulchres', which is a common law crime prohibiting the disturbance of interred human remains (Logie 1992). There is also a legal opinion that, despite there not being title in human remains in Scotland, 'it is possible to hold that it is theft to steal a body which [...] has been gifted to a laboratory, or placed in a museum' (Gordon 2001: para. 14.27). Museums faced with requests for the repatriation of human remains have therefore taken the pragmatic view that they are the appropriate organization to make a decision on the basis of their possession of the remains, and have normally operated procedures similar to those that they use when responding to requests for items for which they do have title.

While most requests for the repatriation of human remains resulted in one-off decisions to repatriate by museums, in 1990 the University of Edinburgh adopted a general policy 'to return human remains, when so requested, to appropriate representatives of cultures in which such had particular significance, subject to appropriate safeguards' (University of Edinburgh 2004) that has led to them being regarded as international leaders in the repatriation of human remains (Fforde 2009). This readiness by museums to consider repatriation of human remains was also exemplified by Mungo Campbell, Deputy Director of the University of Glasgow's Hunterian Museum, commenting on the university's decision to repatriate four *toi moko*. He is reported as contrasting them with cultural items, saying, 'Human remains are very different, as they cannot be displayed. The process of returning human remains is almost part of everyday business of museums now' (Tree 2009). The origin of the current special treatment of human remains has been discussed elsewhere (e.g. Curtis 2003), but it is worth noting that the distinction of the body from other aspects of life is a product of Western thinking that sees a number of dualities, such as mind:body and nature:culture, critiqued by Ingold (2000). The influence of this thinking is such that many people consider the remains of human bodies to have a universal value, distinguishable from those of animals, cultural items and sacred objects. This ignores the wide variety of beliefs about matter around the world, however, such as that 'among the Ojibwa (of sub-Arctic Canada) the human form is merely one of many guises in which persons may materially manifest themselves, and anyone can change his or her form for that of an animal more or less at will' (Ingold 1994: 24), the way that many people in the West treat pets, or the way in which material objects may also be regarded as having personhood.

A consequence of this duality and of this distinction has been the placing of the study and care of 'human remains' within the remit of the natural sciences,

whereas the remains of human actions and beliefs are treated as 'material culture' and studied by the humanities and social sciences. This may result in the finds from a burial being split between human remains that are in the care of natural scientists, and grave goods being curated by staff who have a background in social anthropology. As a result, knowledge of the scientific research value of human remains, the beliefs of source communities about the remains of their ancestors and the ethical issues relating to their curation may vary significantly among those with responsibility for human remains in museums.

There can also be a similarly generalizing expectation that there is an underlying similarity between all indigenous peoples, such as the statement by the Australian and United Kingdom governments that they 'recognise the special connection that indigenous people have with ancestral remains' (Butler 2001: 24). Unfortunately, such an approach homogenizes a wide variety of experiences and beliefs into a Western-defined entity of 'indigenous people' with which museums can be expected to relate. For example, Jacobs (2009: 93) has argued that the goals of the National Museum of the American Indian 'are described in a way to bind all indigenous peoples together' and that its name 'masses innumerable cultural identities under a general title'. Ingold has considered the ways in which Western notions of what it is to be 'indigenous' are rooted in a model that emphasizes linear descent from an ancestral population in a particular place. This is quite unlike the way that many indigenous people have traditionally considered their relationship to a place being linked to their *lived experiences* of their environment (Ingold 2000). People with a claim to indigenous status have thus been compelled to articulate this in terms that are incompatible with their traditional experience and understanding of the world.

Despite such universalizing beliefs, however, there appears to be an increasing concern for the special treatment of human remains in the West, including arguments about the retention of children's organs by hospitals and the 'Body Worlds' exhibition of dissected 'plastinated' human corpses (Curtis 2003, Lusher 2002) that were among the factors leading to the UK Human Tissue Act 2004 and the production of *Guidance for the Care of Human Remains in Museums* by the UK Government (DCMS 2005) and the *Guidelines for the care of human remains in Scottish museum collections* by Museums Galleries Scotland (MGS 2011). It has been argued that, 'once required as part of religious and moral instruction, the call to remember death and the proximity of objects that resonate with physical decay [...] can be perceived as threatening to modern sensibilities' (Hallam and Hockey 2001: 213). It is the combination of this changing attitude to death, increased demands for informed consent, a view of human remains as the remains of individual people rather than samples of a population and – alongside a greater willingness to respond to the demands of indigenous people – that underlies the greater willingness of museums to repatriate human remains. While this context may have resulted in more sympathetic reactions from museums to requests for the repatriation of human remains, there is a risk that these claims are discussed in Western-derived terms that may differ from those of the claimants; it is also possible that requests that fall outside this category may not receive as positive a hearing.

Sacred Items

The return of the Ghost Dance Shirt by Glasgow Museums is one of the highest profile international repatriations of an item other than human remains. While the story of the repatriation and its follow-up is discussed elsewhere (e.g. Maddra 1999; O'Neill 2006), it is of particular interest as it relates to something other than human remains and has influenced many other museums in their approach to repatriation. Along with a number of other items, the shirt was acquired by Glasgow Museums in 1892 from George Crager of Buffalo Bill's Wild West show, having originally probably been collected from a corpse following the massacre at Wounded Knee in 1890 (Maddra 1999). The initial request was rejected in 1995, with the Director of Glasgow Museums, Julian Spalding, arguing that 'the museum's duty to the modern Lakota was to tell the story of the Massacre, in ways which reflected their point of view' (Glasgow City Council 2000: para. 2.2.2).

On appeal in 1999, and after a procedure had been developed by Mark O'Neill, the new head of museums, repatriation was agreed, primarily on the basis of the circumstances of its acquisition and its importance as a sacred item on condition that 'the shirt be preserved in perpetuity; that it will be displayed at all reasonable times in an appropriate place […] and that in the future, the shirt, accompanied by representatives of the Survivors Association, will be loaned to Glasgow for display' (Glasgow City Council 2000). The significance of Wounded Knee to the Lakota and the way in which it had been acquired were perhaps the most significant factors in the decision to repatriate (CMSC 2000: para. 146). Given the apparently greater willingness of museums to repatriate human remains, it is striking that in the initial request from the Wounded Knee Survivors Association (WKSA), the organization's lawyer, Mario Gonzalez, argued that, 'because the Lakota tradition was to bury a dead person in his/her garments, the objects should be treated as having the same significance as human remains' (Glasgow City Council 2000: para. 2.2.2). This repatriation case is widely regarded as a model of good practice achieving not only a successful repatriation and greater understanding of its cultural context and of the contemporary role of museums, but also the long-term care of the shirt and the donation of a replica of the shirt, which has been displayed in an exhibition which explained its history and repatriation.

Initially, the request included a number of other items of clothing acquired by Glasgow Museums through Buffalo Bill's Wild West show, which were believed to have been collected from Wounded Knee. Despite their probable association with the massacre, the request for the repatriation of these items was withdrawn during the appeal 'given the overwhelming importance of the Ghost Dance Shirt' (O'Neill 2006: 112). Also requested at about the same time, though by Marcella LeBeau personally rather than on behalf of the WKSA, was a Lakota waistcoat presumed to have belonged to Rain-in-the-Face, who had survived Wounded Knee. It was not returned, however, as the museum argued that there was neither evidence that it had been stolen, nor that it was a sacred item (Gilchrist 2007).

**Figure 6.1 Frank Weasel Head, Randy Bottle and Karen White Quills
at the repatriation from the University of Aberdeen in 2003.
Copyright: University of Aberdeen**

The 2003 repatriation by the University of Aberdeen of a split-horn headdress
to the Horn Society of the Kainai First Nation of southern Alberta, Canada, who
are also known as the Blood Tribe, followed a few years later (Curtis 2008)
(Figure 6.1). The headdress had been donated to the university by an Aberdeen
collector who appears to have purchased it in the 1920s while on the Blackfeet
reservation in Montana. Like many collectors, she did not record any tribal names
or other details, so for many years the headdress was merely catalogued as a
'war bonnet', reflecting preconceptions of Native American life, rather than as a
sacred bundle. Contact between the university and the Kainai began in late 2002
with a request for information about a headdress which had gone missing some
decades earlier and which was believed to be in Europe. With the likelihood of
a repatriation request imminent, the university developed a procedure modeled
on that of Glasgow Museums, which led to the headdress being returned in July
2003. It was also influenced by NAGPRA and other legal approaches, notably
that of Alberta's First Nations Sacred Ceremonial Objects Repatriation Act 2000,
under which the Kainai had repatriated a number of sacred bundles. There are
two particularly important aspects to the decision, which sets it apart from other
repatriations by European museums. Discussion about legal title, association with
human remains, or the circumstances of collection did not feature significantly
in the university's decision, unlike the discussions about the Ghost Dance Shirt.

Instead, the recognition of the headdress's immense importance to the Kainai today was the main reason for the decision that it should be repatriated, and, thus, no longer be treated as a museum object. This is similar to the approach in Alberta which would repatriate such an item as being 'vital to the practice of the First Nation's sacred ceremonial traditions' (Province of Alberta 2004). This led to the decision that the university should have no continuing rights after repatriation, such as demands that it be the kept on display, available for loan, or conserved. Also discussed were issues such as photography and the making of a replica. The conclusion reached was that as there could only be four headdresses, making a replica would be inappropriate, while the publication of photographs of a sacred item would be disrespectful. Those making the request did, however, allow that the museum should have photographs for its archive and for use in exhibitions and lectures.

Developing Procedures

These cases show museums finding their way to a new role, making individual ethical and curatorial decisions, while working within laws that were not designed to govern repatriation decisions. In Canada, the Task Force on Museums and First Peoples (Hill and Nicks 1992) considered recommending legislation similar to NAGPRA, but instead called on museums to develop 'a co-operative model of equal partnerships governed by moral, ethical and professional responsibilities rather than legislative obligations' (Nicks 1992: 89). Nonetheless, in Alberta the good relationships that developed became the foundations for legislation that now governs many repatriations, showing that there is not a clear distinction between a legislative and non-legislative approach. It is unlikely that such legislation would be possible in countries like Scotland, particularly as it would need to relate to many peoples throughout the world, so it is important that museums develop clear procedures and take advantage of the lack of legislation to think carefully about their roles and the importance of their decisions. As Mark O'Neill of Glasgow Museums said:

> If museums represent our better selves, our humane values, then we have to admit to the possibility that there may be other values, which are more important than that of possession and preservation. Possession in itself cannot be an absolute value, taking precedence over all others. [...] In Glasgow our vision of museums is not as dusty storerooms but as places where urgent issues of personal and communal meaning and identity can be explored and renegotiated. (Glasgow City Council 2000: para. 4.1.4)

Most museums now have collection policies which state that decisions to de-accession items have to be made by the governing body of the museum acting on professional curatorial advice. Normally, these policies make clear that their

prime concern is their care of the collection in perpetuity and that repatriation would be very unusual, with the University of Edinburgh's pro-repatriation policy for human remains as a rare exception. While the cases in the earlier 1990s were decided on a largely *ad hoc* basis, by 1998 (when Glasgow Museums were faced with the appeal from the WKSA and a number of other requests) they decided to develop a set of criteria with which to consider each request. Subsequently, these criteria have been developed by other museums, such as the University of Aberdeen, and now form the basis of an approach advocated by museum advisory bodies such as Museums Galleries Scotland and used by other museums, with Glasgow's approach also now incorporating these developments. These criteria can be seen as falling into four groups relating to the item, the claimant, the item's significance, and the consequences of the decision (Curtis 2010). Since Glasgow's original criteria were produced there has been a move towards guidance on the presentation of evidence rather than criteria that need to be satisfied.

This follows discussion by Homan (2006) about codes of ethics in which he differentiated 'prescriptive codes' from 'educative codes'. A prescriptive code, 'calls for passive adherence on the part of investigators. The ideals are formulated by others for them to adopt. The educative code, by contrast, engages researchers in the mutual pursuit of good practice. They are required to "strive" and to stay mindful of their obligations' (Homan 2006: 103). By taking the 'educative' approach, the criteria relating to the significance of the item do not specify a particular type of significance or threshold that must be reached, while discussing the 'connection' rather than 'continuity' between claimant and item is more open-ended. The Aberdeen criteria also introduced a discussion of the role of the museum as well as the claimant in an attempt to create a more even-handed approach, through which the museum would also have to present its case if it wished to retain an item (University of Aberdeen 2007). Another important aspect of the Aberdeen procedure is its avoidance of definitions of categories of material as discussed above, such as 'human remains', 'sacred items', or 'cultural artefacts' to try to avoid Western ideas that may not be relevant to the reasons for the request for return. However, it is very difficult to do so, with the use of 'item' acknowledged to be a museum term, and that 'items in the collection may also be considered as ancestral remains and sacred items: the use of the term 'item' in this policy does not diminish the importance of other terms' (University of Aberdeen 2007). Kirsch (2011: 94) has argued that as 'the participants in these debates may be looking at the same material artifacts but seeing something entirely different' there is a need to acknowledge that there is no simple primacy to be given to science, property or kinship in discussions and that a proper resolution will 'require participants to attend to relationships across these domains and to understand how and why such claims are made'.

As Scottish procedures are based on museums having legal title to the items under Scots property law, they cannot be claimed to be neutral or to give much authority to the claimant. Nonetheless, the use of stated criteria does help to ensure that the request can be treated fairly, while the establishment of a

committee in the Glasgow and Aberdeen procedures to which both claimant and museum have to make their case is very important. The University of Aberdeen committee comprises representatives of the governing body and museum staff, but also specialist academic staff from the university and a representative of another Scottish museum as members. More unusually for such a committee, the people making the request are also invited to nominate someone to be a member. In Glasgow there was also a public hearing, at which Marcella LeBeau of the Wounded Knee Survivors Association and Mark O'Neill of Glasgow Museums gave presentations. The emphasis on public involvement reflects the long-standing sense of public interest that Glasgow has in its museums; it also reflects the nature of the city council as a representative political body. Verbal presentations by the claimant have proved to be very important in both Glasgow and Aberdeen (Curtis 2008, Maddra 1999), allowing them to present arguments and evidence that might be inappropriate in writing or for them to choose a style of rhetoric and formality that they consider suitable.

Despite the veneer of equal treatment of claimant and museum shown in the criteria, by acting as a combination of 'defence', 'judge', and 'jury', museums can still be criticized for having failed to escape from the attitudes that lay behind collecting for museums and the social destruction caused by colonialism. Related to this are the costs and practical problems of putting together a request, and the difficulty of presenting a case to suit a museum. Discussing the implementation of NAGPRA by the Makah in Washington State, Tweedie (2002:14) discovered 'how foreign the concept of cultural patrimony was to the Makahs (and their) frustrations with the lack of fit between the law and their material culture'. Despite the Scottish procedures being less tightly tied to legal procedures, they are still based on a Western legal tradition with its emphasis on the ownership of property and an apparently objective procedure. In some cases it could be that the very prospect of being compelled to share traditionally restricted knowledge with uninitiated outsiders in a public setting could prevent a group with a valid claim from pursuing it.

Scottish Identities and Repatriation

I have had it mentioned to me that Scotland has a good reputation for repatriation from museums, though this may relate primarily to the handful of well publicized returns and few high profile rejections. It may also be that as a small country, the close links within the museum community have resulted in common approaches, while there are also certain aspects of Scottish identity that may underlie the perception of a distinctive attitude, among which even the idea of a rational process and a public hearing could be seen as coming from a Scottish tradition of participatory democracy. In his presentation to the public hearing about the Ghost Dance Shirt, Mark O'Neill of Glasgow Museums discussed how the motives of those supporting return 'seemed to be based on Scottish people's self perception

as a just people, and their awareness that they had been beneficiaries as well as victims of imperial conquest' (Glasgow City Council 2000). Likewise, in his letter to the Director of Glasgow Museums requesting the repatriation of Benin bronzes to Nigeria, Bernie Grant (1996), a member of the British parliament, reported that the royal family of Benin drew 'an analogy with the recent return to Scotland of the Stone of Destiny. Just as the Stone is of such great significance to the people of Scotland, so the Benin treasures are significant to the people of Benin.' The return of the Stone of Destiny in 1996 was more complex, however, than the return of a national treasure stolen 700 years earlier might imply. Indeed, the decision by the UK government to return the Stone to Edinburgh was part of last-ditch attempt to counter arguments for a Scottish parliament by highlighting the importance of monarchy and tradition to Scotland. When returned with a show of pageantry, public reaction was muted, with Ascherson (2002: 23) arguing that 'over time the Stone's importance had become essentially that of the grievance it evoked. What mattered about the Stone was precisely its absence [...] its significance to Scots became that of wrongfully acquired English/British property.'

A proper understanding of Scottish attitudes to repatriation is therefore only possible if the country's complex identities are understood. It has been suggested that many aspects of Scottish identity reflect a tension between 'the "heart" (representing the past, romance, "civil society") and the "head" (the present and future, reason, and by dint of that, the British state)' (McCrone 1992: 175). Cairns Craig has argued that Scotland sees itself as being:

> at once a colonised nation (its languages, both Scots and Gaelic, under deliberate repression in favour of English; its institutions being gradually deprived of this unique tradition and integrated in to the English pattern; its heritage corrupted by the deliberate use of its national emblems and symbols as part of the UK *geist* by the British military), and yet an active – and often proud – partner in England's colonising of the rest of the world. By proxy it played a leading role in the world, even if to do so it had to ignore the extent to which it shared the conditions of those on whom it helped enforce British rule. (Craig 1990: 25)

In 1999, Angus Council decided to return two necklaces to the Cook Islands, arguing that they 'had been donated at a time when the museum collected everything and anything from any corner of the globe, and neither has been on display for any lengthy period in recent years' and that the efforts of formerly colonized nations 'in the setting up of national museums to preserve their heritage are to be applauded' (Angus Council 1999). As the decision was not based on a consideration of the necklaces as sacred or funerary items, this is a particularly unusual decision for a museum. Instead, it may be the product of the two aspects of Scottish identity identified by Craig (1990): the combination of a post-colonial empathy, seen in the support for the creation of a museum and an increasingly local focus that is not interested in discussing the colonial exploits of Scots, such that the objects had not been on display in recent years.

97

As well as repatriations from museums in Scotland, the past decade has also seen demands for returns of significant items found in Scotland now housed in museums elsewhere. Most notable among these has been the call by Scotland's First Minister Alex Salmond for the return of the medieval Lewis chess pieces from the collections of the British Museum, saying that he 'will continue campaigning for a united set in an independent Scotland' (Akbar 2007). While there is no reasonable argument that would see such items as being sacred, these cases do show the importance that can be accorded to items in museums. It also shows that a perceived willingness to repatriate items *from* Scottish museums could become part of a political argument in favour of repatriating items *to* Scotland.

However, most of the current claims for the return of items found in Scotland do not simply relate to their return to Scotland, with most of the people arguing for the return of the Lewis chess pieces arguing that they, or at least some of them, should go to the Isle of Lewis where they were found in the nineteenth century. This sense of local identity is a significant feature of Scotland, despite its small size and one that may have been growing recently. A revealing example relates to the discovery in 2001 of part of an elaborately carved Pictish stone erected about AD 800 at Hilton of Cadboll in northern Scotland (James et al. 2008). The largest part of the stone had been found many years previously and had been donated by the landowner to the British Museum in 1921, but then transferred to the National Museum in Edinburgh after public protest. With the finding of the base portion in 2001, much professional discussion focused on determining legal title to it – was it the property of the landowner (Historic Scotland, a government agency), or the national museum? Ethnographic work by Siân Jones (2004: 50) argued that this debate was askew to the attitudes of local people whose 'claims such as "the stone belongs to us" are primarily an expression of a social relationship, rather than one of property'. She also argued that the removal of the stone 'is seen as a further example of the power of landowners and the State, as well as their failure to consult local communities' (Jones 2004: 51).

Archaeological finds in Scotland are normally the subject of the Treasure Trove procedure, part of the Common Law tradition that sees all otherwise ownerless items as the property of the Crown. Finds are allocated by the Crown to museums on the basis of their written claims, which can sometimes be competing, with arguments about whether an item is of local, regional or national significance (Curtis 2007). The powerful feelings in favour of local allocation that were revealed at Hilton of Cadboll can also emerge as competition between a museum in a regional centre (e.g. Glasgow, Aberdeen, Inverness) and an independent museum in a small town (e.g. Tain, Kilmartin) or a local authority service covering a largely rural area (e.g. Aberdeenshire). Since the creation of single-tier local government in 1996, it is now harder for city-based museums to claim a regional role, while many museums now try to claim an exclusive territory. The feelings of local importance have also led to calls for the return of finds within Scotland, such as that by the Member of the Scottish Parliament for Shetland, Tavish Scott (2007) for the Scottish Government 'to assist in the widespread community campaign for

the return of the St Ninian's Isle treasure to Shetland, so that a highly significant part of Shetland's heritage can be enjoyed and understood in the context of the Shetland story by local people and visitors alike', and the return of a prehistoric carved stone from the Orkney Museum in Kirkwall, on the Orkney Mainland, to the island of Westray (Orkneyjar 2008).

Conclusion

This chapter has explicitly focused on the impact of repatriation on museums, though it does not diminish the impact it has had on communities who have regained the remains of their ancestors, sacred and significant items. Although health, education, land rights and other issues may be more urgent calls on limited resources, as Morris Udall said when NAGPRA was passed by the US House of Representatives, 'In the larger scope of history, this is a very small thing. In the smaller scope of conscience, it may be the biggest thing we have ever done' (Udall, quoted in McKeown, 2008: 145).

One of the greatest benefits to museums from becoming involved in repatriation discussions is the depth of understanding that they can gain of different ways of looking at the material world, such as 'acknowledging the communal property systems traditionally used by some Indian tribes not only returns those objects of cultural patrimony to their rightful owners but reinforces the complex social webs within each tribe' (McKeown 2008: 145). For example, the University of Aberdeen's recognition of the headdress as a sacred bundle meant that not only should it be returned from the university's museum, but also that it should not be treated as a museum object at all. This meant that the university did not request that it be the kept on display, available for loan or professionally conserved, instead it is now treated according to the traditional protocols of the Horn Society. The recognition of alternative ways of thinking includes an acceptance that repatriation may not be desired now, but that an indigenous people may wish to defer the return of their ancestors until they are able to care for them properly. It also means a willingness to negotiate the most appropriate level of publicity and to accept that each case may be different. By avoiding a simple 'one size fits all' approach to repatriation, museums have the opportunity to rethink their own attitudes, procedures and classifications as 'an important step towards redressing serious issues of cultural ownership and breaking down the barriers that have been constructed over centuries between themselves and the very cultures they claim to represent and interpret' (Hole 2007: 25).

Both Glasgow Museums and the University of Aberdeen created exhibits based on their experiences of repatriation. In Glasgow, the replica Ghost Dance Shirt presented by Marcella LeBeau in 1998 has been displayed to explore the shirt's context, history, and repatriation, with Glasgow councillors 'in no doubt that this was a better, more educational and more interesting museum display than that which had featured the original shirt' (CMSC 2000). In Aberdeen, the exhibition

'Going Home: Museums and Repatriation' in 2003 also displayed the replica shirt, alongside the story of the repatriation of the headdress, and a discussion of some of the issues behind other requests to museums. Comments by visitors on a board in the exhibition were almost entirely favourable, such as, 'all of humanity is connected to each other' and 'so glad to see this as a discussion – I knew very little about procedures and cases of repatriation'. It would seem that exhibiting the absence of an object can have a powerful impact, no less than that achieved by displaying it.

Developing relationships with source communities has been seen as one of the benefits of repatriation, with museums such as the National Museum of the American Indian institutionalizing consultation with native people about the best ways of storing, exhibiting and handling material in the collections. However, 'the process is slow, and implementation is complicated by the fact that tribal preferences are not uniform' and that 'except for the museum's early consultations, the staff is learning more from tribes who can make the trip to New York' (Rosoff 2003: 78). The idea of the museum as a 'contact zone' was proposed by Clifford (1997) as a move beyond their previous role as places representing imperialist appropriation to places in which that relationship could be rethought. Many of the museums which offer the best examples of this in practice have been those that have been involved in repatriations, such as the development of the Blackfoot Gallery in the Glenbow (Conaty 2003) and the work of the University of British Columbia Museum of Anthropology (Rowley and Hausler 2008). Boast has noted that although 'where there are indigenous stakeholders, we have seen an unprecedented improvement in the empowerment of source communities in the management, use, and presentation of their patrimony in museums' (Boast 2011: 56), he argues that such work is 'a means of masking far more fundamental asymmetries, appropriations and biases' (Boast 2011: 67).

Repatriation can have a profound and long-lasting impact on everyone involved, with Bailie Elizabeth Cameron of Glasgow City Council saying that 'we have ended up forging a place in the history of the Lakota, and the Lakota have become part of the history of Glasgow and of Glasgow museums' (CMSC 2000), while the keeper of the headdress repatriated from Aberdeen bought a kilt jacket to wear when dancing the headdress as a mark of its sojourn in Scotland. For it to lead to 'active collaboration and a sharing of authority' (Clifford 1997: 210) is not automatic and raises many practical issues for museums located far from the source communities of their collections. Whether museums speak of 'repatriation' or 'restitution', the real challenge is for them to respect the varied interests of people making requests which may, or may not, lead to the return of items from collections. Rather than the creation of classifications such as 'human remains' or 'sacred items' that deserve different treatment from other objects and that perpetuate the right of the museum to make decisions, the real challenge is for museums to reconceptualize themselves as not simply being places with collections, but being people who have a responsibility to discuss and challenge their complex legacies.

Bibliography

Akbar, A. 2007. Salmond makes first move in battle to win back Lewis Chessmen, *The Independent* [Online, 26 December] Available at:www.independent. co.uk/news/uk/home-news/salmond-makes-first-move-in-battle-to-win-back-lewis-chessmen-766822.html [accessed: 10 December 2012].

Angus Council. 1999. *Restitution of items from the museum collection: Report by Director of Cultural Services*, Angus Council Recreation and Cultural Services Committee 4 March 2009 [Online] Available at: http://www.angus.gov.uk/ ccmeetings/reports-committee1999/RecreationCulture/231.pdf [accessed: 10 December 2012].

Ascherson, N. 2002. *Stone Voices: The Search for Scotland.* London: Granta Books.

Australian Government 2007. *First repatriation of Torres Strait Island remains from UK* [Online] http://www.formerministers.fahcsia.gov.au/nigelscullion/ mediareleases/2007/Pages/repatriation_26jun07.aspx [accessed: 10 December 2012].

Boast, R. 2011. Neocolonial collaboration: museums as contact zone revisited. *Museum Anthropology* 34(1), 56-70.

Butler, T. 2001. Body of evidence. *Museums Journal,* 101(8), 24-7.

Butts, D. 2002. Maori and museums: the politics of indigenous recognition, in *Museums, Society and Inequality*, edited by R. Sandell. London: Routledge, 225-43.

Clifford, J. 1997. Museums as Contact Zones, in *Routes: Travel and Translation in the Late Twentieth Century*, J. Clifford. Cambridge: Harvard University Press, 188-219.

Conaty, G.T. 2003. Glenbow's Blackfoot Gallery: working towards co-existence, in *Museums and Source Communities: a Routledge Reader*, edited by L. Peers and A. Brown. London: Routledge, 227-41.

Craig, C. 1990. Sham Bards, Sham Nation, Sham Politics: Scotland, Nationalism and Socialism, *The Irish Review* 8 (Spring 1990), 21-33.

Curtis, N.G.W. 2003. Human remains: archaeology, museums and the sacred, *Public Archaeology* 3(1), 21-32.

Curtis, N.G.W. 2007. 'Like stray words or letters': The development and workings of the Treasure Trove system, in *West over Sea: Studies in Scandinavian Sea-Borne Expansion and Settlement Before 1300*, edited by B. Ballin Smith, S. Taylor and G. Williams. Leiden: Brill, 341-61.

Curtis, N.G.W. 2008. Thinking about the right home: repatriation and the University of Aberdeen, in *Utimut: Past Heritage – Future Partnerships – Discussions on Repatriation in the 21st Century*, edited by M. Gabriel and J. Dahl. Copenhagen: International Work Group for Indigenous Affairs and Nuuk: Greenland National Museum and Archives, 44-54.

Curtis, N.G.W. 2010. Repatriation from Scottish Museums: learning from NAGPRA, *Museum Anthropology* 33(2), 234-48.

Department for Culture, Media and Sport (DCMS) 2005. *Guidance for the Care of Human Remains in Museums*. London: Department for Culture, Media and Sport.

Fforde, C. 2009. From Edinburgh University to the Ngarrindjeri Nation, South Australia, *Museum International* 61(1-2), 41-7.

Fforde, C. and Parker, L.O. 2001. Repatriation Developments in the UK, *Indigenous Law Bulletin* 5(6) (February 2001) [Online] Available at: http://www.austlii.edu.au/au/journals/ILB/2001/10.html#Heading39 [accessed: 10 December 2012].

Garratt-Frost, S. 1992. *The Law and Burial Archaeology*, Institute of Field Archaeologists Technical Paper 11, Birmingham: Institute of Field Archaeologists.

Gilchrist, J. 2007. No place like home, *The Scotsman*, 31 January.

Glasgow City Council 2000. *Memorandum submitted by Glasgow City Council to the House of Commons Culture, Media and Sport Committee* [Online] Available at: http://www.publications.parliament.uk/pa/cm199900/cmselect/cmcumeds/371/0051808.htm [accessed: 10 December 2012].

Glasgow City Council 2005. *Minutes of Cultural and Leisure Services Committee* 2 March.

Gordon, G.H. 2001. *The Criminal Law of Scotland*, 3rd Edition, vol. 2, edited by M.G.A. Christie. Edinburgh: W. Green & Son Ltd/Scottish Universities Law Institute.

Grant, B. 1996. *Letter to Julian Spalding, Director, Glasgow Museums re African Religious and Cultural Objects from Bernie Grant MP* [Online, 10 December]. http://www.elginism.com/20110127/3512/ [accessed: 10 December 2012].

Hallam, E. and Hockey, J. 2001. *Death, Memory and Material Culture*. Oxford: Berg.

Herewini, T.H. 2008. The Museum of New Zealand Te Papa Tongarewa (Te Papa) and the Repatriation of Kōiwi Tangata (Māori and Moriori skeletal remains) and Toi Moko (Mummified Māori Tattooed Heads), *International Journal of Cultural Property* 15, 405-6.

Hill, T. and Nicks. T. 1992. *Turning the Page: Forging New Partnerships Between Museums and First Peoples. Report of the Task Force on Museums and First Peoples*. Ottawa: Assembly of First Nations and Canadian Museum of Civilization.

Hole, B. 2007. Playthings for the foe: the repatriation of human remains in New Zealand, *Public Archaeology* 6(1), 5-27.

Homan, R. 2006. Problems with codes, *Research Ethics Review* 2(3), 98-103.

House of Commons Culture, Media and Sport Committee (CMSC) 2000. *Cultural Property Return and Illicit Trade, Seventh Report* [Online] Available at: http://www.parliament.the-stationery-office.co.uk/pa/cm199900/cmselect/cmcumeds/371/37107.htm#a21 [accessed: 10 December 2012].

Ingold, T. 1994. Humanity and animality, in *Companion Encyclopaedia of Anthropology: Humanity, Culture and Social Life*, edited by T. Ingold. London: Routledge, 14-32.

Ingold, T. 2000. Ancestry, generation, substance, memory, land, in *The Perception of the Environment: Essays in Livelihood, Dwelling and Skill*, edited by T. Ingold. London: Routledge, 132-51.

Jacobs, J. 2009. Repatriation and the reconstruction of identity, *Museum Anthropology* 32(2), 83-98.

James, H., Henderson, I., Foster S. and Jones, S. 2008. *A Fragmentary Masterpiece: Recovering the Biography of the Hilton of Cadboll Pictish Cross Slab*, Edinburgh: Society of Antiquaries of Scotland.

Jones, S. 2004. *Early Medieval Sculpture and the Production of Meaning, Value and Place: The Case of Hilton of Cadboll*, Edinburgh: Historic Scotland.

Kirsch, S. 2011. Science, property, and kinship in repatriation debates, *Museum Anthropology* 34(2), 91-6.

Kwasnik, E.I. 1994. *A Wider World: Collections of Foreign Ethnography in Scotland*. Edinburgh: National Museum of Scotland and Scottish Museums Council.

Logie, J. 1992. Scots Law, in *The Law and Burial Archaeology*, Institute of Field Archaeologists Technical Paper No.11, Appendix 4.

Lusher, A. 2002. Corpse Art Outrages Alder Hey Parents, *The Sunday Telegraph*, 3 March.

Maddra, S. 1999. *Glasgow's Ghost Dance Shirt*, Glasgow: Glasgow Museums.

McCrone, D. 1992. *Understanding Scotland: The Sociology of a Stateless Nation*, London: Routledge.

McKeown, C.T. 2008. Considering repatriation legislation as an option: the National Museum of the American Indian Act (NMAIA) & the Native American Graves Protection Act (NAGPRA), in *Utimut: Past Heritage – Future Partnerships – Discussions on Repatriation in the 21st Century*, edited by M. Gabriel and J. Dahl. Copenhagen: International Work Group for Indigenous Affairs and Nuuk: Greenland National Museum and Archives, 134-47.

McLaughlin, M. 2008. Picking the bones out of our imperial past, *The Scotsman*, 8 July.

Museums Galleries Scotland (MGS) 2011. *Guidelines for the care of human remains in Scottish museum collections*. Edinburgh: Museums Galleries Scotland [Online] http://www.museumsgalleriesscotland.org.uk/publications/publication/378/guidelines-for-the-care-of-human-remains-in-scottish-museum-collections [accessed: 10 December 2012].

Nicks, T. 1992. Partnerships in Developing Cultural Resources: Lessons from the Task Force on Museums and First Peoples, *Culture* 12(1), 87-94.

O'Neill, M. 2006. Repatriation and its Discontents: The Glasgow Experience, in *Who Owns Objects: The Ethics and Politics of Collecting Cultural Artefacts*, edited by E. Robson, L. Treadwell and C. Gosden. Proceedings of the First St

Cross-All Souls Seminar Series and Workshop, Oxford, October-December 2004. Oxford: Oxbow Books, 105-28.

Orkneyjar 2008. Westray stone returns home, *Orkney Archaeology News.* [Online, 7 March] Available at: http://www.orkneyjar.com/archaeology/2008/03/01/westray-stone-returns-home/ [accessed: 10 December 2012].

Peers, L. and Brown, A.K. 2003. Introduction, in *Museums and Source Communities: a Routledge Reader,* edited by L. Peers and A. Brown. London: Routledge, 1-16.

Perth and Kinross Council. 2005. *Repatriation Request (Museum of New Zealand),* Report by the Executive Director (Education and Children's Services) to the Lifelong Learning Committee 12 January.

Province of Alberta. 2004. *Blackfoot First Nations Sacred Ceremonial Objects Repatriation Regulation.* Alberta Regulation 96/2004. [Online] Available at: http://www.qp.alberta.ca/documents/Regs/2004_096.pdf [accessed: 10 December 2012].

Rosoff, N.B. 2003. Integrating Native Views into Museums Procedures: Hope and Practice at the National Museum of the American Indian, in *Museums and Source Communities: a Routledge Reader,* edited by L. Peers and A. Brown. London: Routledge, 72-9.

Rowley, S. and Hausler, K. 2008. The Journey Home: A Case Study in Proactive Repatriation, in *Utimut: Past Heritage – Future Partnerships – Discussions on Repatriation in the 21st Century,* edited by M. Gabriel and J. Dahl. Copenhagen: International Work Group for Indigenous Affairs and Nuuk: Greenland National Museum and Archives, 202-12.

Scott, E. and Luby, E.M. 2007. Maintaining relationships with native communities: the role of museum management and governance, *Museum Management and Curatorship* 22(3), 265-85.

Scott, T. 2007. S3M-116 Tavish Scott: Return of the St Ninian's Isle Treasure to Shetland, *Scottish Parliament Business Bulletin* No. 81/2007: Tuesday 5 June.

Te Papa 2009. *Karanga Aotearoa Repatriation Programme Summary Document: Background, Research Methodology, International and Domestic Repatriation.* [Online] Available at: http://www.vastarvet.se/upload/vastarv/Dokument/2009%20Nov%20Te%20Papa%20Summary%20Background%20Repatriation.pdf [accessed: 10 December 2012].

Tree, O. 2009. Glasgow museum returns Maori heads after 150 years, *Scotland on Sunday.* [Online, 6 December] Available at: http://news.scotsman.com/scotland/Glasgow-museum-returns-Maori-heads.5887692.jp [accessed: 10 December 2012].

Tweedie, A.M. 2002. *Drawing Back Culture: The Makah Struggle for Repatriation,* Seattle: University of Washington.

University of Aberdeen 2007. *Responding to requests for the return of items in the University's museum collections* [Online] Available at: http://www.abdn.ac.uk/museum/museum_policies.shtml#appendiximuseums [accessed: 10 December 2012].

University of Edinburgh 2004. *Edinburgh University Library – Library Collections Policy*. [Online] Available at: http://www.ed.ac.uk/polopoly_fs/1.13157!fileManager/collectionspolicy.pdf [accessed: 10 December 2012].

Chapter 7

In Consideration of Restitution: Understanding and Transcending the Limits of Repatriation under the Native American Graves Protection and Repatriation Act (NAGPRA)

Helen A. Robbins

Introduction

In the United States, the enactment of the Native American Graves Protection and Repatriation Act (NAGPRA; 25 U.S.C. § 3001, et seq. (2006)) in 1990 was an important force in bringing about a sea change in museum practice and principles.[1] Repatriation is now a vital component of contemporary museum practice in the United States and is becoming increasingly important both domestically and internationally. It can be a way to address the changing nature of relationships between institutions and indigenous communities and it provides an opportunity to establish mutually beneficial relationships among individuals, museums, tribes, and governments.

While the NAGPRA legislation has had broad ramifications, in the nexus of museum and tribal relations, there are two primary effects. Of great significance initially were the provisions of the law and regulations that required museums[2] with Native American collections to consult with federally recognized tribes and to return certain classes of culturally affiliated items. As part of the consultation process, museums had to provide summaries of collections, submit and publish

1 The views expressed in this chapter are my own and do not represent the opinion of the Field Museum.

2 Contrary to common usage, NAGPRA's definition states that a museum 'means any institution or State or local government agency (including any institution of higher learning) that receives Federal funds and has possession of, or control over, Native American cultural items. Such a term does not include the Smithsonian Institution or any other Federal agency' (25 U.S.C. § 3001(8) (2006)). In this chapter, the term 'museum' will be used in accordance with the Statute's definition in the context of NAGPRA, but will retain its common meaning elsewhere.

**Figure 7.1 Leigh Wayne Lomayestewa playing a gourd instrument that
 mimics the sound of frogs. Photograph: Helen Robbins, 2012**

inventories of the human remains held, and provide access to archival materials
(see Figure 7.1). Here NAGPRA acted as the much needed wedge that forced
institutions, both museums and federal agencies, to engage with their subjects
and to reveal information and details about items and how they were collected

(cf. Bruchac 2010, Fine-Dare 2002, Haas 1996, Heard Museum 1990, Mihesuah 2000). Although some academics and institutions were already conducting repatriations and working with indigenous scholars and native communities before 1990 (cf. Ferguson and Hart 1985, Ferguson, Anyon, and Ladd 2000, Jacknis 2000, Niezen 2000: 176-83, Roth 1991), the majority of museums remained cloistered; access to collections and related documents were limited to academics or those with the right connections. Second, the radical shift in access mandated by NAGPRA brought about increased engagements between individuals and organizations. These, in turn, are fostering changes in attitudes and opening the door for collaborations, knowledge sharing, and other initiatives (Bruchac 2010, Graham and Murphy 2010). Nevertheless, as much as museum staff and tribal members strive to collaborate and work to change the historical relationships between museums and tribes, under NAGPRA, the repatriation process continues to be complicated, lengthy, and, at times, difficult.

Background

The history of how and why repatriation legislation came about in the United States has been addressed by several authors from a wide variety of perspectives (e.g., Fine-Dare 2002, Lovis et al. 2004, Meighan 2000, Mihesuah 2000, Trope and Echo-Hawk 2000). To briefly summarize, NAGPRA was enacted to deal with a very specific set of issues that arose during the history of interaction between Native Americans and the United States Government. Throughout the twentieth century numerous strategies, including lawsuits and legislation, were undertaken to address treaty violations and other injustices that had occurred during the long period of American expansionism (cf. Deloria 1974, 1985, Josephy 1985, Prucha 1988). But it was not until well after the successes of the US civil rights and human rights movements that began in the 1950s and 1960s, that the issue of Native American ancestral human remains and objects in museum collections was formally addressed by the US Government through the passage of the National Museum of the American Indian Act (NMAIA; 20 U.S.C. § 80q et seq.) in 1989 and the passage of NAGPRA in 1990.

The colonization of what is now the United States occurred in many waves, over many hundreds of years, and was conducted by several nations – England, France, Russia, Spain and the United States. Explorers, miners, missionaries, settlers, traders, trappers and whalers, to name only a few, materially contributed to these imperialist projects. Ultimately, the policies of the US Government resulted in an ever-expanding 'frontier', where even federally established tribal boundaries became permeable. The land was opened up to massive immigration and resource exploitation. The result for the native populations was dislocation, population decimation, and far-reaching cultural change (cf. Deloria 1974, 1985, Prucha 1988, Tanner 1987, Washburn 1988). It was within this social and historic context that anthropologists, archaeologists, private collectors and soldiers,

among others, acquired a vast number of Native American cultural items. This bounty of material, much of which now resides in museums or in federal and state repositories, not only included a significant amount of items of cultural and/or religious import, but also an astonishing number of human remains and funerary objects.

A major reason that such a large amount of Native American cultural items had been collected was the widespread belief in the nineteenth and early twentieth centuries that the Indian people and their cultures would die out, be corrupted by Western influence and/or be assimilated. E.S. Curtis, the photographer, wrote his thoughts about the 'Vanishing Race':

> They knew not what they reckoned. Advancing civilization has crushed all before it; primitive men can but snap and snarl like a brute cur at the giant which has been his destructor. The Buffaloes are gone; the human brother is but a tottering fragment, robbed of his primitive strength, stripped of his pagan dress, going into the darkness of the unknown future. (Cited in Makepeace 2002: 65)

As a result, private individuals and museums went forth to collect as much material as they could from these groups (Cole 1985, MacDonald 2005). It was not just quantity they sought; collectors wanted to get the most important cultural items from all over the world (Figure 7.2).

They targeted objects that were rare, had religious significance or great value. Not only did they want items that had monetary or aesthetic value from a Western perspective, they also went after items that were, or had been, most valued by the communities of origin.[3]

> [...] I obtained this old piece for the Museum's collection from the last of the house group, the members of which are known as the founders of the Kaguanton Clan. When I carried the object out of its place no one interfered, but if only one of the true warriors of that clan had been alive the removal of it would never have been possible. I took it in the presence of aged women, the only survivors in the house where the old object was kept, and they could do nothing more than weep when the once highly esteemed object was being taken away to its last resting place. (Shotridge 1929: 339-41)

Scientists, including medical doctors and anthropologists, also wanted human remains in order to study differences – thought to be innate – between the 'races

3 From the pueblos in the southwestern United States, for example, collectors aggressively went after *Kachina* masks, altar pieces, and other secret/sacred items, such as the *Ahayu:da, War Gods, from Zuni*. In the Northeast, among the Iroquoian groups, institutions and individuals focused on the acquisition of wampum belts used to signify alliances between groups and, because of their importance, generally thought to be inalienable.

Figure 7.2 Artists Nathan and Stephen Jackson at work on a new pole in
Stanley Field Hall. Photograph: John Weinstein. Copyright:
The Field Museum, GN90988_091d

of men'. In one often referred to example from 1867, the Surgeon General of the United States sent out a circular requesting that medical officers gather a wide range of anthropological and zoological specimens for the Army Medical Museum. 'Besides interesting medical and surgical specimens', he also asked for 'rare pathological specimens from animals, including monstrosities' and 'typical crania of Indian tribes, specimens of their arms, dress implements, rare articles of their diet, medicines, etc' (Barnes 1867). Ultimately, approximately 3-4,000 sets of remains acquired by the Army Medical Museum were transferred to the Smithsonian Institution (Lamb 1917: 632). Further, collectors also sought complete human remains or body parts, simply as curiosities.

Some of the ethnographic and archaeological materials were collected or excavated legally and legitimately, but, in other cases, collectors used unsavory and sometimes illegal tactics. The result was that museums have in their collections a remarkable array of Native American material with an equally varied provenance. NAGPRA was created as an explicit recognition of this history and acknowledgement that Indian rights had been systematically breached (US House 1990; McKeown and Hutt 2003). Tribes and lineal descendents would be accorded the same rights and privileges as other groups of people (Trope and Echo-Hawk 2000) and many of these rights would be applied, essentially, retroactively. In other words, the legislation turned a small part of Western property law on its head by allowing the possibility of claims on objects that had been held by museums for decades. No longer could museums use the legal Doctrine of Laches as a way to assert their property rights in North American Indian objects. Time and open possession were not enough to claim title. Ownership, however, could still be demonstrated by museums, as will be touched upon later, but it could no longer be assumed. The ability for tribes to make claims on items that had been alienated decades or hundreds of years prior was truly a radical, if small, change in the basic tenets of Western property law. The Human Tissue Act of 2004 in the United Kingdom has had much the same effect by allowing institutions, under certain circumstances, to de-accession human remains.

Some Challenges to the Implementation of NAGPRA

NAGPRA is widely considered to be 'landmark legislation' that fundamentally transforms the way US museums and tribes interact. There is a tension, however, that becomes manifest during the process of implementing NAGPRA that is both inherent in the fabric of the legislation and tied to history and to perception. In the words of Colin Kippen[4] (2009), 'NAGPRA is an incredibly complex and technical piece of legislation'. Some of this complexity derives from the fact that the legislation was a 'compromise' created as a way to balance the interests of multiple

4 Kippen is an attorney and former member of the NAGPRA Review Committee. He was the first Native Hawaiian to serve on that Committee.

constituencies (McKeown and Hutt 2003; US Senate 1990). Archaeologists, Native Americans, museum professionals, Native Hawaiians, politicians and lawyers all participated in the convoluted process. Consequently, many were satisfied, but few were happy with all the definitions and requirements (Deloria 1992). The reality, openly stated only by a few, is that many, on either side of the debate, do not want a compromise. For them, NAGPRA failed by either doing too much or too little.

Nevertheless, compromises were made. The end result is that the repatriation provisions in NAGPRA have a very limited scope, are, in many instances, poorly written and conceived, and fail to adequately address the needs of all constituents (Haas 2001). For example, despite common perceptions (in some cases, fears), NAGPRA applies to only a very few categories of items. These include human remains, associated funerary objects, unassociated funerary objects, sacred objects and objects of cultural patrimony. The definitions provided in the law and regulations further limit the quantity of items that are eligible for repatriation under NAGPRA. The definition of Native American, for example, continues to be problematic. According to the Statute, 'Native American' means of, or relating to, a tribe, people, or culture that *is* indigenous to the United States (emphasis added) (25 U.S.C. § 3001(9)). Much of the argument in the hotly debated 'Kennewick Man' case (Bonnichsen et al. v. United States et al., 217 F. Supp. 2d 1116 (Dist. OR. 2002), and capably discussed by Bruning (2006) and Siedemann (2003), focused on the specificity of this definition.

Another key reason that NAGPRA falls short of expectations and results in conflict is that NAGPRA is used to define categories of objects that are not only not 'Western', but are also multiple. The law cannot possibly capture the complexity and diversity of one cultural group's beliefs, let alone comprehend the meaning systems of many cultures (cf. Curtis 2003). The Committee did acknowledge and try to address this limitation to some degree. The US Senate Report (1990: 7) states 'that there are over 200 tribes and 200 Alaska Native villages and Native Hawaiian communities, each with distinct cultures and traditional and religious practices that are unique to each community […]' and therefore 'the definitions of sacred objects, funerary objects, and items of cultural patrimony will vary according to the tribe, village, or Native Hawaiian community.' While this recognition is, on the face of it, useful, the law creates categories that require tribes and museums to fit objects into legal boxes and definitions that frequently are not culturally salient. Moreover, the artificial categorization of cultural items can also be seen as 'antithetical and disrespectful to traditional native beliefs' (Kippen 2009). Museums, in turn, must assess claims according to the law, regardless of how problematic it may be, while interpreting the varying cultural definitions and meanings of each claimant group. This is no easy task in practice given the diversity of Native American and Hawaiian cultures within the United States. The end result is that tribes and museums do not always agree that a requested item should be repatriated under NAGPRA and they must articulate why within this Western and adversarial legal framework.

In addition to the issues touched on above, NAGPRA adds another wrinkle to the repatriation claim process. Not only does the requested item need to fit within at least one of the law's circumscribed categories, tribes are also required to present evidence that demonstrates that the museum does not have right of possession to the requested materials. This section of the law was explicitly created in response to tribal concerns that many 'important ceremonial objects' were originally stolen and ended up in museums (US Senate 1990: 8). It was meant to create a framework and express a clear standard for tribes to reclaim items by not presuming that museums had good title to everything in their collections. Nevertheless, once the tribe provides evidence the museum then must 'return such objects unless *it can overcome such inference and prove that it has a right of possession* to the objects' (25 USC. § 3005(c) (emphasis added). This requirement, one necessitated by the constraints of Western property law and the intent to be consistent with that body of law, potentially limits the items subject to repatriation under NAGPRA (Boyd and Haas 1992: 271-3, Haas 1996, US Senate 1990: 9). Thus many items that tribes might like to or think they should be able to repatriate may not be eligible because the museum believes it can prove right of possession and asserts that right.[5] Furthermore, it is not such a simple task to demonstrate a museum's right of possession or lack thereof for items alienated in centuries past and in cases where the item's collection history is unclear or unknown.

Within this imperfect substrate of Western law, another challenge is that there is often a divide between what NAGPRA actually states and allows and what people believe it says or think it ought to say. The disjuncture is in part interpretative – one can read law narrowly or broadly; one can read and interpret the law based on legislative history; or the law can be framed ideologically – that is referenced strategically, but the interpretation is more a reflection of the perspective of the reader than of the language of the law (Bruning 2006: 506). While there is a wide interpretive spectrum, in the case of NAGPRA, the dissent goes beyond that and the end result is, in effect, continued polarization. The range of perspectives can be seen in the growing literature on repatriation as well as in the public comments during Congressional and Senate Hearings on NAGPRA. Even more clearly perhaps, testimony and statements made during disputes at NAGPRA Review Committee meetings (cf. RC 2006, 2009, 2010) and arguments put forward in the Kennewick Man case (Bruning 2006) demonstrate the interpretive divide. Based on the above, it is apparent that a number of museums sometimes do construe the specific terms and definitions in the law differently than some tribes. Regardless of whether or not these interpretations of NAGPRA are substantively correct, they

5 The Willamette Meteorite, or *Tomanowos*, located at the American Museum of Natural History (AMNH) in New York is a clear example of a case where a tribe requested the item as a sacred object under NAGPRA, but the Museum asserted its ownership rights and these were legally affirmed. It is also a good example of how the Confederated Tribes of the Grand Ronde and the AMNH worked together to find a solution that was to the benefit of all (Graham and Murphy 2010).

can make museums vulnerable to criticisms of being overly legalistic, covetous and anti-Indian. In turn, it is also clear that some advocates believe the law should do more than what its provisions state. They believe that evidence presented by tribal members should carry more weight and influence than other types of evidence[6] and argue that museums should take responsibility for past actions (RC 2006). While these types of interpretive differences are to be expected, they create impediments to successful and timely implementation.

Finally, to make matters more complicated and potentially contentious, it is the obligation of each museum to determine if a tribe's request fulfils all of the requirements of the law and its implementing regulations. It is the museums that must send out the inventories and summaries, make the determinations of cultural affiliation, and decide whether requested items meet the standards set forth in NAGPRA. Although museums must consult with tribes throughout the process, scholars, such as Riding-In (2009) and Bruchac (2010: 148), have criticized the legislation for giving so much authority to museums. They see this part of the legislation as more than a little flawed. This obligation that the law puts on museums is, indeed, problematic due to the fact that museums often have other legal obligations and ethical duties that must be considered along with repatriation law (cf. Malaro 1985, Boyd and Haas 1992). These obligations include, but are not limited to, preserving the collections and fulfilling their duty to the public. The museums, therefore, have to somehow manage and transcend the likely conflicts of interest that emerge out of repatriation requests.

For most US museums, the first priority and focus of repatriation efforts has been to meet the legal obligations as defined. By necessity – lack of funds and staff – museums have concentrated on first fulfilling their legal requirements before other types of outreach and collaborative or creative initiatives. A pervasive concern continues to be that the institution is in compliance with all applicable law, federal and state, as it complies with NAGPRA and its associated regulations. As a result, many of the larger institutions take a systematic approach to following the law, which involves intense analysis and thought. Not surprisingly, tribes have not been keen on the museums' role as the authority to decide whether or not human remains and objects can be affiliated, fit into the NAGPRA categories and therefore should be returned; museums, in turn, are, at the very least, ambivalent about their role in the process. They must follow the many laws that apply to them, including the obligation to care for and retain collections (cf. Malaro 1985). Just as NAGPRA provided very few funds to support tribal repatriation efforts, the government also did not see fit to adequately fund museums' compliance efforts.[7]

6 See comments made by Review Committee Member, Sonya Atalay (RC 2009: 34-5).

7 The National Park Service does award consultation and documentation grants to museums through their NAGPRA Grants programme. These grants, however, have only contributed a small fraction of the actual cost of museum compliance with NAGPRA.

The result has been that museums and tribes often struggle to find the resources to pay for research, consultation and analysis.

Moving Beyond the Limitations

Despite profound problems both real and perceived with NAGPRA and its administration (cf. US Government Accountability Office 2011; Makah 2008), the positive outcomes are why NAGPRA can be seen, in general terms, as a success. It is also why tribes and museums continue to come to the table. NAGPRA has resulted in the repatriation of tens of thousands of human remains, hundreds of thousands of funerary objects, and thousands of important cultural and/or religious items. The enactment of NAGPRA has, very simply, made repatriation in the United States viable. Further, for museums, the law has created an environment where repatriation and issues related to it could move to the forefront. As a result, the discussion, both public and private, has evolved and shifted over time (Haas 1996). Although the ideological effects of the law are multiple and may be opposing, all of this thinking, talking and writing ultimately affects how people understand indigenous issues, the place and purpose of the museum, as well as that of science. One effect, for example, was to increase the understanding of what lay behind tribes' quest for repatriation rights. Ultimately, it reconfigured widely held perceptions about the object-ness of objects. Increasingly, museum staff began to see beyond the aesthetics and scientific value of objects and to comprehend their life, meaning, and importance (cf. Curtis 2003). Concomitantly, museums have started to rethink and broadly question the preservation ethic. Should museums keep everything and can museums be more than collections/object-based entities? This greater appreciation of the meaning and importance of materials in collections, however, does not always translate into physical repatriation, nor should it necessarily. What it does do, however, is create opportunities for future engagement between tribes and museums.

Because of NAGPRA, the NMAIA, and the commitment of native and non-native participants, museums and tribes are conceiving of and beginning more collaborative projects. These initiatives include traditional care of sensitive items, co-curated exhibits, projects that provide digital access to tribes, the use of X-Ray Fluorescence (XRF) technology to detect heavy metals on objects, and the commissioning of new art (Moore 2010, Odegaard and Sadongei 2005, Smithsonian 2011) (Figure 7.3). Most of these types of projects have developed directly out of repatriation consultations. Although flawed and problematic, NAGPRA has been a catalyst for positive change within museums and provided unforeseen opportunities for tribes and museums. Museums in the United States must look beyond the law to define forward-looking priorities that recast their place in the world as a resource and as a site of engagement and partnership with indigenous communities. Collaborative projects such as those mentioned have enormous promise and create the opportunity for the formation of a new

Figure 7.3 **Photo break during XRF testing of Zuni cultural items located at the Field Museum. From left: Octavius Seowtewa, Susan Benton Bruning, Cheryl Podsiki and Davis Nieto. Photograph: Helen Robbins, 2009**

multilingual museum that reaches out beyond historical taints and physical constraints. The museum needs to be recast and reformed to move beyond its colonial history. Repatriation has created that opening.

Bibliography

Barnes, J.K. 1867. *(Circular, No. 2) War Department, Surgeon General's Office, Washington, D.C., April 4, 1867.* [Online] Available at http://bottledmonsters. blogspot.com/2010/09/sgo-circular-2-1867.html [accessed: 13 February 2012].

Bonnichsen et al. v. United States et al., 217 F. Supp. 2d 1116 (Dist. OR. 2002).

Boyd, T.H. and Haas, J. 1992. The Native American Graves Protection and Repatriation Act: Prospects for New Partnerships Between Museums and Native American Groups. *Arizona State Law Journal*, 24(1), 253-82.

Bruchac, M.M. 2010. Lost and Found: NAGPRA, Scattered Relics, and Restorative Methodologies. *Museum Anthropology*, 33(2), 137-56.

Bruning, S.B. 2006. Complex Legal Legacies: The Native American Graves Protection and Repatriation Act, Scientific Study, and Kennewick Man. *American Antiquity*, 71(3), 501-21.

Cole, D. 1985. *Captured Heritage: The Scramble for Northwest Coast Artifacts.* Seattle: University of Washington Press.

Curtis, N.G.W. 2003. Human Remains: The Sacred, Museums and Archaeology. *Public Archaeology,* 3, 21-32.

Deloria, V. Jr. 1974. *Behind the Trail of Broken Treaties: An Indian Declaration of Independence.* New York: Delacorte Press.

Deloria, V. Jr. (ed.). 1985. *American Indian Policy in the Twentieth Century.* Norman: University of Oklahoma Press.

Deloria, V. Jr. 1992. Indians, Archaeologists, and the Future. *American Antiquity,* 47(4), 595-8.

Ferguson, T.J., Anyon R. and Ladd E.J. 2000. Repatriation at the Pueblo of Zuni: Diverse Solutions to Complex Problems, in *Repatriation Reader: Who Owns American Indian Remains?,* edited by D.A. Mihesuah. Lincoln: University of Nebraska Press, 239-65.

Ferguson, T.J. and Hart, E.R. 1985. *A Zuni Atlas.* Norman: University of Oklahoma Press.

Fine-Dare, K.S. 2002. *Grave Injustice: The American Indian Repatriation Movement and NAGPRA.* Lincoln: University of Nebraska Press.

Graham M. and Murphy N. 2010. NAGPRA at 20: Collections and Reconnections. *Museum Anthropology,* 33(2), 105-24.

Haas, J. 1996. Power, Objects, and a Voice for Anthropology. *Current Anthropology,* 37, supplement, S1-22.

Haas, J. 2001. Sacred Under the Law: Repatriation and Religion Under the Native American Graves Protection and Repatriation Act (NAGPRA), in *The Future of the Past: Archaeologists, Native Americans, and Repatriation,* edited by T. Bray. New York: Garland Publishing, 117-26.

Heard Museum. 1990. *Report of the Panel for a National Dialogue on Museum/ Native American Relations, February 28, 1990.* [Online]. Available at: http:// rla.unc.edu/saa/repat/Legislative/HeardReport.1990-02-28.pdf [accessed 12 February 2012].

Jacknis, I. 2000. Repatriation as Social Drama: The Kwakiutl Indians of British Columbia, 1922-1980, in *Repatriation Reader: Who Owns American Indian Remains?,* edited by D.A. Mihesuah. Lincoln: University of Nebraska Press, 266-81.

Josephy, A.M., Jr. 1985. *Red Power: The American Indians' Fight for Freedom.* Lincoln: University of Nebraska Press.

Kippen, C. 2009. *Testimony of Colin Kippen before the House Resources Committee on the Native American Graves Protection and Repatriation Act.* [Online, 7 October 2009] Available at: http://naturalresources.house.gov/UploadedFiles/ KippenTestimony10.07.09.pdf [accessed: 30 September 2011].

Lamb, D.C. 1917. The Army Medical Museum in American Anthropology, in *Proceedings of the Nineteenth International Congress of Americanists,* edited by F.W. Hodge, Washington, DC, 625-32.

Lovis, W.A., Kintigh, K.W., Steponaitis, V.P. and Goldstein, L.G. 2004. Archaeological Perspectives on the NAGPRA: Underlying Principles, Legislative History, and Current Issues, in *Legal Perspectives on Cultural Resources*, edited by J.R. Richman and M.P. Forsyth. Walnut Creek: Altamira Press, 165-84.

MacDonald, H. 2005. *Human Remains: Episodes in Human Dissection*. Victoria, Australia: Melbourne University Press.

Makah Indian Tribe and the National Association of Tribal Historic Preservation Officers. 2008. *Federal Agency Implementation of the Native American Graves Protection and Repatriation Act* (Washington, DC: 30 June 2008).

Makepeace, A. 2002. *Edward S. Curtis: Coming to Light*. Washington, DC: National Geographic.

Malaro, M.C. 1985. *A Legal Primer on Managing Museum Collections*. Washington, DC: Smithsonian Institution Press.

McKeown, C.T. and Hutt, S. 2003. In the Smaller Scope of Conscience: The Native American Graves Protections & Repatriation Act Twelve Years After. *Journal of Environmental Law*, 21, 153-212.

Meighan, C.W. 2000. Some Scholars' Views on Reburial, in *Repatriation Reader: Who Owns American Indian Remains?*, edited by D.A. Mihesuah. Lincoln: University of Nebraska Press, 190-99.

Mihesuah, D.A. (ed.) 2000. *Repatriation Reader: Who Owns American Indian Remains?* Lincoln: University of Nebraska Press.

Moore, E. 2010. Propriation: Possibilities for Art after NAGPRA. NAGPRA at 20: Collections and Reconnections. *Museum Anthropology*, 33(2), 125-36.

Niezen, R. 2000. *Spirit Wars: Native North American Religions in the Age of Nation Building*. Berkeley: University of California Press.

Odegaard, N. and Sadongei, A. 2005. *Old Poisons, New Problems: A Museum Resource for Managing Contaminated Cultural Materials*. Walnut Creek: Altamira Press.

Prucha, F.P. 1988. *The Great Father: The United States Government and the American Indians*. Abridged Edition. Lincoln: University of Nebraska Press.

RC (Native American Graves Protection and Repatriation Review Committee). 2006. Transcript of the 3-4 November 2006, meeting in Denver, Colorado. National NAGPRA Program, National Park Service, Washington, DC.

RC (Native American Graves Protection and Repatriation Review Committee). 2009. Transcript of the 30-31 October 2009, meeting in Sarasota, Florida, National NAGPRA Program, National Park Service, Washington, DC.

RC (Native American Graves Protection and Repatriation Review Committee). 2010. Transcript of the 17-18 November 2010, meeting in Washington, DC. National NAGPRA Program, National Park Service, Washington, DC.

Riding-In, J. 2009. *Native American scholar James Riding-In: Stored remains a human rights violation*. [Online] Available at: http://www.annarbor.com/news/ native american-scholar-visits-university-of-michigan-discusses-holdings-of-indian-remains/ [accessed: 30 September 2011].

Roth, E. 1991. Success Stories. *Museum News*, February: 41-5.

Shotridge, L. 1929. The Kaguanton Shark Helmet. *The Museum Journal (The Museum of the University of Pennsylvania)*, September-December, 339-43.

Siedemann, R.M. 2003. Time for a Change? The Kennewick Man Case and Its Implications for the Future of the Native American Graves Protection and Repatriation Act. *West Virginia Law Review*, 106(1): 150-76.

Smithsonian Institution. National Museum of Natural History. Repatriation Office. 2011. [Online] Available at: http://anthropology.si.edu/repatriation/projects/index.htm [accessed 13 February 2012].

Tanner, H.H. (ed.) 1987. *Atlas of Great Lakes Indian History*. Norman: University of Oklahoma Press.

Trope, J.F. and Echo-Hawk, W.R. 2000. The Native American Graves Protection and Repatriation Act: Background and Legislative History, in *Repatriation Reader: Who Owns American Indian Remains?*, edited by D.A. Mihesuah. Lincoln: University of Nebraska Press, 123-68.

US Code. 1989. National Museum of the American Indian Act. Amended in 1996. Public Law 101-85, codified at 20 USC. § 80q et seq. (2006).

US Code. 1990. Native American Graves Protection and Repatriation Act, Public Law 101-601, codified at 25 USC. § 3001, et seq. (2006).

US Government Accountability Office. 2011. *GAO-10-768, Native American Graves Protection and Repatriation Act: After Almost 20 Years, Key Federal Agencies Still Have Not Fully Complied with the Act.*

US House. 1990. Report of the House Committee on Interior and Insular Affairs 101-877. Congress, Washington, DC.

US Senate. 1990. Senate Report 101-473. Senate, Washington, D.C.

Washburn, W.W. (ed.) 1988. *History of Indian-White Relations, Volume 4, Handbook of North American Indians*, W.C. Sturtevant, general editor. Washington: Smithsonian Institution.

PART III
Reflections on Returns

Chapter 8
Repatriating Agency:
Animacy, Personhood and Agency in the
Repatriation of Ojibwe Artefacts

Maureen Matthews

In the last 30 years, the repatriation of Native American artefacts to their North America source communities has begun to reset the balance of power between Native American people and museums. In the wake of sharp criticism, museums and museum professionals are now motivated by respect for the sensibilities of contemporary aboriginal peoples (Ames 1992, Phillips and Berlo 1995, Miheshuah 1996, 2000, Riding In 2000, Clifford 2004). Simultaneously, a renewed anthropological interest in the role of objects in social processes has led to a theoretical approach which incorporates objects as actors in explanations of social events (Mauss 1950 (1990), Strathern 1988, 2004, Gell 1998, Latour 1993 (1991), Henare et al. 2007). In this mode, objects are seen to be doing things and are thus the rightful subject of anthropological inquiry. This chapter focuses on such an object, an Ojibwe[1] medicine man's water drum, or *mitigwakik*, caught up in a wrongful repatriation.

As a case study, one could hardly find an event more charged than repatriation. Repatriation claims are generated by a history of compound historical and personal injustices. Individuals and communities initiate the process to redress cultural losses and assuage a general and a personal sense of grief. For museums, repatriation claims strike at the heart of their ethos of preserving objects for the greater good, their ultimate *raison d'être*. This chapter presents an even more fraught situation, a wrongful repatriation. In 1998, over 80 Anishinaabe ceremonial artefacts from a small anthropology museum at the University of Winnipeg were secretly given to

1 I use the term Ojibwe and Anishinaabeg interchangeably to refer to those who call themselves Anishinaabeg. These people are often referred to as Ojibwa and their language is written Ojibwe. I follow Roger Roulette and Pat Ningewance in choosing to spell both Ojibwe. See Nichols and Nyholm (1995: xxiii-xxvii). Hallowell refers to the people of Pauingassi as Northern Ojibwa or Saulteaux, a name which dates back to the French traders who encountered these peoples' ancestors in the area near what is now Sault St Marie, Ontario (see Peers 1994: xv-xviii). Ojibwe/Ojibwa peoples are described in various volumes of the Smithsonian Handbook of North American Indians (Steinbring, in Helm 1981: 244, 254, also: Trigger 1978, DeMallie 2001).

a politically-adept, well-intentioned Ojibwe cultural revitalization group unrelated to the source community, in spite of clear provenance and significant interest in the collection within the source community. It is a situation where the conjunction of politicized museum artefacts and honestly-held views about cultural rights led to a gross injustice.

Understanding this wrongful repatriation requires a dual perspective, integrating the Ojibwe philosophical and social environment of the drum (Hallowell 1960) into an anthropological understanding of the theoretical personhood of objects (Strathern 1988, 2004, Gell 1998, Henare et al. 2007). This is apt because our 'epitomizing object' (Fogelson 1985: 84), a *mitigwakik* or water drum, is (usually) grammatically and metaphorically animate to Ojibwe speakers. Similarly, recent anthropological theory situates objects as actors in everyday life, with a social significance far beyond our conventional awareness (Latour 1993 [1991], 2005). In both views, aboriginal and anthropological, Naamiwan's drum is credited with social agency, that is, the power to act in the world. The purpose of this chapter is to draw inferences from this set of events by taking seriously the human inclination to ascribe animacy and attribute social agency to objects. Doing so is a contemporary practice, not an attribute of primitivism. If, as a Western society, we did not believe that objects have the capacity to speak to us across time and culture, we would not have museums (cf. Mack 2003). From an Ojibwe perspective, if a powerful drum, isolated in a museum and feeling forgotten, had the will to become famous, it could not have initiated a set of events better calculated to bring it back to the centre of everyone's attention than this mistaken repatriation.

Naamiwan's Drum

In order to simplify a complex repatriation narrative, this chapter follows one of the 80 artefacts caught up in the repatriation, a 200-year-old water drum, or *mitigwakik*. Perhaps not the most valuable artefact nor the most beautiful, it may be the artefact with the broadest range of social connections. Early in the twentieth century, it was owned by the renowned Ojibwe medicine man, Naamiwan, who lived in the northern Manitoba community of Pauingassi. Naamiwan was born nearby in 1850 and died in Pauingassi in 1943 at the age of 93. A photograph of Naamiwan (Fair Wind, John Owen) and his wife Koowin, taken at Pauingassi in 1933 by American anthropologist, A. Irving Hallowell, shows an indomitable 83-year-old man and his frail wife in front of a large, finely-crafted Waabano pavilion (see Figure 8.1). Naamiwan is surrounded by the ceremonial objects of his practice, a combination of medicinal and murderous power available to very few. On the post to his right, guarding the eastern door of the Waabano pavilion stands a *bineshishikaan*,[2] the carved image of his *aadizookaan*, his spirit-helper,

2 *Bineshishikaan* is a term for a carved sculpture of a Thunderbird, lit. 'like a bird' (Roulette 2004).

a Thunderbird. Naamiwan has a rattle in one hand and a drumstick in the other and at his feet sits his *mitigwakik*, his personal water drum, his ritual brother or *wiikaan*, his ally in war, his agent in healing and his envoy into the future.

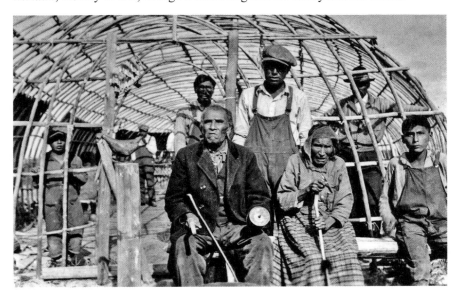

Figure 8.1 Naamiwan and his wife, 1933. Copyright: American Philosophical Society, Hallowell Collection

Naamiwan used his water drum in both the Waabano ceremony and the Midewiwin, the Grand Medicine Society, the pre-eminent Ojibwe ceremony. The presence of the carved Thunderbird comes as no surprise as drums and the rights to use them are considered the province of Thunderbird spirits (Transcript: CGO 1996). This drum, built for Naamiwan's grandfather sometime in the late-eighteenth century, predates the family's move from Lac Seul in Ontario (about 1800, Harms 2012). It is made out of a single round of a poplar tree too large to have come from the Pauingassi area, hollowed out by carving and burning the interior. It was subsequently used by both Naamiwan and his eldest son Angus, behind Naamiwan in Hallowell's photograph, and inherited by his grandson, the respected elder, Omishoosh (Charlie George Owen), farther back inside the Waabano pavilion.

Naamiwan's drum is still remembered in Pauingassi where people speak of it as if it were a person, sitting among them, using the animate verb 'he/she sits', *abij/abid*. Omishoosh says that the drum's strength and capabilities originated with its maker, Naamiwan's grandfather. When Naamiwan played the drum, it was with his grandfather's strength. When he dared his strong, young grandson to stop his arm while he drummed, Omishoosh couldn't do it (Transcript: CGO 1996). After

the death of Angus Owen, the drum was retired and placed in respectful solitude on an island north of the community.

In the winter of 1969-70, this remarkable drum, along with 234 other artefacts from Pauingassi, was purchased by a professor for the University of Winnipeg. Dr Jack Steinbring intervened when he heard that an outfitter was buying ceremonial artefacts and selling them to tourists. He promised the people that the objects would be kept safe at the University of Winnipeg and that community members could visit whenever they wished. There was only one visit from Pauingassi; in 1995, Omishoosh came at the invitation of Dr Jennifer Brown[3] and spent a day in the Anthropology Museum looking at everything, naming things and talking about the memories they evoked. He admired the pristine storage conditions provided for the artefacts, using the complex verb '*gii-ganawaabanjigaadegin*', to indicate that their aesthetic well-being had been addressed. He said that seeing the artefacts so comfortable in their retirement made him happy; he could feel the positive presence and approval of his ancestors who had used these objects to such great effect years ago (Transcript: CGO 1995).

When Omishoosh first saw the water drum in the museum, he was particularly delighted, acknowledging the old man's 'kettle/pail, *akik(oog)*' with an affectionate grammatically animate euphemism. In the Ojibwe language a distinction between animate and inanimate is required and Ojibwe speakers typically use animate agreement when referring to all types of drums. But, Omishoosh, a unilingual Ojibwe speaker with a sophisticated, expert vocabulary, referring directly to the water drum in his presence, slipped deftly back and forth between the animate and inanimate nouns sometimes using them both in the same paragraph.[4] Like the reference to the 'old man's pail', this linguistic discretion, a form of 'respectful talk' (Black-Rogers 1986) that is characteristic of Ojibwe speakers, obliquely highlights valued objects. While this is evident to speakers, Omishoosh's subtle use of animate and inanimate references to the drum presents an interpretive problem. It means that a universal key to the spiritual significance of objects,

3 Dr Brown and I collaborated on several radio programmes including Isinamowin: the White Man's Indian (Matthews 1990) and Fair Wind's Drum (Matthews 1993) and on a biography of Naamiwan (Brown 1993). She was, at the time, a professor of History at the University of Winnipeg, and introduced me to the work of A.I. Hallowell.

4 Kettle is etymologically related to *mitigwakik*, the usual name for a water drum in Ojibwe – literally 'wooden pail' which is also animate. Omishoosh used '*mitigwakik(wag)*, water drum' and '*dewe'igan(ag)*, drums', both of which are animate, at the museum. On another occasion he used a very special way to talk about a drum as animate using a derivative of the animate verb *madwe'o* 'to beat upon something animate', '*madwe'akokwe*'. This form is used only on ceremonial occasions or when speaking privately because it reveals that the speaker is or has been involved in ceremonial practice. But while he was at the museum talking specifically about the water drum, he alternated between these animate forms and the inanimate form *madwe'igan(an)*, a noun which means any *thing* to strike or beat upon, all the while talking specifically about this water drum. Water drums conventionally do not have personal names but become 'alive' when their hide covering is in place.

a classificatory category of great interest to museum curators, can *not* be divined solely from Ojibwe grammar.

Nevertheless, the attribution of animacy provides a metaphysical prelude to the social agency of drums, allowing Ojibwe speakers to readily incorporate meaningful artefacts in explanations of events. It registers the possibility that erstwhile objects may transcend the boundaries of their materiality and take on the social roles of persons, a mode Hallowell calls 'other-than-human persons' (Hallowell 1960: 45). The Ojibwe, he said, have a 'personalistic theory of causation'. '*Who* did it, *who* is responsible, is always the crucial question to be answered' (Hallowell 1960: 45). And the answer may very well be a drum. In order for objects to be credited with this degree of social agency, it is helpful that they are primed by the grammatical presumption of personhood.

Alfred Gell developed a parallel interest in the personhood of objects, in particular in the social agency of works of art. In *Art and Agency* (1998), Gell proposed a theoretical model which situated art objects, not as signifiers of culture, but as actors in social networks. He cast them as other-than-human persons with both agency – the capacity to act – and a degree of intentionality – the will to act (Gell 1998: 16-17). Gell relied on the lead provided by Marilyn Strathern, who worked out the many ways that both 'people and things assume the social form of persons' (Strathern 1988: 145), when he argued that 'art objects are the equivalents of persons, or more precisely social agents' (1998: 7). Museum objects have the same potential to assume the social form of persons, keeping in mind Strathern's caveat, that a whole person is a theoretical impossibility. In her view, only the relationships of persons can be whole and each fleeting relationship engages only a small facet of our 'partible' personhood – hence her term 'dividual'. Museum artefacts, like their human curators are 'dividual'; their personhood is the sum of a facetted array of relationships many of which are unknown to one another.

Strathern argues that maximal personhood, a mode where person/objects are at their most person-like, is achieved when multiple relationships are acknowledged by acquaintances, when one's social network is contextually rich, when the person/object has real choices in life and enough agency to make those choices without interference (Strathern 1999: 14). At the other end of the relational spectrum, person/objects are at their most object-like when they are trapped by the inescapable obligations of one overarching relationship. For example, ownership claims, relational claims made by persons (who have choices and agency) in respect of objects (who do not) impose non-optional obligations (e.g. as a possession or a slave).

As wholly-owned possessions of museums, artefacts are caught at the object-like end of this relational spectrum, their prestige deployed to burnish the reputation of the institution. Their museum personhood may eventually be augmented by relationships within the institution, with curators, conservators, visitors, with the collection as a whole and with their classificatory relations on the shelves of the museum but the social fact of ownership is inescapable. If museums engage with source communities, the extended personhood of artefacts may re-emerge through

the addition of an array of family, community and ceremonial relationships to those of the museum. Repatriation, the return of person-like things to their families and home communities, sometimes flows from these relational changes, but not before the rupture of the overarching museum ownership relationship.

In the case of the Naamiwan's water drum, its Ojibwe personhood is similarly relational, shifting meaning from person to object within the dictates of its social connections. While the anthropology museum might have been a source of social vitality generated by interactions with curators, students, visitors and classificatory co-residents, the museum's separation of the Pauingassi artefacts into 'sacred' and 'secular' categories divided them from each other: the 'sacred' artefacts, the drum among them, were placed in restricted access storage, isolated from contact and devoid of agency deriving from museal relationships.

The drum's latent Pauingassi personhood re-emerged with the visit of Omishoosh who told a story about how, as a young boy, his life was saved by the drum in a Midewiwin ceremony. The drum's maximal Anishinaabe personhood, evident when all grammatical ambivalence vanishes, emerges in a story told by Omishoosh's cousin, St John Owen, in which the drum commits a long-distance murder. Every verb is animate, the drum took his victims inside itself, *ogii-biindiganaa*, trapped them*, naazikaazowan*, and then killed them, *nichigaazonid.* 'That old man did terrifying things!' St John said when he finished the story. '*Aapijigii-gagwaanisagichigea'aakiwenzi!*' (Transcript: St.JO 1994). Naamiwan and his drum are '*wiikaanag*, ritual brothers' and it is their collaboration which makes this deed possible. The drum is an ally with extraordinary power who hunts and kills at the behest of Naamiwan.

One of Gell's distinctive and controversial theoretical contributions was to put a name to 'distributed personhood' – the role of objects as 'embodiments of the power or capacity to will their use' (Gell 1998: 23) (using the horrifying example of land mines) and to identify in works of art, evidence of a form of 'secondary' agency which is 'socially and cognitively practicable' and acknowledged by others (Gell 1998: 16).

Ojibwe speakers also make a precise and nuanced distinction between primary and secondary agency. Animate entities, including people and objects, are *bemaadiziwaad* – 'those who have life'. There is no presumption of volition or agency but they certainly can be said to embody the 'capacity to will their use' (Gell 1998: 23). They are playing the roles intended for them and following their preordained fate. Powerful medicine men and their spirit helpers, the *aadizookaanag*, are *bemaaji'iwemagak*, 'those who bring life into something' (and naturally they can also take life out of someone, *onisaan*). They have power and agency aplenty.

Thunderbirds, the most powerful *aadizookaanag*, are at the apex of a cascade of *Anishinaabe* power and agency. Medicine men like Naamiwan who can count on their help, are also considered to be *bemaaji'iwemagak,* and are accorded enviable access to *near* primary agency. The water drum, Naamiwan's ally, is *bemaadizid*; it simply has life. The drum has dangerous capabilities, but from an

Ojibwe point of view, it has secondary agency, the sort mere mortals possess. This agency is something which is judged retrospectively. Rather than being seen as an inherent quality or attribute of a person or object, agency emerges from an evolving process of assessment. Evidence is tested and assumptions proved – or not – by events as they transpire; and in the meantime, as Mary Black-Rogers observes, Ojibwe speakers live comfortably with unfinished judgements in a state of long term 'percept ambiguity' (Black-Rogers 1977).

The Repatriation

After his 1995 visit, Omishoosh asked that the drum and other artefacts be photographed so that he could use the pictures for teaching in the Pauingassi School. He emphasized that the artefacts were retired and should not be used ceremonially (Transcript: CGO 1995 Nov 17). Four years later, after repeated requests, I was finally granted permission to photograph the objects and undertake a project to reconnect them with the stories from Pauingassi. And then came a stunning revelation. A letter from the university informed us that 41 of the 235 artefacts from Pauingassi, part of a group of more than 80 objects from the Anthropology Museum at the University of Winnipeg, had been quietly given away to a US-based Ojibwe cultural revitalization group with no connections whatsoever to Pauingassi or its people (Kruizenga 2001, 2002a, 2002b). This cultural 'reclamation' was described as the rightful repatriation of sacred objects to the 'the traditional spiritual community'. The letter specifically mentioned Naamiwan's drum, catalogue number 'E5211, purchased by Jack Steinbring in 1970 that was noted in our records as purchased from Nanpaykun, made by Namuin, [Naamiwan] 50 years old'.[5]

Rationale for the 'reclamation' was provided in a memo circulated in the Anthropology Department. The artefacts reclaimed were those which had previously been designated as 'sacred' or 'sensitive,' as 'things which no one can access or see'.[6] This 'sacred' status, an imposition of a museum classificatory system, a restrictive relationship enforced by the museum as owner rather than a reflection of Pauingassi sensibilities, defined the vulnerable artefacts. Those artefacts thought to be secular were not removed. This attribution of sacredness was paired with an invocation of animacy. Omishoosh's point of view was written off in an erroneous memo: 'The objects [...] were considered "dead" by their principal informant.'[7] The memo distinguished between Omishoosh, 'our principal informant' and those 'Indigenous people' who adhere to a 'Traditional value system' and whose suitability as new owners of the Pauingassi artefacts

5 Memo dated 29 September 1999 entitled 'Re: Berens River material'.
6 Memo dated 23 September 1999 entitled 'Re: Anthropology Museum Repatriations'.
7 Attachment to memo of 23 September 1999 entitled 'Comments on Course Proposal by Maureen Matthews' dated Wednesday 15 September 1999.

was related to the authenticity of their contemporary 'Traditional practice'. The missing objects had 're-entered the Traditional community through such events as the convening of the Grand Medicine Lodge (Three Fires Society) in Bad River, Wisconsin (summer 1998)'.[8] The 'reclamation' was a well-kept secret for a year and a half. No one in Pauingassi or in the University administration had been informed, and there was no documentation of the transaction.

Omishoosh's initial reaction was concern for the people who now had the drum (Transcript: CGO 1999). Although it was retired, the drum was by no means incapable. One needed the authority of Thunderbirds to handle it and, importantly, Naamiwan's ghost was still about.[9] Those with primary agency, the power to make things happen, '*bemaaji'iwemagak*' are apparently not bound by normal constraints and appear in the lives of others long after they have passed away. Thus Naamiwan's drum not only embodies dangerous capabilities but can still be moved to act by Naamiwan in his ambient form. In February of 2000, Omishoosh sent a letter to the President of the University of Winnipeg in syllabics asking that the artefacts be returned for the good of all (Perreaux 2001, 2002).

After that things just fell silent. There is no public record of what went on at the University but for the next two years, the staff in the museum stayed in place, no move was made to recover the objects, no invitation to photograph the objects ever materialized and no attempt was made to get in touch with Omishoosh.[10] By the spring of 2001, Omishoosh was upset and in response to a question about the removal of the objects, he called it 'theft, *gimoodi*'. (Transcript: CGO 2001 Feb). Omishoosh passed away just after Christmas 2002.[11] There had been no move by the University to rectify the situation. Omishoosh's letter had never been answered.[12] There hadn't been the slightest apology to him or his family. His grandfather's drum was in Wisconsin in the possession of the spiritual leader and

8 Attachment to memo of 23 September 1999 entitled 'Comments on Course Proposal by Maureen Matthews' dated Wednesday 15 September 1999.

9 Whereas when most people die, they will be 'so-and-so-*iban*', the '*ban*' suffix indicating, 'the late' and implying that they have gone to the Land of the Summer Birds permanently, this suffix is never used for Naamiwan, nor for Omishoosh who passed away 30 December 2001.

10 The family finally received a formal apology from the President of the University and the head of the Anthropology Department in early 2008. The family had to provide a copy of Omishoosh's letter because it had apparently been lost.

11 In a proposed obituary for the *Globe and Mail* (unpublished), Jennifer Brown writes that government records indicate his date of birth as 1 January 1909 which would mean he died just before his 93rd birthday. Her scepticism about this date is probably warranted as 1 January is the default date if the actual date is unknown. Omishoosh told us in the summer of 1992 that he was 76. By his math, he could have been 85 or 86 at his death on 30 December 2001.

12 It was finally acknowledged and answered in January 2008 in a letter to Omishoosh's grandson Nelson Owen.

Chief Executive Officer of the Three Fires Midewiwin Society, Eddie Benton-Banai, who had no previous connection to the drum, the family, or the community.

Eddie Benton-Banai is an American political activist who started Three Fires in the early 1970s. The Three Fires Society's goals are to relearn ceremonies and revive the Midewiwin Lodge, promote the well-being of the *Anishinaabe* people, achieve freedom from alcohol, drugs and family violence, and provide educational opportunities for children and youth (Three Fires Website). Eddie was also a co-founder of the American Indian Movement (AIM). Both Three Fires Midewiwin Society and AIM have been active in Manitoba for at least 20 years. AIM members have contributed to the political environment in which repatriation has become accepted museum practice in the US and Canada and were among the first to articulate repatriation claims (Graef 2008). They have also helped to create the rhetoric of repatriation, a discourse which posits aboriginal artefacts in museums as imprisoned and alienated victims of colonialism, waiting to be liberated.

Eddie Benton-Banai calls Naamiwan's water drum, 'Grandfather, *Mishoomis*'. He says he had no part in bringing the drum to the US but kept the drum at his home for a number of years. He says they first saw the drum at the Bad River Three Fires Midewiwin Ceremonies in June 1986 and agreed to look after it as a sacred duty. Another member of Three Fires said how honoured they felt to be its keepers and emphasized the happiness the drum must have felt to be part of ceremonies again (Transcript: CN 2002). Eddie knew little about Pauingassi or its people, believing them to be 'white Christians' (Transcript: EBB 2002: 7). 'I think that very likely that community has been pounced upon by white racist preachers, who are doing everything they can to destroy us, to destroy our covenant with the spirit' (ibid: 8). When asked about Pauingassi objections to the repatriation, he said that he wouldn't give the drum back until the people were capable of performing traditional ceremonies to his satisfaction.

> The day that Pauingassi does the traditional ceremonial things that are required and if they convince me that they will never again fall into white hands, I'll see to it that they get returned. The items that belong to Pauingassi. That's it. (ibid: 11)

In practice, repatriation and other cultural property rights claims are ownership claims, claims made by persons in respect of things (Strathern 1999: 6). One of the reasons contemporary repatriation literature is so unsatisfying is that it fails to grapple with the conflict between rights claims as ownership claims and indigenous understandings of the animacy and personhood of the artefacts caught up in repatriation. Strathern argues that personhood is particularly relevant in instances where relations are impinged upon by conceptions of human rights, as they are in repatriation (e.g. Riding In 2000). Claiming cultural property rights, asserting ownership rights over artefacts as things, as Strathern points out, means that indigenous cultural understandings related to the nature of animate person-like entities and their agency, their possibility of acting in the world, are suppressed. Setting repatriation literature in the context of human rights as many authors do

(Cowan, Dembour and Wilson 2001, Bell and Napoleon 2008, Bell and Paterson 2009) and pressing for legal remediation based on Euro-American property law, as is the case in the United States with NAGPRA (Trope and Echo-Hawk 2000), has also problematized the concept of 'culture'. As Strathern points out, rights claims require, 'that we live in a "post-cultural"' world 'which posits individuals as ontologically prior to the cultural milieu which they create' (Rapport 1998: 386) and one in which:

> 'culture' becomes 'an optional resource', one to be employed by individual actors on a global stage who are free to create identities for themselves (1998: 387, 388). It is a modernist position of course to imagine that one can choose. Much of the rhetorical justification for Culture is in fact cast in terms of allowing people (the 'right') to practice their customs as they always have done. (Strathern 1999: 17-18)

Strathern above and Wagner (1981 [1975]) both argue that it is a logical impossibility for persons to exist without or before their culture; that it is not possible to lose your culture any more than it is to get it back. However this presumption that culture is both alienable and retrievable is essential to the legal environment of cultural human rights and to neo-traditionalist movements like the Three Fires Midewiwin Society.

The idea of culture as a 'right' poses another serious problem for those who are imagined to have this right. People advance cultural rights claims because they are without power. If they had power, they'd do what they want. If they must petition for rights which derive from their cultural identity, they are obliged to present a culturally-authentic image of themselves, both objectifying and partial, to what Colin Samson calls 'the rights conferring political machinery' (Samson 2001: 228). In the case of repatriation, culture (performed by persons who claim cultural things) is something they must have, the authentic expression of which has been defined in advance by the museums (the rights conferring political machinery) which will decide on the validity of their claim.

This cultural performance is part of what Crane calls 'museal discourse' (Crane 2000). All parties in this discourse accept, as a basis of interaction, the intellectual conventions of museums; that the objects embody culture, can teach and possibly even sustain culture and that their possession confers cultural prestige. They believe that interpretive agency and social power can be acquired through the appropriation of cultural objects. Authentic repatriation claimants are expected to be engaged in 'traditional' cultural practices, and in the case of Three Fires, this was their explicit argument – they were *the* authentic Traditional Ojibwe Midewiwin Society. Within the context of 'museal discourse', 'traditional' claims present a problem because they are impossible to interrogate (Phillips and Phillips 2005: 16-17). Without the excellent provenance of the Pauingassi collection, judging simply on the rhetorical conviction of 'traditional' claims made on behalf of Three Fires, few would have found fault with this repatriation.

But the connection to Pauingassi was known, and, in spite of this, the objects were transferred to Three Fires. In their activist mode and in conjunction with museums, Three Fires members had a hand in creating the authenticating Ojibwe cultural performance which is now expected from those who wish to elicit cultural property rights. Omishoosh's breezy casualness with the artefacts, his failure to demand a smudge with sweet grass (never used ceremonially in Pauingassi) and his disinclination to acknowledge the 'sacred' and 'secular' distinction so important to the museum, undermined his credibility with the curator. For these reasons, he had no moral purchase whatsoever with those who operated the museal 'rights conferring machinery' to which Samson alludes (Samson 2001: 228).

Pauingassi elders, perceived as de-cultured Ojibwe, and the artefacts, perceived as imprisoned and 'sacred' were both confined to their most thing-like modes. Their lack of agency paralleled their depersonalization. It did not matter that, in Pauingassi, there could be no history of dealing 'traditionally' with museums; the people were entirely unaware of museums and their dark colonial history. In spite of immediate personal and ceremonial histories, Pauingassi claims were dismissed when Omishoosh failed to perform 'culture' to the satisfaction of those immediately involved in the repatriation. A changing political and emotional context generated by the cultural-rights imperatives of repatriation gave the artefacts an urgent role in an altogether different scenario. They were seen to have been abandoned by Pauingassi people who had stopped practising their 'culture' in favour of 'white Christianity'. The needs, values and agency of a contemporary Traditional Ojibwe spiritual revival group trumped Pauingassi relationships and negated Pauingassi Anishinaabe agency.

The Return of the Drum

Eddie Benton Banai met Nelson Owen, the grandson of Omishoosh Owen in May 2002 (Transcript: EBB/NO May 2002). Nelson and his wife Elaine had taken the lead in pushing to get the artefacts back. By that time, Eddie realized that the people of Pauingassi were not as he had imagined and quickly offered to give the drum back (see Figure 8.2). Five days after the meeting, Nelson got a phone call about arranging the return of Naamiwan's drum. He was assured it was to be a quiet, private and dignified affair. No media were to be involved; the Owens had to promise not to tell anyone. The Owens arrived at the appointed time and place to find a TV camera crew and a room full of reporters. Nelson and Elaine, wanting only to accept the drums and go home, endured a lengthy ceremony, singing and praying, and a press conference (Transcript: NO 2002).

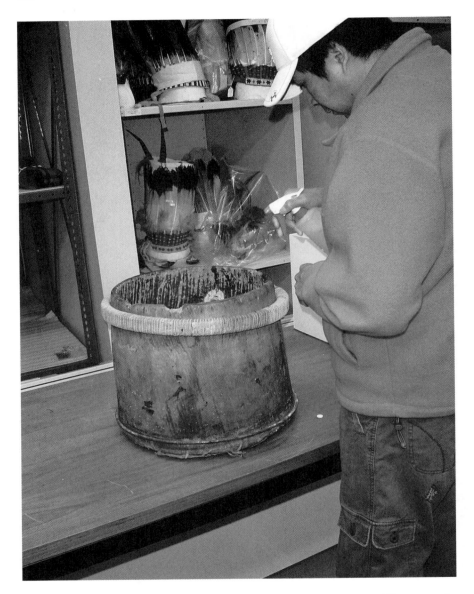

Figure 8.2 Nelson Owen caring for Naamiwan's water drum. Photograph: Maureen Matthews, 2007

In a newspaper report about the ceremony, Terrance Nelson, one of the participants, wrote that the drums had been granted their wish to 'go home', adding that Benton-Banai, 'a deeply spiritual man […] says the spirits of the waterdrums asked to go home. He had to comply despite being forced to enter into a swirl of

controversy' (Nelson 2002).[13] From a Pauingassi point of view, one might say that the regrettable 'swirl of controversy' (Nelson 2002) is an eruption of the agency of a firmly recalcitrant object (Latour 2000: 116); that Naamiwan's drum, unwillingly appropriated to enhance Three Fires' reputation, was reasserting its Pauingassi family and community relationships.

From a relational perspective, ownership claims – and repatriation claims are ownership claims – are both a fact and an illusion; they may temporarily constrain a person/object, but they don't necessarily cut off other outcomes and prevent other scenarios. When the museum decided to repatriate the drum to Three Fires, it submerged a set of relationships with the Owen family which re-emerged when Eddie Benton-Banai talked to Nelson Owen. At that point, Eddie experienced a radical shift in his feelings about the drums and their rightful ownership.

As Strathern points out, when action becomes necessary, agency (or lack of agency) becomes evident. 'Agency is evinced in the ability of persons to (actively) orient themselves or to align themselves with particular relationships' (Strathern 1999: 14-15). From this perspective, the return of the drum came about because of a new and expanded perception of the complex personhood of the drum and a desire to reconcile the 'nature of obligations and how people meet the debts they perceive'. As Strathern explains: 'The claims which bear in on the actors as immediate reasons for their actions are based on the fact of their relationships with one another' (Strathern 1999: 15). In the case of Naamiwan's drum, while being incorporated in the Three Fires community, it carried an undercurrent of Pauingassi agency with it. 'An object may make present powers or forces that affect a person's life' (Strathern 1999: 15), as Eddie Benton-Banai learned when he met Nelson Owen.

If agency is the smoke to personhood's fire, then it is a signal worth watching, and in the case of Pauingassi, there has been a gradual shift in the agency of the

13 This setting of the drums as grammatically animate and the attribution of agency which is implied has both Ojibwe and repatriation advocacy roots. Gosden and Knowles warn against too freely attributing agency, warning that agency is a relational process. '[T]hings are not agents in their own right, and the material world is only given force and significance through human activity […] Any use of the active voice when describing objects must be suspect' (Gosden and Knowles 2001: 23). This caution is properly engaged when the attribution of animacy is overly convenient. To say as Eddie Benton Banai has done, that the 'spirits' directed the drums to Wisconsin gives to divine entities the responsibility for their transit across the border in contravention of the Canadian Cultural Property Export Act. This is understandably something that a human actor might not want to claim. There was the matter of a looming Provincial Auditor General's report and an RCMP investigation. All these events may have concentrated minds but they also generated a certain amount of self-serving talk about animacy. And it is not the only instance in this repatriation where claims of rather literal animacy on behalf of ceremonial objects have been advanced as a convenient explanation. As artefacts trickled back to the museum and nearby laboratory, both before and after the Auditor General's forensic audit, the university was content to explain their reappearance as an example of the artefacts 'walking back' (McKinley 2007).

drum, the Owen family and their community. The family have recently applied to repatriate the entire Pauingassi Collection, to take responsibility for the artefacts which now mean so much to them. And in a recent application for a World Heritage site which would see Pauingassi First Nation join with four other First Nations to protect their cultural landscape, Pauingassi is seen as a keystone community, at the cultural heart of the region, with a gift for articulating ecological understandings in complex and evocative Ojibwe language. What they are repatriating, in addition to the drum, is the social agency to represent themselves in the world.

Bibliography

Ames, M. 1992. *Cannibal Tours and Glass Boxes: The Anthropology of Museums.* Vancouver: University of British Columbia Press.

Bell, C. and Napoleon, V. (eds) 2008. *First Nations Cultural Heritage and the Law: Case Studies, Voices and Perspectives*. Law and Society Series, edited by W. Wesley Pue. Vancouver: University of British Columbia Press.

Bell, C. and Paterson, R.K. (eds) 2009. *Protection of First Nations Cultural Heritage: Law, Policy and Reform.* Law and Society Series edited by W. Wesley Pue. Vancouver: University of British Columbia Press.

Black-Rogers (as Black), M.B. 1977. Ojibwa Taxonomy and Percept Ambiguity. *Ethos* 5(1), 90-118.

Black-Rogers, M.B. 1986. Ojibwa Power Interactions: Creating Contexts for 'Respectful Talk', in *Proceedings of Conference on Native North American Interaction Patterns*, Mercury Series No 112, edited by R. Darnell and M. Foster. Ottawa: National Museums of Canada, 44-68.

Brown, J.S.H. with Matthews, M. 1993. Fair Wind: Medicine and Consolation on the Berens River. *Journal of the Canadian Historical Association,* 4, 55-74.

Clifford, J. 1997. *Routes: Travel and Translation in the Late Twentieth Century.* Cambridge: Harvard University Press.

Clifford, J. 2004. Looking Several Ways: Anthropology and Native Heritage in Alaska. *Current Anthropology*, 45(1), 5-30.

Cowan, J.K., Dembour, M-B. and Wilson, R. 2001. *Culture and Rights: Anthropological Perspectives.* Cambridge: Cambridge University Press.

Crane, S. 2000. *Museums and Memory*. Stanford: Stanford University Press.

DeMallie, R.J. (ed.) 2001. *Plains: The Handbook of American Indians: Volume 13.* Handbook series edited by William C. Sturtevant, 17 vols. Washington: Smithsonian Institution Press.

Fogelson, R. 1985. Night Thoughts on Native American Social History in *The Impact of Indian History on the Teaching of United States History*, Occasional Papers in Curriculum, No 3. Washington: D'Arcy McNickle Center for the History of the American Indian, 67-89.

Gell, A. 1998. *Art and Agency: An Anthropological Theory*. Oxford: Clarendon Press.

Gosden, C. and Knowles, C. 2001. *Collecting Colonialism: Material Culture and Colonial Change.* Oxford: Berg.

Harms, P. 2012. *The Political Economy of the Modern Fur Trade.* Paper to the Rupert's Land Research Colloquium, University of Winnipeg, Winnipeg. 18-19 May 2012.

Hallowell, A.I. 1960. Ojibwa Ontology, Behaviour and World View, in *Culture in History: Essays in Honour of Paul Radin,* edited by S. Diamond. New York: Columbia University Press.

Henare, A., Holbraad, M. and Wastell, S. (eds) 2007. *Thinking Through Things: Theorizing Artefacts Ethnographically.* London: Routledge.

Kruizenga, L. 2001. Pauingassi artefacts spirited into U.S. by Three Fires Society: Community demands immediate return of sacred items. *The Drum,* 2001 August, vol. 4, 1.

Kruizenga, L. 2002a . Provincial Auditor investigates artefacts' transfer: Probe to review policies for repatriation of artefacts. *The Drum,* 6 March 2002.

Kruizenga, L. 2002b. Provincial Auditor confirms allegations: Dozens of artefacts missing from the U of W museums in *The Drum,* 2002 July, vol. 5, 7.

Latour, B. 1993 (1991). *We Have Never Been Modern.* Harlow: Longman.

Latour, B. 2000. 'When things strike back: a possible contribution of "science studies" to the social sciences'. *The British Journal of Sociology,* 51(1), 107-23.

Latour, B. 2005. *Reassembling the Social: An Introduction to Actor Network Theory.* Oxford: Oxford University Press.

Mack, J. 2003. *The Museum of the Mind: Art and Memory in World Cultures.* London: The British Museum.

Matthews, M. 1990. *Isinamowin: The Whiteman's Indian* on *IDEAS,* Nov 1990, CBC Radio One.

Matthews, M. 1993. *Fair Wind's Drum* on *IDEAS,* May 1993, CBC Radio One.

Matthews, M. 2002 April. *Fair Wind's Water Drum* on The Sunday Edition, 28 April 2002, CBC Radio One.

Mauss, M. 1950 (1990). *The Gift* translated by W.D. Halls. London: Routledge.

McKinley, V. 2007. *Object Information.* University of Winnipeg: Anthropology Museum.

Mihesuah, D.A. 1996. American Indians, Anthropologists, Pothunters, and Repatriation: Ethical, Religious, and Political Differences. *The American Indian Quarterly, Special Issue: Repatriation: An Interdisciplinary Dialogue* 20(2), 229-37.

Mihesuah, D.A. (ed.) 2000. *Repatriation Reader: Who Owns American Indian Remains?* Lincoln: University of Nebraska Press.

Nelson, T. 2002. Our Grandfathers are not Artefacts, in *Grassroots News* [Online, June] Available at: http://www.grassrootsnews.mb.ca/news.html [accessed: June 2002].

Nichols, J.D. and Nyholm, E. 1995. *A Concise Dictionary of Minnesota Ojibwe.* Minneapolis: University of Minnesota.

Peers, L. 1994. *The Ojibwa of Western Canada: 1780-1870*. Winnipeg: University of Manitoba Press.

Perreaux, L. 2001. Native leaders want artefacts given to U.S. group returned: Questions raised about exporting cultural works. *The National Post,* 28 September 2001. [Online] Available at: http://www.nationalpost.com/news/story.html?f=/stories/20010928/710356.html [accessed: September 2001].

Perreaux, L. 2002. University of Winnipeg slammed over lost artefacts. *The National Post*, 26 June 2002, A, 16.

Phillips, R.B. and Berlo, J.C. 1995. Our (Museum) World Turned Upside Down: Re-presenting Native American Arts. *Art Bulletin*, 77(10), 6-24.

Phillips, R.B. and Phillips, M.S. 2005. Double Take: Contesting Time, Place, and Nation in the First Peoples Hall of the Canadian Museum of Civilization. *American Anthropologist, New Series* 107(4), 694-704.

Rapport, N. 1998. The Potential of Human Rights in a Post-Colonial World. *Social Anthropology*, 6, 381-88.

Riding In, J. 2000. Repatriation: A Pawnee's Perspective in *Repatriation Reader: Who Owns American Indian Remains?* edited by Devon A. Mihesuah. Lincoln: University of Nebraska Press, 106-20.

Samson, C. 2001. Rights as the Reward for Simulated Cultural Sameness: The Innu of the Canadian Colonial Context in *Culture and Rights: Anthropological Perspectives* edited by Jane Cowan, Marie-Benedicte Dembour, and Richard Wilson. Cambridge: Cambridge University Press, 226-48.

Steinbring, J. 1982. Saulteaux of Lake Winnipeg in *Subarctic, The Handbook of North American Indians: Volume 6*, edited by June Helm. Handbook Series edited by William C. Sturtevant, 17 vols. Washington: Smithsonian Institution Press, 244-55.

Strathern, M. 1988. *The Gender of the Gift: Problems with Women and Problems with Society in Melanesia*, Studies in Melanesian Anthropology 6. Series edited by D. Tuzin, G. Herdt and R. Lederman. Berkeley: University of California Press.

Strathern, M. 1999. Losing (out on) intellectual resources in *Fabrications: The Techniques of Ownership* edited by Martha Mundy and Alain Pottage. London: London School of Economics Modern Law Review, 201-33.

Strathern, M. 2004. The Whole Person and Its Artifacts. *Annual Review of Anthropology,* 33, 1-19.

Three Fires Midewiwin Society web-site. Available at: http://www.threefires.net/tfn/about.htm [accessed 30 May 2009].

Trigger, B. (ed.) 1978. *Northeast, The Handbook of American Indians: Volume 15*, Handbook series edited by William C. Sturtevant, 17 vols. Washington: Smithsonian Institution Press.

Trope, J.F. and Echo-Hawk, W.R. 2000. The Native American Graves Protection and Repatriation Act: Background and Legislative History in *Repatriation Reader: Who Owns American Indian Remains?* edited by Devon A. Mihesuah. Lincoln, Nebraska: University of Nebraska Press, 123-68.

Wagner, R. 1981 (1975). *The Invention of Culture: Revised and Expanded Edition.* Chicago: University of Chicago Press.

Transcripts and Translations

Ojibwe Transcripts: by Roger Roulette © (1992-2008)
To simplify referencing in the text, I have used the initials of the interviewee, the year and date if relevant and the page.
Omishoosh/Charlie George Owen (CGO)
CGO 1995 16 Nov: p. 67.
CGO 1995 17 Nov: p. 27.
CGO 1996 13 Feb: p. 52.
CGO 1999 18 Oct: p. 31.
CGO 2001 Feb: p. 22.
St. John Owen (St.JO) 1994: p. 8.
Eddie Benton Banai and Nelson Owen (EBB/NO) 2002 8 May: p. 18.

English Transcripts by Maureen Matthews (1992-2009)

Nelson Owen – NO 2002 13 May
NO 2005 25 June
Eddie Benton Banai – EBB 2002 18 March
Charlie Nelson – CN 2002

Chapter 9

Debating the Restitution of Human Remains from Dutch Museum Collections: The Case of the Skulls from Urk

Demelza van der Maas

This chapter will offer an overview of the recent developments in the debate on collecting and exhibiting human remains in Dutch museums by highlighting the case of the restitution of six human skulls from the collection of the University Museum of Utrecht to the inhabitants of the former island of Urk. By analysing this case, I would like to argue that the discussions on collecting and exhibiting human remains are connected to a recent process in the humanities in which the construction of a national or local identity is increasingly connected to the material presence of the past. This material presence refers to objects, things or even human remains. Drawing upon the idea of the so-called *material turn* or *return to things*, I will connect arguments used in the restitution case of the so-called *Urker Skulls* to what can be considered a significant shift in Western philosophy: the changing status of the body as a consequence of the *return to things* in humanities and social sciences.

The Return to Things

Requests for the restitution of (ancestral) human remains from museum collections come from different communities, different countries and even different parts of the world. Nevertheless, the similarities between many of the cases are striking. The so-called source communities – a concept that in itself is highly contested – often feel that the restitution of the remains of their ancestors at least partially compensates for the historical injustice that was brought upon them throughout the years. Furthermore, for many of the claiming parties, the remains represent local – religious – culture and embody the local cultural identity. Restitution means a restoration of the natural religious or ritual order.

Since the late 1980s, notions of identity are increasingly connected to material representations of the past. The exponential, world-wide growth of the number of museums and heritage sites over the past few decades offers the striking evidence of this process. Museums materialize memory and identity by connecting them to a place, to certain images and maybe most importantly, to things. The renewed

interest in things in the human sciences is also referred to as the *material turn* or the *return to things* (Edwards and Hart 2004, Dudley 2010, Domanska 2006). According to historian Ewa Domanska the return to things entails a 'Rejection of constructivism and textualism and a longing for what is "real", where 'regaining' the object is conceived as a means for re-establishing contact with reality' (Domanska 2006: 337). Correspondingly, Dudley pointed out that much of the 'materialist' analysis over the past twenty years has focused on the role of objects in social and cultural life, but simultaneously leads us away from the 'reality, significance and very tangibility of material surfaces' (Dudley 2010: 2). Domanska distinguishes four tendencies that have led to the return to things, two of which I shall discuss in this chapter. First of all, the changing conception of the dichotomy between spirit and matter (or mind and body) in which matter is no longer perceived as inferior to spirit. This has led to the moral and ethical discussions on exhibiting the body as an object. Secondly, the crisis of identity in modern society has led us to perceive objects and things as the 'other' of human beings. The thing participates in creating human identity and, if you will, legitimates it (Domanska 2006: 338-9).

Modern Western philosophy is heavily influenced by the ideas of the German philosopher Immanuel Kant (1724-1804). Kant was the first to claim there is a philosophical distinction between the subject or the human mind, and the object or thing as the product of human understanding. In his line of reasoning, which forms the foundation of modern Western science, the body is an object of empirical study that can only be 'known' through the subjective mind and it is therefore inferior to it (Leezenberg and De Vries 2003: 49). Researching, collecting and exhibiting the human body was legitimate because the body was considered nothing more than a thing. In Western science the body was objectified; it existed only because it was constructed by the subject. According to Domanska, the return to things can be seen as a reaction and critique to this anthropocentrism. Scholars increasingly 'reject the idea of the supreme importance of the human being and turn to other, equally important forms of existence such as animals, plants and things' (Domanska 2006: 338).

In the following chapter, it is argued that the recent discussions on collecting and exhibiting human remains are connected to the return to things in the human sciences. It is precisely because of these developments that the skulls from Urk came to be at stake in a conflict that revolved around museum ethics, scientific value versus emotional value and most of all, around identity and power.

The Dutch Situation

The discussion on collecting and exhibiting human remains in countries such as the USA, Canada, Australia and New Zealand started in the early 1980s. In the Netherlands however, it wasn't a controversial issue until the late 1990s, when the Kunsthal (Rotterdam) hosted an exhibition, *Bone by Bone: Human Remains from Dutch Museum Collections* (1998). The extensive media-coverage surrounding

Bone by Bone, caused a public debate on museum ethics and led to the first official claim for restitution of human remains from a Dutch museum. Other claims involving human remains from all over the world soon followed. The first official restitution took place in 2005 when a *Toi Moko* from the collection of the Ethnographic Museum of Leiden was returned to Maori representatives from New Zealand (Ministerie OC&W 2005).[1]

While the USA adopted the Native American Graves Protection and Repatriation Act in 1990 (see Robbins, Chapter 8) and Great Britain formalized the framework for the repatriation of human remains from British national museums with the Human Tissue Act in 2004, the Dutch government has not developed any legislation concerning the collecting, exhibiting or repatriation of human remains. Since museums were increasingly confronted with these complex issues, the Ethical Committee of The Netherlands Museums Association developed a Code of Ethics on Collecting and Exhibiting Human Remains, which was, and is, a guideline for all associated Dutch museums (Ethische Codecommissie voor Musea 2007). The code especially deals with issues of provenance and the exhibition practice and mainly draws upon the ICOM Code of Ethics.[2] In principle, human remains may only be exhibited for educational, scientific or research purposes.

Two years after the publication of the Code of Ethics, the committee was presented with a restitution claim involving six human skulls from the collection of the University Museum of Utrecht in 2009. Before analysing the restitution case, I will first offer a short overview of the history of the skulls to explain in which historical and scientific context they were obtained, how they became part of the collection of the University Museum of Utrecht and how they have been exhibited over the years.

The Skulls of Urk: Their Lives as Objects of Research

Our story starts in 1877 on the island of Urk, a tightly-knit, religious community in the middle of the former Zuiderzee ('Southern Sea'). The people of Urk were mostly fishermen and well-known throughout the country for wearing traditional costumes. The relatively isolated location of the island led many scientists to believe that the most authentic form of 'Dutchness' had been preserved on Urk. The islanders were a popular research population for many scholars, such as doctors, ethnographers and physical anthropologists, because they were thought to be genetically 'pure'. The Urkers were often portrayed as 'noble savages'; pure of blood and soul, but lower on the evolutionary ladder than 'normal' Dutch people.

1 Toi Moko is the name given to human remains of Maori origin. More specifically, they refer to the heads of Maori warriors killed in battle.

2 The full ICOM Code of Ethics can be consulted at: http://icom.museum/what-we-do/professional-standards/code-of-ethics.html.

The Dutch physician Dr Van Hengel (1811-92) visited Urk in 1877. One day, he tricked the grave digger and stole three skulls from the local cemetery.[3] Van Hengel wanted to give them to the famous Dutch professor Pieter Harting (1812-85), who had published a book about the physiological features of Urk and its inhabitants in 1853. Harting's research on the evolutionary status of the islanders – mostly conducted through the measuring of skulls – had been inconclusive because of a lack of research material (Harting 1853: 60). Harting, who had dedicated his later career to zoology and paleontology, thanked Van Hengel for his efforts, but never conducted any research on the stolen skulls from Urk. After his death in 1885, they became part of the collection of physical anthropology of the University Museum of Utrecht. Even though the practice of physical anthropology remained popular until after the Second World War, the skulls were never used for research purposes. Moreover, they weren't exhibited in over a century.

The Skulls of Urk: Their Lives as Museum Objects

The University Museum of Utrecht was founded in 1928 and collects objects that represent the history of the University of Utrecht and its scholars, and the (history of) education and research at the University of Utrecht. The skulls from Urk remained part of the collection, not only because they were linked to one of the most famous nineteenth-century professors of Utrecht, but also because they represented a very specific history of science: that of the practice of physical anthropology. When the museum relocated to a new building in 1996, all the scientific and historical collections of the University of Utrecht that had previously been spread throughout the city were brought together. In the renewed museum the exhibitions were focused on the historical development of the collections and their changing function in the academic context (Van Delft 1996). It was precisely because of this new museal paradigm that the skulls from Urk finally came out of storage. Curators now discovered that there were not three, but *six* skulls from Urk in the museum collection. The origins of the other three skulls remain uncertain to this day.

Some of the skulls were displayed in one of the permanent exhibitions of the University Museum: the so-called Cabinet of Curiosities. This Cabinet of Curiosities intended to give insight in the background and interests of collectors in the eighteenth century. The exhibition was furnished with as many authentic elements as possible, including the cabinets that were used for the display of the objects (Van Delft 1996). The skulls were displayed amidst an ensemble of animal skeletons and prehistoric celts. In *NRC Handelsblad*, a Dutch national newspaper, the exhibition was described as follows:

3 The exact way Dr Van Hengel took the skulls from the island has been documented in his correspondence with Prof. Harting. These letters are in the possession of the University Museum of Utrecht.

The museum has arranged objects from its own collection in four original cabinets and one replica, according to the organization principles of those days: ocean life, poisonous and healing plants, archeology, anatomy and pathology of humans and animals, hunting trophies from the Netherlands East Indies, coins and skeletons. The focus is not on the individual objects but on the atmosphere of the ensemble as a whole: Look at all the pretty things we have brought together. (Van Delft 1996 – translation by author)

It is quite remarkable that the skulls from Urk were the only human remains on display in this exhibition and the provenance of the objects was separately explained in the exhibition leaflet (Universiteitsmuseum Utrecht 1997: 11). The skulls were removed from the permanent exhibitions of the museum some years later.

In 1998, three of the skulls were loaned to the Tropenmuseum in Amsterdam for a temporary exhibition, *Antropologica*, organized to celebrate the hundredth anniversary of the Dutch Anthropological Foundation. *Antropologica* presented an overview of the history and development of the discipline of anthropology in the Netherlands. The three skulls from Urk were displayed in a part of the exhibition that discussed evolutionism. Here, the practice of physical anthropology was explained and historically contextualized: the physical anthropologist studied the physical features of humans in search of the biological genesis of the human and animal worlds. Furthermore it was explained how physical anthropologists used Charles Darwin's (1809-82) evolutionary theory to explain cultural differences between people (Tropenmuseum 1998: 2). The skulls from Urk were presented in a display together with some of the instruments that were used for the measurement of skulls. Other objects in the showcase were facial casts from the inhabitants of the Indonesian island of Nias. These casts were made by the famous Dutch anthropologist J.P. Kleiweg de Zwaan (1875-1971).

In both exhibitions, the skulls from Urk were objectified as things, representing the history of science more than being the mortal remains of what was once a living person. The value of the skulls lay in their interrelationship with other things, such as the instruments that were used to study them.

The Skulls of Urk: Their Lives as Contested Heritage

Only a few years before the *Antropologica* exhibition, the Urker Skulls had received some other media attention. In 1995, the Dutch historian Bert Theunissen published an article in a national newspaper in which he elaborated on the theft of the skulls from the cemetery of Urk (Theunissen 1995). The article went unnoticed until 2004, when a few Urkers discovered it during a research project on their local history. They decided to contact the University Museum for an informal meeting and to find out if there was any chance the skulls could be repatriated to Urk.

It soon became clear that the museum had no such intentions. Curator Reina de Raat stated at the time:

> The skulls are of historic and scientific significance. They are part of a unique collection that symbolizes the nineteenth century search for identity. We can't use photos instead of the skulls, they don't nearly have as much impact. (Ten Voorde 2007 – translation by the author)

The decision not to restitute the skulls to the people of Urk led to the founding of the committee Skulls of Urk in 2007. In July of 2008 the committee, representing the people of Urk filed an official request for the restitution of six skulls from the collection of the University Museum of Utrecht. The museum decided to bring the case to the Ethical Committee of the Netherlands Museums Association after which both parties agreed to accept the verdict of the Ethical Committee as binding.

The arguments that were brought forward by both parties in this case fit perfectly into the return to things but differ in the degree of agency they attribute to the 'things' or, in this case, the skulls. As a critique of anthropocentrism and a cure for the modern crisis of identity, the *return to things* draws heavily upon the idea that things, objects and by consequence human remains have performative qualities and participate in creating human identity, on a collective as well as on an individual level. In the following, the arguments of both parties will be outlined and connected to the presupposed performative potential of the skulls.

The Case of the People of Urk

In their official request for the restitution of the skulls, the Committee Skulls of Urk emphasized the fact that Urk is a very close, deeply religious community in which family ties are important and the dead body is to be treated with respect. The Committee referred to several important sections of the Code of Ethics, most importantly section six which states that museums should work in close collaboration with the communities from which their collections originate, as well as those they serve (De Vries 2009, Ethische Codecommissie voor Musea 2007).[4]

In their official request, the Committee Skulls of Urk presented six well documented arguments on the basis of which the skulls should be returned to Urk. First and foremost, the people of Urk can officially be considered the next of kin. Genealogical researchers concluded that all the members of the committee are direct descendants of the people that were buried in the cemetery of Urk around 1800. Secondly, the presence of the skulls in any museum collection is painful for

4 The official request can be consulted at: http://urkerschedels.blogspot.com/2008/07/officieel-verzoek-teruggave-urker.html.

the people of Urk, on specific cultural and religious grounds. Tiemen Roos, the chairman of the Committee Skulls of Urk, stated in an interview in 2007:

> My ancestors have been buried in anticipation of their resurrection. This is also evident in the way they were buried. People from Urk lie in their graves with their head to the west and their feet pointing eastward, so they'll be facing Jerusalem at the day of the Second Coming of Christ. According to the prophet Zachary, that's where Jesus Christ will return at the Mount of Olives. Science does not have the right to desecrate the graves of the people of Urk. (Ten Voorde 2007 – translation by the author)

To underline the religious significance of the skulls, interviews with the press took place on the cemetery or near the church. Short documentaries were made by the national evangelical broadcasting foundation, and local politicians underlined the importance of the return of the skulls by referring to bible passages.

In their third argument, the committee stated that the people of Urk had indicated they would like to see the skulls restituted to the island. In the period leading up to the request for restitution, the committee had worked hard to involve the local community in the public debate about the skulls. There was a website and a blog on which the locals were informed and invited to give their opinion on the matter. Several articles were published in local newspapers. In September 2007, the National Museum of Antiquities in Leiden organized a debate on collecting and exhibiting human remains. Roos, the chairman of the Committee, gave a presentation about the skulls and he was accompanied by a substantial amount of Urkers (De Vries 2009). When asked about the emotions of the locals regarding the skulls in an interview, Roos admitted that certainly not everybody on the island was as passionate about the case as he was, but that it was definitely a topic of lively discussion for many people (Van der Maas 2010b).

The fourth argument used was the fact that at least three of the six skulls were wrongfully appropriated, which should be taken into consideration in relation to current standards on provenance. The Committee argued that it was absolutely unthinkable that people of Urk in any time willingly handed over the mortal remains of their ancestors to an outsider and that the theft was a violation of graves as well as a violation of local religious beliefs (De Vries 2009).

The fifth argument was that the restitution of the skulls would be a form of retribution for the people of Urk from the scholarly world, 'whose research formed the foundation of the systematic marginalization of the people of Urk throughout the twentieth century' (De Vries 2009). On a general level, this argument can be connected to the increasing role of the discourse of the 'Other' in Western society. Ever since the Second World War and the following period of decolonization, previously marginalized or suppressed groups have claimed their position in history and science by creating counter disciplines and counter histories. These counter disciplines and histories are effectively meant to define a subaltern identity within a 'hostile' society. Identity is essentially a historical construct and

is especially fostered in times of political and cultural turmoil (Leerssen 2006: 16). Urk has experienced quite some political and cultural turmoil, particularly after the Dutch government decided to drain the Zuiderzee in 1918 to create new land for agricultural purposes. This meant that, as of 1942, Urk was no longer an island, it became part of the new 'polders'. The Dutch government was skeptical about the perspectives of the former islanders: they were poor, ill-educated fishermen who had lost their main source of income. Some sociologists even advised the government to evacuate the whole island and relocate the inhabitants. For many of the islanders, the continuing governmental interference in their community and the ongoing scientific research on their physical and mental qualities that continued well into the 1940s, was painful. According to the Urkers, the results of the research stigmatized them as inferior people. Even more so, the results were misused to deny them a fair chance in the new land, as the islanders were considered incapable of farming (*De Ochtenden* 2007).

As a reaction to the dominant negative stereotypes surrounding their community, the Urkers started to promote their culture. In the restitution case, the skulls became material representatives of a collective identity with a highly positive symbolic value. The skulls were connected to a painful history but the restitution would be a form of retribution and a possibility to celebrate and share local culture and traditions with the outside world in a performative way. Historian Jay Winter stated that:

> The performance of memory is a set of acts, some embodied in speech, others in movements and gestures, others in art, others still in bodily form. The performative act rehearses and recharges the emotion which gave the initial memory or story embedded in its sticking power, its resistance to erasure or oblivion. (Winter 2010: 12)

In the battle for restitution the skulls became a contested space and the highly performative material embodiment of immaterial local religious culture, memory and identity. But, the performative qualities of the skulls lie in their interaction with humans, the way they function as the 'other' of human beings and thus not in the objects themselves.

The sixth argument the committee presented, was the statement that the restitution of the skulls would not be harmful for the University Museum or its collection. It will come as no surprise that the curators of the museum thought otherwise.

The Case of the University Museum

When the University Museum received the claim for restitution, they initially declined it for two reasons. First of all, the museum considered itself the legal owner of the skulls because the theft was barred by lapse of time. The museum

thus admitted that the skulls were wrongfully appropriated, but the illegal acquirement of bodies or body parts was a quite common practice in the nineteenth century and should not be judged by the standards of our own time. Second, the museum considered the skulls to be a significant part of an ensemble within their collection (Nieuwsblad Het Urkerland 2007). It is indeed quite rare that human remains in museum collections are accompanied by documents, in this case letters the physician Van Hengel wrote to professor Harting, describing in detail how he deceived the local gravedigger to obtain the skulls. For the museum, the skulls represent the character of physical anthropology in the late-nineteenth century. And because they are a museum of the history of the University and its research, this can indeed be considered a very important argument.

The Urkers felt they were stigmatized by science, but curator Paul Lambers responded that they were by no means the only peoples who were subject to physical anthropological research, even within the boundaries of the Netherlands. He put the claims of structural marginalization and discrimination of the people of Urk into perspective by arguing that physiognomic research on farmers, peasants and fishermen was an accepted practice in the late-nineteenth and the early-twentieth century. Lambers pleaded for a historical contextualization of the skull theft: 'The theft certainly does not deserve the beauty prize, but if you consider the historical context it's quite understandable' (Nieuwsblad Het Urkerland 2007 – translation by the author).

Once the official claim was presented to the Ethical Committee in 2009, the University Museum focused their arguments against restitution on section 2 of the Code of Ethics. The basic principle of this section is that 'museums are obligated to acquire, preserve and praise their collections as a contribution to the safeguarding of our natural, cultural and scientific heritage' (Ethische Codecommissie voor Musea 2009: 9). The University Museum saw the claim for restitution as a threat to its core business, which is safeguarding academic heritage for future generations. Lambers said in an interview: 'The idea is that we, as a museum exist to preserve these kinds of things […] If you don't have that drive, that motivation […] well you might as well quit altogether' (Van der Maas 2010a – translation by the author). For the University Museum, the skulls are of significance because they are the material representation of a very specific scientific history. Lambers said in another interview:

> Keeping these skulls has a function. They tell us something about the history of science. Together with the other related objects they form the only known and documented ensemble on skull measurements in the Netherlands. Burying that would be a terrible waste. (Ten Voorde 1997 – translation by the author)

Thus, the arguments used by the University Museum and its curators focused mainly on the documental value of the skulls. As a museum of academic practice, the University Museum focuses on the way knowledge is shaped and reshaped, but also the ways in which people gain access to reality. The skulls are not just human

remains, but representatives of a scientific discourse that shaped our perception of the world for many years. Furthermore, the history of the skulls is co-shaped by the instruments with which they are studied. Following this line of reasoning, is not surprising that the museum argues that the greatest value of the skulls lies in their crucial position in the ensemble of instruments, skulls and letters. In other words, the intrinsic value of the skulls lies not only in the performative quality of the things themselves and in their relation to human culture, but also in their interrelation with other *things*. The materiality of the object is crucial, not its context.

The Verdict

In September 2009 the Ethical Committee advised the University Museum to return the skulls to the people of Urk, with the following statement:

> The request for restitution was filed with the explicit intention to re-bury the skulls within their own community, consistent with the religious beliefs of the people of Urk. The University museum does not contest the fact that the skulls were obtained from the island of Urk. The request for restitution was not filed by a person of direct descent, but by a committee of representatives. The skulls are not more than three hundred years old. The Committee Skulls of Urk has offered to bury the skulls above the ground in a special coffin, to keep the possibility for future scientific research open.
>
> The Ethical Committee advises the Museum to return the six skulls, under the strict condition that they will be re-buried and will no longer be items of cultural heritage in the sense of article 6.2 of the Code of Ethics. This can be done in a special coffin, as suggested by the Committee Skulls of Urk. Because said Committee is considered representative for the people of Urk, no DNA research is required to prove direct descent. (Ethische Codecommissie voor Musea 2009: 3-4 – translation by the author)

The Ethical Committee ruled in favour of the Committee Skulls of Urk, thereby acknowledging the important role of human remains as the performative embodiment of local culture and religion. As compensation, the University Museum was allowed by the Urkers to take DNA samples from the skulls and make 3D pictures that were later used to produce life-like wax replicas.

On 5 June 2010, the skulls were officially returned to the people of Urk during a semi-religious ceremony in one of the island's many churches. For the last time, the skulls were at the centre of a ritual performance of identity, strengthening local interpersonal relationships and connecting people over a shared (interpretation of) history. A local choir, dressed in traditional costume sang psalms. An elderly man who was once subject to anthropological research held an emotional speech, a poem (written specially for the occasion) was read out and, finally, the director of

the University Museum symbolically handed over the ownership of the skulls. The actual funeral was held in private.

Conclusion

In this chapter I have discussed the restitution case of the skulls from Urk by placing it within the theoretical and philosophical context of the *return to things* or *material turn* and stressing role of the performative qualities of things in general and human remains specifically. In my object-centred analysis, the skulls were considered active agents in the production of meaning and identity.

The six skulls from Urk are now buried in a grave that was created at exactly the same spot where the former charnel house from which they were stolen was located. The people of Urk hope that along with the skulls, the ingrained prejudices against their community are now buried forever.

Bibliography

De Lange, H. 1998. Als hier nou uw opa zou liggen?. *Trouw*, 16 November, 1.
De Ochtenden (Radio Show by VPRO). 2008. 17 September.
De Vries, L. 2009. *Officieel Verzoek tot Teruggave Urker Schedels*. [Online] Available at: http://urkerschedels.blogspot.com/2008/07/officieel-verzoek-teru ggave-urker.html [accessed: 5 August 2011].
Domanska, E. 2006. The material presence of the past. *History and Theory*, 45, 337-48.
Dudley, S.H. 2010. Museum Materialities. Objects, sense and feeling, in *Museum Materialities. Objects, Engagements, Interpretations*, edited by S.H. Dudley. London: Routledge, 1-17.
Edwards, E. and J. Hart (eds) 2004. *Photographs, Objects, Histories: On the Materiality of Images*. London: Routledge.
Ethische Codecommissie voor Musea. 2007. *Advies inzake het verzamelen en tentoonstellen van menselijke resten* [Online] Available at: http://www. museumvereniging.nl/LinkClick.aspx?fileticket=rodcbgzCrc0%3d&tabid= 134 [accessed: 5 August 2011].
Ethische Codecommissie voor Musea. 2009. *Advies Urker Schedels*. [Online]. Available at: http://www.museumvereniging.nl/LinkClick.aspx?fileticket=IY_ WGEjrWkk%3d&tabid=134 [accessed: 5 August 2011].
Gallagher, S. 2010. Museums and the return of human remains. *International Journal of Cultural Property*, 17, 65-86.
Harting, P. 1853. *Het eiland Urk, zijn bodem, voortbrengselen en bewoners, beschreven door P. Harting, hoogleraar aan de Utrechtse Hoogeschool*. Utrecht: Van Paddenburg & Comp.
Leerssen, J. 2006. *De bronnen van het vaderland*. Nijmegen: VanTilt.

Leezenberg, M. and De Vries, G. 2003. *Wetenschapsfilosofie voor geestesweten-schappen.* Amsterdam: Amsterdam University Press.

Leyten, H. 2000. Menselijke Resten in musea: houden of laten gaan? *Museumvisie,* 24(2), Visie IX–XVI.

Ministerie van OC&W. 2005. *Van der Laan geeft Maori-hoofd terug aan Nieuw-Zeeland* [Online] Available at: http://www.museumethiek.nl [accessed: 5 August 2011].

National Park Service – U.S. Department of the Interior. 2011. *What is NAGPRA?* [Online] Available at: http://www.nps.gov/nagpra/FAQ/INDEX.HTM#What_is_NAGPRA? [accessed: 5 August 2011].

Nieuwsblad Het Urkerland. 2007. *Geef ons onze schedels terug* [Online] Available at: http://www.opurk.nl/nieuws/nieuwsoverzicht/168-plaatselijk-nie uws-2007/16831.html [accessed: 5 August 2011].

Ten Voorde, J. 2007. Getouwtrek om oude Urker schedels. *Reformatorisch Dagblad,* 15 September, 6.

Theunissen, B. 1995. Ik heb de schedels in mijnen koffer geborgen. *NRC Handelsblad,* 1 May.

Tropenmuseum. 1998. *Antropologica. 100 Jaar studeren op Culturen.* Amsterdam: Tropenmuseum.

Universiteitsmuseum Utrecht. 1997. *Rariteitenkabinet. Beschrijving objecten.* Utrecht: Universiteitsmuseum.

Van Delft, D. 1996. Een doos met een tuin. Utrechts Universiteitsmuseum betrekt nieuwe behuizing. *NRC Handelsblad,* 12 October, W&O, 1.

Van der Maas, D. 2010a. *Interview with Paul Lambers.* Utrecht, 31 March.

Van der Maas, D. 2010b. *Interview with Tiemen Roos.* Urk, 21 April.

Vanvugt, E. 2000. Laat de botjes spreken! *Museumvisie,* 24(2), Visie II–VIII.

Winter, J. 2010. Introduction. The performance of the past: memory, history, identity, in *Performing the Past: Memory, History and Identity in Modern Europe,* edited by K. Tilmans. Amsterdam: Amsterdam University Press: 11-34.

Chapter 10

A Crate in the Basement: On the Works of Kazimir Malevich Loaned to the Hanover Museum[1]

Ines Katenhusen

Introduction

In April 2008, after many years of legal battles, the heirs of the Russian artist Kazimir Malevich (1879-1935) came to an agreement with the City of Amsterdam regarding the return of five works from the collection of the Stedelijk Museum (Kennedy 2008). A few months later, in November of that year, one of the pieces, a *Suprematist Composition* of 1916, was auctioned at Sotheby's in New York for 60 million US dollars. This was the highest price ever reached for a work of Malevich and indeed for any picture by a Russian painter (Melikian 2008). Eight years before, the money spent on another Malevich painting, *Suprematist Composition (1923–1925)*, auctioned in New York at Phillips had been less than a third, amounting to just 17.8 million US dollars (Horsley 2008).

Both suprematist compositions (Lamac/Padrta 1978) are part of a collection of more than one hundred pictures, drawings, information charts and architectural sketches that were once stored in a crate that Malevich left in Germany in the late 1920s. In May 1935, the 56-year-old artist died in Leningrad. On his deathbed, he urged that the artworks in the crate be returned to his family as the legitimate owners (Heyting 2006: 184). It took the Malevich family, most of them living in Russia and Eastern European countries, more than 70 years, and the changes that

1 The author would like to thank several institutions for granting fellowships and for various other forms of support: the Busch-Reisinger Museum/BRM, Harvard Art Museums, Cambridge MA, the John Nicholas Brown Center for the Study of American Civilization/ JNBC, Providence, RI, the Fritz Thyssen Foundation, Cologne, the American Institute for Contemporary German Studies/Johns Hopkins University/German Academic Exchange Service, Washington DC, the Fulbright Commission, the German Historical Institute, Washington, DC, and the Terra Foundation for American Art, Chicago/John F. Kennedy Institute for North American Studies, Berlin. Her thanks also go to Lien Heyting, Amsterdam, and Nina Williams, Ashford, the daughter of Naum Gabo. This article was financially supported by Lower Saxonian research funds.

Perestroijka brought, to finally get Western museums to respond to their restitution claims (Minton 2010: 53-5, Hochfield 1999: 65).

Art historically, the importance of the contents of this crate had been known for decades. Until the end of the Cold War (1947-91), its contents, shown in numerous US and European exhibitions, had shaped the Western art world's notion of Kazimir Malevich's artistic work and theory (Beeren et al. 1988). The understanding of his art had also been influenced by the fact that the works remaining in Soviet Russia had been kept in museum stores. Malevich who, after the October Revolution (October/November 1917) had once been the Curator of the Kremlin's art collection in Moscow, had become ostracized (Basner 2000: 15-28). This explains why for several decades, from his death until the end of the Cold War, his work had been almost unknown within the Soviet art scene.

It is this tragic fate of the artist, as well as of his works of art, that seemed to be on the mind of the Head of Sotheby's Russian Art Department in New York, when, in November 2008, he stated that to him, 'history has come full circle' (Jo Vickery, quoted in Maneker 2008). With the New York auction, a chapter had finally closed in the story of the loans from the Malevich crate. This story is one of political, legal, and moral questions regarding art, a story about great art and an almost unimaginable amount of money. To the heirs of Kazimir Malevich, it is the story of their property which had systematically been held back for decades in both East and West. It is also the story of loan and restitution politics that three museums – the Busch-Reisinger Museum at Harvard University, the Museum of Modern Art (MoMA), New York, and the Stedelijk Museum, Amsterdam – actively developed and shaped over the course of time. Each of them had searched and found rather different ways to deal with the works of Malevich that had been given to them (Katenhusen 2009).

The Malevich Oeuvre between East and West

Kazimir Malevich only travelled outside Russia once in his lifetime. In the spring of 1927, more than 70 of his works had been shown in the Great Art Exhibition in Berlin (14 May–30 September) (Andersen 1970). Shortly after the opening, however, he departed for Leningrad for reasons unknown, leaving his artwork behind. Back in Soviet Russia, he was sentenced to prison, which marked the beginning of a defamation campaign that ultimately erased the name of the founder of Suprematism from the annals of artistic life in the country (Federowskij 1988: 112, Stachelhaus 1989: 265-7). In the midst of this, Malevich fell ill with cancer. When he died from this disease in 1935, a representative selection of his work – altogether more than one hundred pieces – was stored in the West, in a large crate. The crate was placed in Hanover's largest museum at the time, the State Museum (Richter 1973: 50, von Riesen 1962: 32-3) (see Figure 10.1). Why Hanover? Up until now, nothing suggests that Malevich had ever visited this city. However, the mid-1920s was a fertile period for avantgarde art in Hanover,

Figure 10.1 Provincial Museum. Source: Niedersächsisches Landesmuseum Hannover

Figure 10.2 Alexander Dorner portrait. Source: Universitätsarchiv Hannover, Best. BCP

mainly due to Alexander Dorner (1893–1957) who had become the Director of Art of the State Museum (1923–37) (Katenhusen 2010) (see Figure 10.2). The artist and director certainly knew about each other's work, even if only through their common acquaintance, El Lissitzky (1890–1941), who lived in Hanover from 1922 to 1927, where he was on very good terms with Dorner (Drutt 1999: 9-24, Gough 2003, Küppers-Lissitzky et al. 1968: 53). Competent and willing to take risks, the art historian Dorner, one of the youngest museum directors in Europe, had worked hard to earn respect. His work benefited both from the general desire for change that permeated the early Weimar Republic (Luckow 1988) and, in Hanover, the acute need for action to be taken in terms of what was, up to that point, an outdated and over-crowded gallery (Katenhusen 2002: 38-49). In quick succession he purchased works from artists who today are among the most important representatives of the classic Modernist period – Heckel, Kirchner and Nolde as well as those by Schlemmer, Kandinsky, Lissitzky, Moholy-Nagy and Baumeister (Katenhusen 2010). Although an acquisition of one of Malevich's work never materialized, the museum nevertheless housed the crate of Malevich's paintings, from May 1930 to approximately autumn 1936.

This is how it came about: in the autumn of 1929, two years after Malevich's return to Soviet Russia, Alexander Dorner, who was planning a purchase, asked the Berlin architect Hugo Häring, a German friend of the artist, to send him the Malevich crate for review.[2] While it is unclear to this day whether Häring had the right to sell works to Dorner, there is sufficient evidence that the crate was sent to the Hanover Museum at the order of Häring in May 1930.[3] There Dorner took his time to arrive at a decision as to which paintings he might want to aquire. According to Häring, it had been agreed with Malevich that the proceedings from any sales should remain in the West, until the artist had time to return. As Malevich never went back, the crate remained in the Hanover Museum, where Dorner occasionally exhibited some of the works. Evidence for this is provided in a letter from Dorner (dating from October 1934), in which he writes that his Museum was still exhibiting pictures by Malevich, among others.[4]

There is one idiosyncracy in the history of the arts in Hanover that is worth mentioning here: after the Nazis seized power, artworks that were labelled 'degenerate' elsewhere, continued to be exhibited in the art gallery of the State Museum. This occurred with the consent of Dorner's superiors. This anomaly can be explained by Dorner's ability to combine paying lip service to party politics with his belief in the evolutionary trajectory of art, in such a way that,

2 Letter from Alexander Dorners to Hugo Häring, 13 November 1929, Nieder-sächsisches Landesarchiv/ Hauptstaatsarchiv Hanover (upcoming: NLA/ HStAH), Hann. 152 Acc. 2006/013, Nr. 53.

3 Receipt of the shipping company Gustav Knauer, 10 May 1930, NLA/ HStAH, Hann. 152 Acc. 2006/013, Nr. 54.

4 Letter from Alexander Dorner to Sigfried Giedion, 6 October 1934, NLA/ HStAH, Hann. 152 Acc. 68/ 94, Nr. 6.

161

GUSTAV KNAUER

SPEDITION ╱ MÖBELTRANSPORT ╱ LAGERUNG

Internationale Speditionen jeder Art

Berlin W Wichmannstraße 7—8 **Paris** 7 & 9 Bld. Haussmann
Breslau Friedrich-Carl-Straße 21 **Wien I** Walfischgasse 15

Fernsprecher: B 5, Barbarossa 0012.
Telegr.-Adr.: Speditionshaus Berlin.
Bankkonto: Darmstädter & Nationalbank
Berlin W 35, Potsdamer Straße 122 a-b.
 Deutsche Bank, Depositenkasse M.
 Berlin W 62, Kurfürstenstraße 115.
Postscheckkonto: Berlin 843.

Prov. Museum
Kunstabteilung
Eing.: *14.5.30*
B.Nr.: *220*

BERLIN W 62, den *10. Mai 1930*

An das

Provinzial Museum

Hannover

Herrn Direktor Dorner

Hierdurch teile ich Ihnen höfl. mit, daß ich im Auftrage de *s Herrn A. von Riesen* *für Friedman* durch Vermittlung de *r Bahn*

nachstehende Sendung

Zeichen	Nr.	Zahl	Art	Inhalt	Gewicht
P.M.	*6128*	*1*	*Kiste*	*Bilder*	*65 kg*

an Sie **per Frachtgut** — ~~Eilgut~~ — franko — unfrankiert — unter Nachnahme meiner Spesen·
in Höhe von

 RM. *5.60*

zur Absendung gebracht habe. Eine Zusammenstellung des Nachnahmebetrages finden Sie endstehend.

Eine Transportversicherung ist meinerseits mangels Auftrages nicht aufgenommen worden. Eine Garantie für unbeschädigte Ankunft des Gutes am Bestimmungsort wird meinerseits nicht übernommen. Sämtliche von mir ausgeführten Transporte unterliegen den in der Anlage beigefügten „Allgemeinen Deutschen Spediteurbedingungen", sowie den „Bedingungen bei Verpackung und Transport von Stückgütern", von denen Sie· freundlichst Kenntnis nehmen wollen.

Ich wünsche Ihnen guten Empfang der Sendung und zeichne

hochachtungsvoll
ppa. **Gustav Knauer**
Kienann

Anfuhr zum Packraum RM.		
Lieferung von Kisten	„	
Einpacken Stunden à RM.	„	
Lieferung von Packmaterial	„	*-.20*
Wiegen, Versandzettel	„	*-.60*
Expeditionsgebühren	„	
Deklaration, Statistik	„	*-.15*
Speditionsversicherung gem. § 40 ff A. D. Sp.	„	*2.10*
Rollgeld zur Bahn	„	
Transportversicherung	„	
Fracht . *Auslagerin* · · · · ·	„	*-.40*
Porto	„	
	RM. *3.60*	

Anlagen

Diesen Betrag habe ich zur Bahnnachnahme erhoben

II.2.2.a

24

Figure 10.3 Delivery slip. Source: Niedersächsisches Landesarchiv/ Hauptstaatsarchiv Hannover. NLA. HStAH. Hann. 152 Acc. 2006/013 Nr. 54

for example, abstract art – including work by Malevich – was viewed as the representative art of the new National Socialist German state, and thus continued to be displayed (Katenhusen 2008). In a letter to Josef Albers, Wassily Kandinsky wrote in November 1936: 'I was just informed that the Hanover Museum [...] is still untouched. Apparently it is as difficult to govern a state as it is to create a work of art.'[5]

There were many who disapproved of Dorner's influence in the early 1930s. They felt betrayed by Dorner's attitude that they considered as an attempt to exhibit modern art according to the liking of the new political leaders (Wendland 1999: 90). Until the end of his life, Dorner considered himself a defender of Modernism. Why else, he argued, would he have taken 'the personal risk' of keeping the works of Malevich in his museum, if not 'to fight the Nazis with their own weapons?'[6] Everyone else, according to him, had lacked the courage.

But in the face of increasing pressure, Dorner too found himself forced to give in. At the beginning of February 1937 he submitted his resignation to the State Museum. When he arrived in New York five months later with his wife in order to start a new life in the US, two of the works loaned by Malevich – a painting and a drawing – were in his luggage (Katenhusen 2009: 151). Permission had not been granted to take these pieces. It is clear that Dorner was not concerned to use them to improve his prospects in the US since according to his notes on the back of the work: 'this drawing should go to a public Institute – in case I die before I have taken care of this trust'.[7] Dorner's widow donated the works to the former Germanic Museum at Harvard University, the Busch-Reisinger Museum, in 1961. The representatives in Cambridge, honoured this request, holding on to the pieces for almost four decades on behalf of the legal heirs of the loan.[8] After members of the Malevich family had approached the museum in 1999, both sides reached an agreement. In recognition of the care with which the Busch-Reisinger Museum had handled the painting, the heirs agreed to leave the drawing in this institution where it is now exhibited as gift of the Malevich family and in honour of Alexander Dorner.[9]

Other museums that came into contact with works from the Malevich crate were less transparent about the origin of the pieces. The Museum of Modern

5 Letter from Wassily Kandinsky to Josef Albers, 14 November 1936, Yale University Library, Josef Albers Papers, Manuscrips and Archives, Group No. 32.

6 Letter from Alexander Dorner to Walter and Ilse Gropius, 21 March 1942, Harvard University, Houghton Library, Walter Gropius Papers (bMS Ger 208, 654). See also Nerdinger 1993: 156-8.

7 Kazimir Malevich: Construction: Two Views, app 1925, verso, Harvard University Art Museums, Busch-Reisinger Museum /Harvard University Art Museums (upcoming: BRM).

8 Letter from Lydia Dorner to Charles L. Kuhn, Harvard University Art Museums, 24 February 1961, BRM, Dorner-Archive: Mrs Lydia Dorner.

9 Two Malevich works will be returned to artist's heirs, Deseret News, 26 December 1999.

Art (MoMA), New York is a case in point. Its founding director, Alfred H. Barr (1902–81), had been invited to the Hanover Museum in 1935 and was 'overjoyed',[10] as he recalled when Dorner showed him Malevich's crate.[11] Four works were sold to the enthusiastic director of MoMA on the spot for $160 (75 per cent of Dorner's monthly salary at that time).[12] Dorner sent an additional 17 works, including the renowned *White on White* (1918) to New York in September 1935.[13] The correspondence accompanying the acquisition provided proof that the 17 works were not intended to stay in the US. Instead, Barr was supposed to send them back to Hanover after the conclusion of the famed exhibition, *Cubism and Abstract Art* (March/April 1936 at MoMA, after that travelling within the US) (Heyting 2006: 106).[14] However, it also became increasingly dangerous for Dorner to continue his work in Hanover. Therefore, sending the paintings to New York may in retrospect also be understood as his attempt to save the Malevich works from being looted, as was the case with other paintings which were part of the infamous *Entartete Kunst* or *Degenerate Art* exhibition in Munich in 1937 (Katenhusen 2009: 156-7). As a matter of fact, not a single piece of art from the Malevich crate was ever looted or destroyed.

Thus, the works remained at MoMA. Over the course of Alfred Barr's long directorship they were labeled either as anonymous or extended loans. After the Barr era (his influence extended until 1967), however, the museum incorporated them into museum property. Only with the shifts in the global political systems in the 1990s did this practice come to an end (Heyting 2006: 134, Vogel 1999). When sued by the heirs for the return of the loans, in the summer of 1999, MoMA approved the payment of a one-time sum reputedly of 5 million US dollars and the return of one work, which the heirs could use at their discretion (Hochfield 1999: 18). The returned painting, *Suprematist Composition (1923-1925)*, was given to the Sotheby's auction by the heirs in May 2000, as discussed earlier.

The agreement that MoMA and the Malevich heirs concluded was as similarly amicable as the one that the artists's relatives established eight years later with the Stedelijk Museum and the City of Amsterdam (Hochfield 2004: 66) – though this was clearly a very different case. The claim concerned 14 works of Malevich which had been on exhibitions in the US in 2003-2004. Ownership issues, thus,

10 Letter of Alfred H. Barr to Max Bill, 19 December 1952 (photocopy), Yale Collection of American Literature (forthcoming: YU), Naum Gabo Papers, Uncat ZA Gabo, No. 19.

11 Copy of a letter from Alfred H. Barr to Max Bill, 19 December 1952 (photocopy), YU, Naum Gabo Papers, Uncat ZA Gabo, No. 19.

12 Alfred H. Barr: Postscript to Notes, 25 February 1958, YU, Naum Gabo Papers, Uncat ZA Gabo, No. 19.

13 Letter from Alice Malette to Alfred H. Barr, 4 September 1935, Museum of Modern Art, New York, Alfred H. Barr Papers, microfilmed version: Archives of American Art, Smithsonian Institute, Washington DC, Nr. 2165, 1055.

14 Letter from Alexander Dorner to Alfred H. Barr, 4 March 1936, BRM, Alexander Dorner Papers, Folder 24.

had to be cleared by a US court. The settlement that was reached in spring 2008 concerned not only the 14 works that were the subject of the US action, but covered the entity of Malevich's work in the city's collection (Zeitz 2008). But why, how, and when did the group of paintings reach the Netherlands?

At the end of the 1950s – when almost everyone who had known about the Malevich crate had died – the Stedelijk had purchased 84 of the works (Heyting 2006: 166f, Hochfield 2004: 65-6, Andersen 1970: 58). Two decades before, in the autumn of 1936, Dorner had sent the remaining works in the crate back to Hugo Häring, a friend of Malevich and his solicitor in the late 1920s, who had continued to hold the works in trust (Katenhusen 2009: 160). After the war, there was heightened interest in Malevich (Joosten 1988: 44). In addition, Häring's health rapidly declined and he needed money. In May 1956, he drew up an affidavit, stating that he had been named sole custodian of the loans by the artist in 1927, and that, in accordance with the law, he was now their owner (Heyting 2004). Not surprisingly, there were doubts from the start about the legality of this act.

Nevertheless, with the help of artists, such as Naum Gabo, the Stedelijk's Director Willem Sandberg increased the pressure on Häring to sell the pieces to the museum much below their market value, arguing that otherwise, the Malevich collection would be torn apart by 'a whole pack of wolves of art dealers and speculators'.[15] Finally, in October 1958, Häring, by now very ill and almost out of funds, agreed. Immediately after the acquisition, the Stedelijk insured the work for over 1 million guilders, almost ten times as high as the sales price of 110.000 guilders (the equivalent of 30,000 US dollars) (Heyting 2004, 2006: 168). It did so in autumn 1958 and – not surprisingly – with very little publicity.

Conclusion

It took more than three decades and a changed world political order until those who were interested in the history of the Malevich crate (out of personal, scholarly or material concerns) were finally heard. If they were given answers to their questions, initially these were motivated morally: Dorner made sure that he had kept the Malevich works in order to save them from destruction and oblivion; Alfred Barr as well as Willem Sandberg joined him in this reasoning. Just one of the museums involved, the Busch-Reisinger Museum, placed some emphasis in identifying the legal heirs of Kazimir Malevich before they actually got in touch with those in charge at Harvard University. MoMA and the Stedelijk, however, who, with their share of 21 and 84 pieces respectively, had significantly more works to care for, only reacted years after the artist's relatives had begun their investigations. In these two cases, Kazimir Malevich's heirs needed the help of specialized legal professionals to be finally taken seriously instead of being regarded as bothersome

15 Letter from Naum Gabo to Willem Sandberg, 24 March 1956, The works and writings of Naum Gabo © Nina Williams.

petitioners. Before the various museums authorities consented to the claims, much had been done to draw the curtain over the circumstances of the Malevich purchases and to make the background of their fate impossible to trace. As to the Stedelijk case, for instance, catalogue contributions which would have shed light on Sandberg's acquisition had to be changed upon legal advice, and archival material requested by researchers who wanted to know more about the case had disappeared in unknown circumstances (Heyting 2004, Hochfield 2004: 65).

It remained, and still remains, unknown what might have finally brought the heads of all three museums, between 1999 to 2008, to accept a compromise, to compensate, and to finally restitute seven out of 107 pieces of art that had once been stored in the Malevich crate. Ethical considerations, and ideas like those which have coined the *Washington Conference Principles on Nazi-Confiscated Art*,[16] do not seem to have played any significant role during the negotiations. Thus, the story of the fate of Kazimir Malevich's crate reflects one essential in the ongoing debate about restitution: Number 9 of the Washington Principles – demanding that 'steps should be taken expeditiously to achieve a just and fair solution' – get far too easily out of sight when it comes to the demands of the international art market.

Primary Sources

Harvard University Art Museums, Busch-Reisinger Museum, Alexander Dorner Papers.
Letter from Alexander Dorner to Alfred H. Barr, 4 March 1936, Folder 24.
Letter from Lydia Dorner to Charles L. Kuhn, 24 February 1961. Dorner Archive – Mrs Lydia Dorner.
Harvard University, Houghton Library, Walter Gropius Papers (bMS Ger 208, 654).
Letter from Alexander Dorner to Walter and Ilse Gropius, 21 March 1942.
Museum of Modern Art, New York, Alfred H. Barr Papers, microfilmed version: Archives of American Art, Smithsonian Institute, Washington DC.
Letter from Alice Malette to Alfred H. Barr, 4 September 1935, Nr. 2165, 1055.
Niedersächsisches Landesarchiv/Hauptstaatsarchiv Hanover (NLA/ HStAH).
Letter from Alexander Dorner to Hugo Häring, 13 November 1929, Hann. 152 Acc. 2006/013, Nr. 53.
Letter from Alexander Dorner to Sigfried Giedion, 6 October 1934, Hann. 152 Acc. 68/ 94, Nr. 6. Receipt of the shipping company Gustav Knauer, 10 May 1930, Acc. 2006/013, Nr. 54. *Private Collection of Nina Williams.*

16 Washington Conference Principles on Nazi-Confiscated Art, 3 December 1998. Available at: http://www.state.gov/p/eur/rt/hlcst/122038.htm [accessed: 4 August 2011].

Letter from Naum Gabo to Willem Sandberg, 24 March 1956, The works and writings of Naum Gabo © Nina Williams.
Yale University Collection of American Literature (YU), Naum Gabo Papers, Uncat ZA Gabo
Letter of Alfred H. Barr to Max Bill, 19 December 1952 (photocopy), No. 19.
Copy of a letter from Alfred H. Barr to Max Bill, 19 December 1952 (photocopy).
Alfred H. Barr: Postscript to Notes, 25 February 1958, No. 19.
Yale University Library, Josef Albers Papers, Manuscrips and Archives.
Letter from Wassily Kandinsky to Josef Albers, 14 November 1936, Group No. 32.

Bibliography

Andersen, T. (ed.) 1970. *Malevich. Catalogue raisonné of the Berlin exhibition 1927, including the collection in the Stedelijk Museum Amsterdam; with a general introduction to his work*, Amsterdam: Stedelijk Museum.
Basner, E. 2000. Malevich's Paintings in the Collection of the Russian Museum (The Matter of the Artist's Creative Evolution), in: *Kazimir Malevich in the Russian Museum*, edited by Y. Petrova, exhibition catalogue Russian State Museum, St Petersburg: Palace editions, 15-28.
Beeren, W.A.L., Joosten, J.M. and Verneman-Boeren, L. (eds) 1988. *Kazimir Malevich. 1878-1935*, exhibition catalogue Russian Museum Leningrad, Tretiakov Gallery, Moscow, and Stedelijk Museum Amsterdam, Amsterdam: Stedelijk Museum.
Douglas, C. 1994. *Kazimir Malevich*, New York: H.N. Adams.
Drutt, M. 1999. El Lissitzky in Deutschland 1922-1925, in *El Lissitzky. Jenseits der Abstraktion. Fotografie, Design, Kooperation*, edited by M. Tupitsyn, exhibition catalogue. Hanover: Sprengel Museum, 9-24.
Federowskij, N.K.S. Malewitsch 1988. 'Berliner Vermächtnis', in: *Osteuropäische Avantgarde aus der Sammlung des Museum Bochum und privaten Sammlungen*, exhibition catalogue. Bochum: Museum Bochum, 110-13.
Gough, M. 2003. Constructivism Disoriented: El Lissitzky's Dresden and Hanover Demonstrationsräume, in *Situating Lissitzky: Vitebsk, Berlin, Moscow*, edited by N. Perloff et al.: Santa Monica: Getty Research Institute, 77–125.
Heyting, L. 2004. Vooral geen schandaal. De strijd van de erfgenamen van Kazimir Malevitsj. *NRC Handelsblad*, 29 October, 15-16.
Heyting, L. 2006. *De verwaalde collectie. De schilder Kazimir Malevitsj en de strijd om zijn erfenis.* Amsterdam: Prometheus.
Hochfield, S. 1999. Malevich Heirs Reclaim Long-Lost Legacy in Historic Settlement with Museum of Modern Art. *Art News*, June, 16-19.
Hochfield, S. 2004. Smoke Screen at the Stedelijk. *ARTnews*, December, 64-6.

Horsley, C.B. 2008. Kazimir Malevich: Suprematism, *The City Review: Art + Auction* [Online], n. dat. Available at: http://www.thecityreview.com/malevich. html [accessed: 17 July 2011].

Joosten, J.M 1988. Malevich in The Stedelijk, in *Kazimir Malevich. 1878-1935*, exhibition catalogue Russian Museum Leningrad, Tretiakov Gallery, Moscow, and Stedelijk Museum Amsterdam, edited by W.A.L. Beeren et al., Amsterdam: Stedelijk Museum, 45-54.

Katenhusen, I. 2002. 150 Jahre Niedersächsisches Landesmuseum Hanover, in: *Das Niedersächsische Landesmuseum Hanover. 150 Jahre Museum in Hanover. 100 Jahre Gebäude am Maschpark. Festschrift zum Jahr des Doppeljubiläums*, edited by H. Grape-Albers. Hanover: Niedersächsisches Landesmuseum, 18-94.

Katenhusen, I. 2008. Ein Museumsdirektor auf und zwischen den Stühlen. Alexander Dorner (1893–1957) in Hanover, in: *Kunstgeschichte im 'Dritten Reich'. Theorien, Methoden, Praktiken*, edited by O. Peters et al. Berlin: Oldenbourg Akademieverlag, 156-70.

Katenhusen, I. 2009 '… die malevich-kiste könnte ein filmmanuskript sein'. Zum Schicksal von Kazimir Malewitschs Gemälde 'Suprematistische Komposition', in *Das verfemte Meisterwerk. Schicksalswege moderner Kunst im 'Dritten Reich'*, edited by U. Fleckner. Berlin: Oldenbourg Akademieverlag, 137-71.

Katenhusen, I. 2010. '… nicht der übliche Typus des Museumsdirektors'. Alexander Dorner und die Gemäldegalerie des Landesmuseums in der Zwischenkriegszeit, in *Werke und Werte. Über das Handeln und Sammeln von Kunst im Nationalsozialismus*, edited by M. Steinkamp et al. Berlin: Oldebourg Akademieverlag, 173-90.

Kennedy, R. 2008. Malevich Heirs Settle, *New York Times*, 25.4.2008.

Küppers-Lissitzy, S. 1968. *El Lissitzky. Life, Letters, Texts*. London: Thames and Hudson.

Lamac, M. and Padrta, J. 1978. The Idea of Suprematism, in: *Kazimir Malewitsch zum 100. Geburtstag*, exhibition catalogue. Cologne: Galerie Gmurzynska 1978, 134-80.

Luckow, D. 1988. Museum und Moderne. Politische und geistesgeschichtliche Voraussetzungen von Museumskonzeptionen in der Weimarer Republik, in: *Museum der Gegenwart. Kunst in öffentlichen Sammlungen bis 1937*, exhibition catalogue. Düsseldorf: Kunstsammlung Nordrhein-Westfalen, 33-45.

Maneker, M. 2008. Sotheby's to Sell Malevich in New York, *Art Market Monitor*, 3.10.2008. Available at http://www.artmarketmonitor.com/2008/10/03/sothebys-sells-malevich/ [accessed: 17 July 2011].

Melikian, S. 2008. Work by Kazimir Malevich sold for record $60 million, *New York Times*, 6 November 2008.

Minton, J.A. 2010. Art Restitution of Nazi-era Looted Art: A Growing Force in Art and Law, *The Journal of Art Crime*, issue 3, 49-55.

Nerdinger, W. 1993. Bauhaus-Architekten im 'Dritten Reich', in: *Bauhaus-Moderne im Nationalsozialismus. Zwischen Anbiederung und Verfolgung*, edited by Bauhaus-Archiv Berlin. München: Prestel, 153-78.

Richter, H. 1973. *Begegnungen von Dada bis heute. Briefe, Dokumente, Erinnerungen*. Cologne: Dumont Reiseverlag.

von Riesen, H. 1962. Vorwort, in: *Kazimir Malewitsch: Die gegenstandslose Welt*, edited by W. Haftmann. Cologne: Dumont Dokumente. Texte und Perspektiven, 31-5.

Stachelhaus, H. 1989. *Kazimir Malewitsch. Ein tragischer Konflikt*. Düsseldorf: Claassen Verlag.

Vogel, C. 1999. The Modern Gets to Keep Malevich Work, *New York Times*, 19 June, at B7.

Wendland, U. 1999. Überbrückungsversuche in der Provinz. Alexander Dorner in Hanover, in *Überbrückt. Ästhetische Moderne und Nationalsozialismus. Kunsthistoriker und Künstler 1925-1937*. Cologne: Verlag der Buchhandlung Walther König, 80-91.

Zeitz, L. 2008, Restitutionsfall Malewitsch. Glückliches Ende, *Frankfurter Allgemeine Zeitung* [Online] (FAZ.NET), 17 May. Available at http://www.faz.net/artikel/C31350/restitutionsfall-malewitsch-guetliches-ende-30234830.html [accessed: 17 July 2011].

Claiming the *Parthenon Marbles* Back: Whose Claim and on Behalf of Whom?

Kalliopi Fouseki

Introduction

The *Parthenon Marbles* (often referred to as the Elgin Marbles) denote the architectural sculptures that were removed by Lord Elgin (1766-1841) from the Athenian Acropolis in 1801-1802. These sculptures were shipped to Britain and sold to the British Museum in 1816 (Hitchens 1997: 41), an act that caused controversial debates in the House of Commons. From 1981, disputes around the repatriation of the *Marbles* were further revived when Melina Merkouri, Minister of Culture in Greece (1981-85), directed the official Greek governmental campaign for the return of the *Marbles* to Greece. Since then, the repatriation claim has become one of the major cultural issues in Greece and has been linked with significant cultural projects such as the Olympic Games in Athens in 2004, and the construction of the New Acropolis Museum in Athens (now known as the Acropolis Museum) which started in 2000 and completed in 2007 (Fouseki 2006, 2007). The Acropolis Museum was designed by the Greek state as a new national emblematic symbol (Plantzos 2011: 618) with the aim of hosting the repatriated *Marbles*. During the 1990s the initial claim for the return of the *Marbles* to Greece was superseded in national and international official discourses by the reunification of the *Marbles* with the Parthenon Temple. The reunification thesis suggests that the full purpose and values of the Parthenon temple can be properly comprehended only if the *Marbles* are located within their original topographical context (Hamilakis 2007: 262; Kynourgiopoulou 2011: 159).

This chapter aims to investigate Greek public opinion regarding the issue of the return of the *Parthenon Marbles* to Greece. Based on a public survey conducted in Athens in the summer of 2010, the chapter will argue that the wider discourse on the return of the *Parthenon Marbles* revolves around two main arguments: reunification and repatriation. The chapter argues that the reunification thesis is academically-led, highlighting aesthetics, integrity and the universal value of the *Marbles*, and that the *Marbles* are an integral part of a world monument. The reunification argument stresses the relocation of the *Marbles* to the Acropolis Hill. It is an 'authorized heritage discourse' (AHD), one that privileges monumentality, universal significance and scientific or aesthetic expert judgements (Smith 2006). Indeed, AHD has been inspired by the 'grand narratives of Western national and

elite class experiences' since the nineteenth century and has been reinforcing 'ideas of innate cultural value tied to time, depth, monumentality, expert knowledge and aesthetics' (Smith 2006: 299). As a consequence, AHD affirms and legitimizes particular identities and values – often at national level while obscuring or devaluing others (Smith 2006: 300, 30).

By contrast, the repatriation claim, adopted initially by Melina Merkouri and dominating the wider public discourse (including media), promotes the return of the *Marbles* to their original home and *topos*. The latter, as will be shown below in the findings of the public survey, is conceived as an abstract, idealized place that extends beyond the geographical boundaries of the Acropolis Hill or the city of Athens. The claim for the return is linked to the need of the Greek people to foster their sense of belonging. The return is also viewed as a gesture of social justice and as restoration of pride and respect. Thus, although reunification dominates national and international official discourses, within unofficial narratives, the notion of repatriation seems to prevail.

Both the repatriation and the reunification arguments fit within the claim for return, defined by the former Museums and Galleries Commission generally as the 'transfer of an object from a museum collection to a requesting party, following a decision at the highest level of approval within the museum, generally its governing party' (Legget 2000: 29). Repatriation refers to the return of an object to a party 'found to be the true owner or traditional guardian, or their heirs and descendants' and for whom the object is 'deemed essential to the identity, and to the cultural and spiritual well-being or history of the party' (Legget 2000: 29). The term restitution focuses on the return of an object to an individual or a specific community (Legget 2000: 29).

This paper will argue that the official and unofficial discourses regarding the return of the *Parthenon Marbles* focus on reunification and repatriation respectively. It will be stressed that the reunification argument is academically-led and does not necessarily manifest wider Greek public views. For Greeks, the return of the *Marbles* does not rely on the indispensability to re-assemble the Parthenon temple but rather derives from the pursuit of Greek people for social justice and identity reaffirmation in the global arena. Consequently, Greeks view the return of the *Marbles* principally as an issue of human and cultural rights (Schmidt 1996).

Since the repatriation claim for Greeks is emotionally grounded, Greeks do not focus on the materiality of the *Marbles* and their tangible value as works of supreme art but on the repatriation process itself. In other words, it is mainly intangible meanings that are assigned by Greeks to the *Parthenon Sculptures*, whilst experts and national authorities attach tangible values associated with aesthetics and monumentality. This is partly because the reunification argument intends to be an objective, powerful set of ideas that will render the return of the *Marbles* a unique case in comparison with other restitution claims worldwide. However, emphasis on the materiality of the *Marbles* neglects that what really

matters for Greeks is not the cultural object but the process of return, the act of repatriation. Indeed, for Melina Merkouri repatriation is a political act:

> I was born – and I believe all Greek children are born – thinking that in a way we built the Acropolis and the Parthenon. It is our heritage, our identity. Asking for the return of its parts is a political act, an act of independence (cited in Yalouri 2001: 83).

If the reunification rhetoric deviates substantially from unofficial voices, then the question that emerges is – who is the rightful authority to make a claim for return and on behalf of whom?

Public Opinion Regarding the Return of the *Parthenon Marbles* to Greece

Interestingly, public opinion in Greece regarding the return of the *Marbles* has not been investigated thoroughly before.[1] This section will explicate the findings of 100 semi-structured interviews conducted by the author with Athenian residents who were approached randomly in squares and coffee shops in the summer of 2010. Although the sample is not representative of the Greek population as a whole, this research constitutes the first qualitative public survey conducted in relation to this topic. The aim is to expand the survey in the future in order to include respondents from other Greek areas, as well as the Greek diaspora in London.

Participants in the survey (for the profile of the respondents see Table 11.1) were asked about their perceptions of the *Marbles* displayed in the British Museum and the meanings and values they assign to them. In addition, they were asked whether they had visited the Acropolis Museum. Respondents who had visited the latter were invited to express their opinions about the 'Parthenon Gallery' which is intended to display the repatriated *Parthenon Marbles*. As only 19 per cent of the respondents had visited the Acropolis Museum, this paper focuses on responses regarding the display of the *Parthenon Marbles* in the British Museum. However, it should be mentioned that those who had visited the Acropolis Museum tended to be more inclined towards reunification than those who had not visited.

1 Data on public opinion related to the return of the *Parthenon Marbles* rely mainly on polls conducted via newspapers. In the UK, for instance, a poll carried out by The Guardian on 24 June 2009 asked readers whether is it time to return the Parthenon Marbles. Ninety-five per cent of the respondents were in favour of the return. In Greece, Greeks have often signed relevant campaigns. However, a study investigating why the public in Greece wants the *Parthenon Marbles* to return has not been conducted.

Table 11.1 The profile of respondents in the public survey

Gender	Age	Education
Female: 53%	18-34: 48%	School: 58%
Male: 47%	35-54: 28%	University: 40%
	Over 55: 24%	Technical qualification: 2%

The need for the return of the *Marbles* to their original *topos* was stressed by the vast majority of participants (71 per cent) (Figures 11.1 and 11.2). Interestingly, eight respondents did not favour the repatriation of the *Marbles*, arguing that their display in the British Museum functions as a means to promote Greece internationally. The latter included mainly individuals who had either studied abroad or were under 25-years-old.

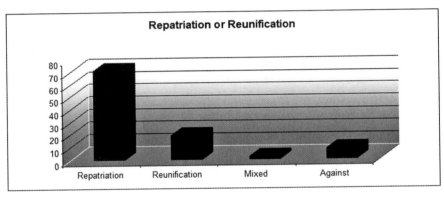

Figure 11.1 Public responses to the question: *What is your opinion regarding the Parthenon Sculptures that are currently displayed in the British Museum?*

The following sections will focus on analysing responses of the majority who are in favour of the return, while investigating the differences between the reunification and repatriation arguments.

The Return of the *Marbles* to their *Topos*: A Spatial Approach

Central to both the reunification and repatriation argument is the notion of *topos* (place). However, in the reunification thesis *topos* is rather narrowly identified with the Parthenon temple, the Acropolis Hill and/or the Acropolis Museum. By contrast, *topos* in the repatriation claim is referred to as encompassing not only a geographically demarcated country but an 'imagined homeland'. Indeed the word

topos in Greek not only marks a physical place, a site where the past makes its presence felt (Leontis 1995: 19), but invokes the presence of Hellenism (Leontis 1995: 69). Thus *topos* does not solely connote a 'real place' but also a *heteros topos*, an 'other place' (Foucault 1986). This *heteros topos* is a heterogeneous space formed by 'a set of relations that delineates sites which are irreducible to one another and absolutely not superimposable on one another' (Foucault 1986: 23). Heterotopia is thus a socially created space 'rarely seen for it has been obscured by a bifocal vision that traditionally views space as either a mental constructor or a physical form – a dual illusion' (Soja 1989: 18). Therefore, heterotopias are often 'obscured from view by excessive emphasis on their empirical opaqueness or their ideational transparency' (Soja 1995: 15). In other words, a heterotopia is an actual place that is 'conceived as being otherwise and existing outside normative social and political space' (Leontis 1995: 43). Heterotopias are real places which function as 'counter-sites', as 'other places' in which 'the real sites […] are simultaneously represented, contested, and inverted' (Foucault 1986: 24). In retrospect, it could be argued that heterotopias are more of an idea about space than an actual place (Genocchio 1995: 43). It is an idea which consequently produces and theorizes space as 'transient, contestory, plagued by lapses and ruptured sites' (Genocchio 1995: 43).

It could be argued that Foucault's concept of heterotopias is rather vague and does not explicitly state what is excluded from the concept (see Genocchio 1995: 38). Potentially, any place and space constitutes a heterotopia. Despite the vagueness of the term, the significance of Foucault's argument relies on its potential wider implications for any attempt to define or differentiate notions of 'other, absolutely different, resistant or transgressive space' (Genocchio 1995: 39). For instance, the Acropolis could form a heterotopia since the West has used – or even abused – the Acropolis Hill for collecting artefacts, providing an aesthetic education, expanding historical knowledge, and enhancing national treasures and international prestige (Leontis 1995: 60). It could also be argued that the British Museum is a heterotopia. It is a 'real physical place' located in Britain but is also perceived as an 'other' place, a place of world cultures. It is these 'other places' that are mirrored in peoples' minds which define heterotopias. Heterotopias may exist as real geographical entities as well as cognitively and socially constructed spaces that are being constantly transformed into conceptual, imagined, unconfined places.

Reunifying the *Marbles*: An 'authorized heritage discourse?'

Firstly, they should not be known as 'Marbles'. They are sculptures in relief. Secondly, they are a representative sample of one of the most important monuments from an art, aesthetic and historic point of view in Greek history. Without them the Parthenon looks incomplete. (Female, 35-46, Archaeologist)

This section will argue that national and international official discourses on reunification – such as memorandums submitted by the Greek government to the British Select Committee, websites of international committees for the reunification of the *Parthenon Marbles* and newspaper articles – constitute an example of 'authorized heritage discourse' (Smith 2006). As will be indicated, the afore-mentioned documents highlight similar sets of values including aesthetics, integrity, universality and monumentality.

Indeed, this value set is clearly emphasized in the statements of the former British *Committee for the Restitution of the Parthenon Marbles* (and currently the *Committee for the Reunification of the Parthenon Marbles*) according to which: 'The *Parthenon Marbles* – or more precisely, the *Parthenon Sculptures* are not freestanding works of art but integral architectural members of one of the most magnificent and best-known monuments in the world: the Parthenon' (http://www.parthenonuk.com/index.php/the-case-for-thereturn?showall=&start=3). It is not only the aesthetic and universal values that are stressed but also their role in facilitating 'scholars' and people to 'understand'. Insistence on the universality of the sculptures is closely related to the expertise of archaeologists and historians who can evaluate a monument in relation to other monuments (Byrne 1991) and can therefore define what is of universal value and what is not. Thus identifying the universal value of heritage is clearly dependent on knowledge, previous research and expert evaluation (Hodder 2010: 862).

Similarly to the *British Committee*, a memorandum submitted by Congressman Donald M. Payne in 2000 specified that:

> To properly address the best interests of the Parthenon Sculptures, it is helpful to keep in mind two important factors. The first is the intrinsic nature of the art, that is, that the Sculptures were never intended to be movable, decorative art but comprised integral portions of a complete artistic and historic rendering. […] The second is the importance of the Parthenon Temple itself both as a place of worship and as a world symbol of democracy and culture. (Payne 2000: http://www.publications.parliament.uk/pa/cm199900/cmselect/cmcumeds/371/371ap41.htm)

This statement once again stresses that it is due to the integrity of the sculptures and the universality of the Parthenon temple that the *Marbles* should be reunited with the Parthenon. The *American Committee for the Reunification of the Parthenon Sculptures* (ACRPS) adopts a similar rhetoric when it asserts that the 'integrity of the unique Monument known as the Parthenon' is one of 'our first and foremost concerns' (http://www.parthenonmarblesusa.org/index.php/the-sculptures/the-case-for-reunification).

Overall, the statements above embrace the main attributes of an 'authorized heritage discourse' – beauty, aesthetics, integrity and universality. They focus on 'aesthetically pleasing, material objects, sites, places and/or landscapes that current generations "must" care for, protect and revere so that they may be passed

to nebulous future generations for their "education"' (Smith 2006: 29). Education and scholarship are presented here as the ultimate aim of the reunification process.

A similar, although slightly less materialist approach, is adopted by the *Australian Hellenic Council of the Parthenon Marbles* (AHC). According to the council:

> The Parthenon Sculptures are an integral part of one of the most important buildings ever constructed, and should be returned to their rightful owners. The Parthenon is a testament of human genius, a work of unsurpassed beauty and a symbol of freedom and democracy without equal anywhere in the world. (Diamandis 2009: http://www.helleniccouncil.org.au/press/downloads/AHC_ Parthenon_Marbles.pdf)

Although this statement focuses again on the integrity, universality and beauty of the Parthenon temple and its sculptures, the characterization of Greeks as the 'rightful owners' complies with the notion of social injustice inherent in the repatriation claim, as will be discussed. Similarly, the memorandum of the *International Organizing Committee of New Zealand for the Restitution of the Parthenon Marbles,* submitted in March 2000 reads:

> That the Marbles were actually cut from the structure of the Parthenon is painful to know. The injustices which occurred, when the Marbles were taken by Lord Elgin from a people who had no say in the matter, dictates that these Marbles should be returned to from where they were taken [...] The matter of the *Parthenon Marbles* is important on many levels including artistic merit, historic authenticity, international goodwill and respect for traditional places of worship. (Payne 2000: http://www.publications.parliament.uk/pa/cm199900/cmselect/cm cumeds/371/371ap41.htm)

Thus the rhetoric of both the Australian and New Zealand committees is more holistic than the British or the American one since, in addition to the values of experts, they consider the symbolic and spiritual importance of the sculptures. This may be interpreted by the long history and engagement of these countries with Aboriginal repatriation claims.

It is not only the international committees that stress the integrity and the aesthetics of the Marbles. Similar discourses are adopted by the Greek Government which, since the 1990s, has been gradually shifting from the legal ownership claim towards a co-ownership argument, which advocates that the *Marbles* be reunited with their original context. Indeed, the reunification argument does not imply legal ownership (Greenfield 1996: 257) and therefore it is being used as an alternative diplomatic tactic for the return of the *Marbles* to Greece. For instance, similar sets of values are underscored in the following memorandum statement submitted by the Greek Government:

The sculptural decoration and architectural elements of the Parthenon were not created as independent works of art; they were conceived and designed from the outset as integral parts of the monument [...] the cultural, historical, archaeological and aesthetic values of the Parthenon are most closely interwoven with the city in which it was created, Athens. (The Greek Government 2000: http://www. publications.parliament.uk/pa/cm199900/cmselect/cmcumeds/371/0060503. htm)

In this statement, the spatial relationship between the *Marbles* and their *original context* is slightly broader since the context does not refer only to the Acropolis Hill but also to the city of Athens as a whole. Despite this wider geographical approach, the memorandum continues by emphasizing that the reunification will allow for the first time since the dismantling of the *Marbles* their presentation 'as a unified ensemble in their original sequence and correct relationships, and in visual contact with the unique monument they once adorned' (The Greek Government 2000: http:// www.publications.parliament.uk/pa/cm199900/cmselect/cmcumeds/371/0060503. htm). It is only at the very end of the memorandum that the Greek government calls for moral and cultural justice: 'The time is ripe for reuniting the *Parthenon Marbles* in their original home. Their return will redress the cultural and moral injustice of their enforced exile' (The Greek Government 2000: http://www.publications. parliament.uk/pa/cm199900/cmselect/cmcumeds/371/0060503.htm).

This statement signifies that ultimately the core claim of the Greek government is a claim for ownership and justice. However, the Greek government, in its attempt to provide a powerful diplomatic tactic for achieving the return of the *Marbles* to Greece, focuses on reunification, an argument that highly expresses the values of experts who are perceived as the 'legitimate' guardians of Greek cultural heritage. The question thus that emerges is to what extent the reunification thesis represents wider Greek public perceptions. It is this issue that the following sections aim to address.

Repatriating the *Parthenon Marbles*

Singh has argued that 'at the heart of any nation's call for repatriation lies the idea of the *patria*, the homeland, an entity that can demonstrate its legitimate claim to the artefacts being repatriated' (2010: 133). This *patria* is perceived, as mentioned above, differently between those who support reunification and the wider public. The survey revealed that for the significant majority of respondents (71 per cent), the repatriation of the *Marbles* was advocated not only because they are perceived to be part of their Greek heritage but also because they were stolen from their original *topos* (Figures 11.1 and 11.2).

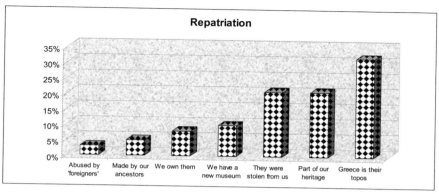

Figure 11.2 Reasons for repatriation

Interestingly, the majority of the respondents who emphasized the indispensability of the repatriation of the *Marbles* (32 per cent) justified their response on the basis that Greece constitutes their 'legitimate' *topos*: 'They are part of our culture. They should be located in the "topos" where they were made. They are our cultural heritage. Their topos is here' (Female, 36-45, University degree, Pre-school teacher). The return of the *Marbles* to their original *topos* is the medium for Hellenism to reclaim its heritage from Western appropriation. Although Hellenism has a universal value – mainly appreciated by the international expert community – it also requires a native expression which can only be achieved locally (Leontis, 1995: 119). The reterritorialization of the *Marbles* will enhance national pride and esteem: 'The Parthenon Marbles for me are part of our cultural heritage, they are our "kamari" (pride) and a symbol of our Greekness' (Male, 36-45, private sector employee, University degree). Undoubtedly, heritage has powerful emotional and intellectual appeal since it excites a feeling of prestige and, therefore, a sense of pride (Edson 2004: 345). The emotion of pride emerges not only because *their Marbles* are being admired worldwide but also because their return will re-establish an 'honourable profile' worldwide (Mouliou 1996).

The repatriation of the *Marbles* will also constitute the response against international accusations regarding Greece's inability to protect its heritage (Yalouri 2001: 82). This is further reinforced by the inauguration of the Acropolis Museum as mentioned by ten respondents. Although the Acropolis Museum is not regarded as the original *topos* for the Marbles, it is the 'emblematic', symbolic evidence of Greece's ability to safeguard its heritage, re-establishing its identity nationally and internationally. Since the Acropolis Museum signifies a cultural achievement in the present aimed to display the symbolic cultural achievements and markers of Greek cultural past (Kynourgiopoulou 2011: 158), the return of the *Marbles* to Greece will reaffirm national identity and will decrease feelings of inferiority.

The need for national identity reaffirmation is also linked to the need for social justice, as was emphatically mentioned by 31 respondents: 'The Marbles

should definitely return to Greece – all of them [the foreigners] have looted us. Everyone who passed by Greece stole a piece of our history!' (Male 55-65, Primary school education, Hospital worker). What this statement shows is that for Greeks ownership is not a legal issue but an issue of social justice and morality since ownership is merely 'cognitive' (Boyd et al. 1996). Cognitive ownership represents the link between people and places defined by some form of intellectual, conceptual or spiritual meaning that a group or individual attach to the site (Boyd et al. 1996: 125). Cognitive ownership does not involve a value judgement and should not imply one (Boyd et al. 1996: 125). It is primarily a function of the people who associate with the heritage feature rather than the inherent quality of the heritage feature (Boyd et al. 1996: 125). This social approach identifies the place in terms of a fluid, less static history (Boyd et al. 1996:123). Moreover, heritage ownership is often 'more spiritual than pecuniary, more about identity and less about control' (Hodder 2010: 870). Any form of ownership is interlinked with identity formation, affirmation and reaffirmation and identity. Thus, the displacement of iconic and emblematic cultural objects 'disrupts the collective memory of identity' (Kynourgiopoulou, 2011: 162). It is not only the Greek collective identity that is disrupted but the need of Greeks for social justice since they feel the 'legitimate' owners of their heritage.

The appropriation of Greek antiquities by 'foreigners' is viewed as a disrespectful act, an act of sacrilege. A few respondents mentioned that the Marbles should return because 'they are being abused abroad since foreigners do not know how to respect them' making also specific reference to receptions organized by the British Museum in the Duveen Gallery where the *Elgin Marbles* are displayed. Sacred connotations and notions of respect related to antiquities have prevailed since the beginning of the nineteenth century – if not earlier – when classical antiquities were described in official discourses as 'sacred heirlooms of antiquity' (Hamilakis and Yalouri 1999, Yalouri 2001: 137). The Acropolis Hill, for instance, is known as 'sacred rock'. The 'soil' to which the *Parthenon Marbles* should return is also perceived as holy (Leontis 1995: 40). If the display of the *Parthenon Sculptures* is seen as sacrilege then their return will mark their re-sacralization process in its entirety. The re-sacralization process that the repatriation claim connotes relates to the relocation of the *Marbles* to their 'holy soil' whilst the reunification argument advocates relocation to the vicinity of the sacred rock of the Acropolis.

Animated *Marbles*

Both the reunification and the repatriation rhetoric use the metaphor of the *Marbles* as animated, integral members of a living national body. Respondents, for instance, in the survey occasionally refer to the *Marbles* as 'children that have been taken away from their father' … 'They should return! No question! Any child that has been taken away should return to its country of origin' (Male, 55-65, Technical School, Surveyor). The difference between the reunification and

repatriation discourses though is that the *Marbles* in the first rhetoric are presented as belonging to a national body while in the second they are presented as belonging to a family. The connection with a family, the father, reveals the interconnected relationship between nationhood and kinship (see Yalouri 2001: 66). Terms such as motherland, fatherland, patria, Vaterland, allude to metaphorical associations of the nation-state with parenthood (Malkki 1992: 66). Motherland and fatherland suggest that 'each nation is a grand genealogical tree, rooted in the soil that nourishes it' (Malkki 1992: 28).

The Marbles and the caryatids have been portrayed in a series of folk stories as human beings petrified by magicians (Hamilakis 1999: 308; Kynourgiopoulou 2011: 158) or caryatids as human beings that 'cry' for the abduction of their 'sisters' (Hamilakis 1999; 2007: 255, Kynourgiopoulou 2011: 158). This animation may be partly explained by the monumentality of these statues that give the impression of 'real people', a perception that has often been expressed by respondents who visited the Acropolis Museum and who were impressed by the 'caryatids' because: 'they look so natural […] as if they are about to start walking and talking to you' (Female 26-35, Technical qualification, Nurse). In addition, the *Marbles* are often described in the press as imprisoned (Hamilakis 2007, 279) or as having real emotions of nostalgia for the 'homeland', pain and agony of living in exile and in separation from their relatives (Hamilakis 1999: 314). It could be argued that the sculptures stand as a 'homology for Greeks in exile, for Ulysses, for the notion of "nostos", the desire for the return to the homeland' (Hamilakis 1999: 314). In the case of the reunification argument, Hamilakis argues that it is the nostalgia for the whole that demands the return of the *Marbles* and which can probably be seen as a 'recollection of forcefully separated national entities' (Hamilakis 2007: 282). I would further argue that for the reunification argument, it is the nostalgia of experts for admiring the aesthetics of the Parthenon in its completeness, while for Greeks it is the nostalgia for re-territorializing Hellenism in its wholeness.

Reterritorializing the *Parthenon Marbles*

This analysis has revealed that the notion of *topos, patria, terra*, is central to both arguments. However, *topos* is visualized differently in official and unofficial narratives because the sets of values that are attached to the *Marbles* are different. Topos in the reunification argument is defined as the place that will enhance the integrity and the aesthetics of the sculptures – that is the Acropolis Hill and/or the Acropolis Museum. For the repatriation claim though, topos is the soil, the home, the land, the country, or the 'imagined nation' (Anderson 1983) – notions that strongly emerge from identity affirmation and social justice. The 'holy soil' or 'holy topos' is again defined differently in both arguments. For the reunification argument the 'holy soil' is identified with the 'sacred Rock' of the Acropolis and the Parthenon Temple, while for the repatriation claim it connotes broadly the 'Greek land'. In both arguments, the Acropolis and Greece are perceived as

heteroi topoi, as places of different order that are imbued with eternity, beauty and universality (Leontis 1995). The difference is that Acropolis in reunification arguments is a clearly distinct, geographically demarcated space, while, for repatriation claimants, the Acropolis is an imagined, geographically unbounded heterotopos, identified with the Greek soul and spirit, home and ancestral identity. Thus, while for the reunification supporters, the return of the *Marbles* will mark the completion of the 'aesthetics' in its wholeness, for repatriation supporters their return to their original topos will signify the re-territorialization of Hellenism in its wholeness, proving Greece's ability to protect its heritage (Yalouri 2001: 82). In conjunction with the notion of *topos*, it is also the notion of authenticity and originality that are viewed differently in the two arguments. While for the reunification thesis the 'authentic, original topos' refers to the real existence of the Acropolis Hill, for repatriation claimants, authenticity is cognitively constructed. Indeed, the Parthenon Gallery of the Acropolis Museum overemphasizes the authenticity of the 'material' by contrasting the original sculptures with replicas which aim to visualize the absence of the originals. By contrast, for repatriation claimants, it is the networks of relationships between people, objects, spaces that are central in the notion of authenticity, rather than the things themselves (Jones 2010).

Conclusion

This chapter has argued that the reunification discourse is academically-led and does not portray wider public opinion. It was further stressed that the reunification thesis is an indicative example of the 'authorized heritage discourse', a hegemonic discourse that constitutes the 'way we think, talk, and write about heritage' (Smith 2006: 11). It is therefore an argument that reflects expert values attached to heritage, such as aesthetics, monumentality and integrity. Although it could be argued that the repatriation claim is also authoritatively discursive since it was shaped and disseminated by Greek governmental authorities and is also embedded in the nationalist ideology of the nineteenth and twentieth century that admires classical antiquities as emblems of Western civilization, a closer examination of public rhetoric reveals notions that are similar to the repatriation discourses of human remains in Australia. Notions of belonging, social justice, restoration of pride and respect, underline repatriation claims overall (see for instance Atkinson 2010: 18, Krmpotich 2010).

Similarly, for Greeks, the return of the *Marbles* to their original home is associated with Greek need for social justice and identity reaffirmation in the global arena. Hence emphasis on the materiality of the *Marbles* does not take into consideration that what really matters for Greeks is not the sculptures themselves but the process of return, the act of repatriation. Although both arguments attempt to respond to the British Museum's colonialist contention that Greece is incapable of preserving its heritage, their discursive approaches differ in that

the reunification argument is a materialist thesis, while the repatriation claim is emotionally-led. The universal value underlined in the reunification argument is evaluated in terms of objective and abstract knowledge about cultural variation, types, and norms and has been defined through 'practices of expertise that have a distanced universalizing character' (Hodder 2010: 863).

Overall, it could be argued that valuing the Parthenon as a world monument and its sculptures as artefacts of supreme art obscures the process of repatriation, which is what really matters for Greeks. Heritage is not a 'thing', a site or building but a process (Smith 2006). This implies that heritage is fundamentally intangible. In the case of the *Marbles* an important element in the process of return is the attribution of social justice. Greeks own the *Marbles* 'cognitively' (Boyd et al. 1996) rather than legally. This spiritual ownership intersects with identity formation, affirmation and reaffirmation. It also denotes why for Greeks the appropriation of the *Marbles* by the British Museum for organizing 'parties' is an act of de-sacralization. The return of the *Marbles* will form a re-sacralization process, a process that will welcome the *Marbles* to their 'holy soil'.

If we accept, as this chapter has argued, that the reunification, official discourse differentiates substantially from the repatriation claim by Greek people, then the question that emerges is who is claiming the reunification of the *Marbles* and on behalf of whom? In addition, it needs to be questioned how ethical it is for experts or governmental authorities to frame claims of the return of cultural property on the basis of their own judgemental criteria and values, neglecting meanings and symbolisms that are attached by the wider public. Such questions prompt detailed and systematic investigation of wider public opinion, the findings of which should be used as a basis on which a return claim should rely. Claims for the return of 'cultural property' should holistically encompass values and aspirations of the wider public and not only those of the 'intellectual elite'. I would therefore suggest that claims for the return of 'cultural property' should adopt a holistic discourse, encompassing not only academic and expert perspectives, but also wider public opinion which has been investigated systematically. Such an approach does not only constitute a moral action, it can also provide a potentially powerful diplomatic tool.

Acknowledgements

I would like to thank Dr Georgios Alexopoulos, Dr Marilena Alivizatou, Dr Stelios Lekakis and Dr Anastasia Sakellariadi for their invaluable, thought provoking comments. I would also like to thank Dr Louise Tythacott and Dr Kostas Arvanitis for their constructive and detailed editorial work.

Bibliography

Anderson, B. 1983. *Imagined Communities: Reflections on the Origin and Spread of Nationalism*. London: Verso.

Atkinson, H. 2010. The Meanings and Values of Repatriation, in *The Long Way Home: the Meanings and Values of Repatriation*, edited by P. Turnbull and M. Pickering. New York: Berghahn Books, 15-19.

Boyd, B., Cotter, M., O'Connor, W. and Sattler, D. 1996. Cognitive Ownership of Heritage Places: Social Construction and Cultural Heritage Management, in *Archaeology and Material Culture Studies in Anthropology*, edited by S. Ulm et al. St Lucia: Anthropology Museum, University of Queensland, 123-40.

Byrne, D. 1991. Western hegemony in archaeological heritage management, *History and Anthropology* 5(2), 269-76.

Diamandis, P. 2009. *Restitution of the Parthenon Marbles*. [Online]. Available at: http://www.helleniccouncil.org.au/press/downloads/AHC_Parthenon_Marbles. pdf [accessed: 20 August 2011].

Edson, G. 2004. Heritage: Pride or Passion, Product or Service?, *International Journal of Heritage Studies*, 10(4), 333-48.

Foucault, M. 1986. Of Other Spaces, *Diacritics* 16 (1), 22-7 (translated by Joy Miscowiec).

Fouseki, K. 2006. Conflicting Discourses on the Construction of the New Acropolis Museum, *European Review of History* 3(4), 533-48.

Fouseki, K. 2007. Developing and Integrating a Conflict Management Model into the Heritage Management Process, in *Which Past, Whose Future: Treatments of the Past at the Start of the 21st Century: An International Perspective*: Proceedings of a conference held at the University of York 20-21 May 2005, edited by Grabow S. et al. Oxford: Archaeopress, 127-36.

Gennochio, B. 1995. Discourse, Discontinuity, Difference: the Question of 'Other' Spaces, in *Postmodern Cities and Spaces*, edited by S. Watson and K. Gibson, Oxford-Cambridge: Blackwell, 35-46.

Greenfield, J. 1996. *The Return of Cultural Treasures*. Cambridge: Cambridge University Press.

Hamilakis, Y. 1999. Stories from Exile: Fragments from the Cultural Biography of the Parthenon (or 'Elgin') Marbles, *World Archaeology*, 31(2), 303-20.

Hamilakis, Y. 2007. *The Nation and its Ruins: Antiquity, Archaeology, and National Imagination in Greece*. Oxford: Oxford University Press.

Hamilakis, Y. and Yalouri, E. 1999. Sacralizing the Past: Cults of Archaeology in Modern Greece, *Archaeological Dialogues*, 6(2), 115-19.

Hitchens, C. 1997. *The Elgin Marbles: Should they be Returned to Greece?* London: Verso.

Hodder, I. 2010. Cultural Heritage Rights: From Ownership and Descent to Justice and Well-being, *Anthropological Quarterly*, 83(4), 861-82.

Jones, S. 2010. Negotiating Authentic Objects and Authentic Selves: Beyond the Deconstruction of Authenticity, *Journal of Material Culture*, 15(2), 181-204.

Krmpotich, C. 2010. Remembering and Repatriation: The Production of Kinship, Memory and Respect, *Journal of Material Culture*, 15(2), 157-80.

Kynourgiopoulou, V. 2011. National Identity Interrupted: The Mutilation of the *Parthenon Marbles* and the Greek Claim for Repatriation, in *Contested Cultural Heritage: Religion, Nationalism, Erasure, and Exclusion in a Global World*, edited by Silverman, H. Springer: New York, 155-70.

Legget, J.A. 2000. *Restitution and Repatriation: Guidelines for Good Practice,* London: Museums and Galleries Commission.

Leontis, A. 1995. *Topographies of Hellenism: Mapping the Homeland.* London: Cornell University Press.

Malkki, L. 1992. National Geographic: The Rooting of Peoples and the Territorialization of National Identity among Scholars and Refugees, *Cultural Anthropology*, 7(1), 24-44.

Mouliou, M. 1996. Ancient Greece, its Classical Heritage and the Modern Greeks: Aspects of Nationalism in Museum Exhibitions, in *Nationalism and Archaeology*, edited by Atkins, J.A. et al. Glasgow: Cruithne, 174-99.

Payne, D.M. 2000. *Memorandum submitted by Congressman Donald M Payne.* [Online] Available at: http://www.publications.parliament.uk/pa/cm199900/cm select/cmcumeds/371/371ap41.htm [accessed: 20 August 2011].

Plantzos, D. 2011. Behold the Raking Geison: the New Acropolis Museum and its Context-free Archaeologies, *Antiquity* 85, 613-30.

Schmidt, P. 1996. The Human Right to a Cultural Heritage: African Applications, in *Plundering Africa's Past*, edited by P.R. Schmidt and R.J. McIntosh. Bloomington: Indiana University Press, 18-28.

Singh, K. 2010. Repatriation without Patria: Repatriating for Tibet, *Journal of Material Culture* 15(2), 131-55.

Smith, L. 2006. *Uses of Heritage.* London: Routledge.

Soja, E. 1989. *Postmodern Geographies: The Reassertion of Space in Critical Social Theory.* London: New York, Verso.

Soja, E. 1995. Heterotopologies: A Remembrance of Other Spaces in the Citadel-LA, in *Postmodern Cities and Spaces*, edited by S. Watson and K. Gibson. Oxford-Cambridge: Blackwell, 13-34.

The American Committee for the Reunification of the Parthenon Sculptures, 2007. *The Case for Reunification.* [Online] Available at: http://www.parthenon marblesusa.org/index.php/the-sculptures/the-case-for-reunification [accessed: 20 August 2011].

The Committee for the Reunification (formerly Restitution) of the *Parthenon Marbles*, nd. *The case for the return: the Parthenon Marbles an integral part of a famous monument.* [Online] Available at: http://www.parthenonuk.com/index. php/the-case-for-the-return?showall=&start=3 [accessed: 20 August 2011].

The Greek Government. 2000. *Memorandum submitted by the Greek Government.* [Online] Available at: http://www.publications.parliament.uk/pa/cm199900/ cmselect/cmcumeds/371/0060503.htm [accessed: 20 August 2011].

Yalouri, E. 2001. *The Acropolis: Global Fame, Local Claim*. Oxford-New York: Berg.

Index

Page numbers in **bold** refer to a figure or table.